A GUIDE TO

TRAVEL WRITING & PHOTO-GRAPHY

ANN & CARL PURCELL

Writer's Digest Books

Cincinnati, Ohio

95 94 93 92 91 5 4 3 2 1

Library of Congress Cataloging in Publication Data

Purcell, Ann.
 A guide to travel writing and photography/by Ann and Carl Purcell. — 1st ed.
 p. cm.
 Includes index.
 ISBN 0-89879-466-8 (pbk.)
 1. Travel writing. 2. Travel photography. I. Purcell, Carl. II. Title.
G151.P87 1991
808'.06691 — dc20 90-28357
 CIP

Edited by Beth Franks
Designed by Clare Finney

This book is dedicated to each other and to our children, Peter, Stacey, Adam and Laura, each a veteran traveler.

Contents

Introduction

We chose to be travel writers because we love to travel. Our primary motivation is not money; instead we are driven by a restless curiosity to know the world and the people in it. To write well, you must know and understand the places you visit: but above all you must experience each destination and become involved with its people. This is the essence of travel: to see and hear, to taste and smell, to exchange ideas and feelings. We seek the adventure and stimulation of new places and different cultures. As travel writers and photographers, we want other people to see the world through our eyes.

The outsider looks on our lives as glamorous, filled with adventure and excitement as we ride the jet stream to faraway exotic destinations. While this may be true, there is a harsh reality to the downside of travel writing, which involves sitting at a word processor and meeting deadlines, paying the rent, getting the children off to school, and boarding the dog and cat. Travel is not always comfortable. To cross the ocean, we often fly for hours in the cramped economy section of a jumbo jet; we bounce over washboard roads in a Land Rover, and get eaten alive by mosquitoes in a steaming jungle. This is not the glamorous life-style portrayed in the pages of *Travel & Leisure*, but it is the real world for a travel writer.

Of course this world also has its rewards: those magic moments when a butterfly settles in the protective arms of a mountain orchid, or the setting sun turns the sky to a crucible of molten gold. Many people have to go to a museum or see a documentary film to meet a tribe of Masai warriors, take a gondola ride through the canals in Venice, or hear the splash of water as Thai trainers bathe their elephants. We feel very fortunate that we can actually be on the spot where life is being lived — breathing the dust at the foot of the Egyptian pyramids; burning the roofs of our mouths with hot, succulent chunks of chicken straight off a charcoal pit in southern China; or awakening on a frosty Austrian morning to the melodic sound of cowbells as the herd moves through the village on the way to pasture.

We got into this fascinating field of work through the back door. We both had careers with the Agency for International Development in the State Department. Our assignments often took us overseas, whetting our appetites for travel, and giving us the opportunity both to write and do photography in connection with our work. Our jobs were interesting and often challenging, but the frustrations of government bureaucracy made us decide that working for ourselves would be more satisfying.

As people often do, we dreamed of walking along sun-washed beaches on Pacific islands. One bleak winter day, we decided to leave our government careers and go into full-time freelance travel writing. We had a modest income from a monthly column with *Popular Photography* and had sold many freelance stories to other magazines and newspapers. However, we did not immediately act on the mad impulse to cut ourselves off from our nine-to-five govern-

Travel should be composed of journeys of discovery. Hopefully your travel pictures will convey that sense of discovery. Here, we explore the entrance to the cave on Treasure Island in the British Virgin Islands, reputedly the site of Robert Louis Stevenson's classic adventure story.

This picture utilizes the technique of silhouette, which results in a clean, graphic image. The background (outside the cave) is just slightly overexposed with the boat and figure in stark silhouette.

ment careers. We carefully added up our liquid assets (bank accounts) and calculated our monthly expenses. Carl requested and received a year's leave of absence to devote full time to freelance travel writing and photography, while Ann stayed on the job. In about two years, we had reached the point where we could afford for both of us to join our fledgling business.

We work as a team, and that is a very comfortable arrangement for us. As husband and wife, we like to be together and travel together. In our case, we do not specialize. We both write and we both take pictures, and this enables us to work independently when necessary. We believe we complement each other when working on assignment, and there is no sense of competition. If one of us is lucky enough to take the picture that appears on the cover of the magazine, or the other writes the lead to a major article, we both smile broadly as we deposit the check in our joint account. Some travel journalists form partnerships without marriage and still others prefer to work as individuals. These choices are up to you, although the practical details of sharing work as a team will be discussed in more detail later in the book.

You may wonder if there is room for more writers in this crowded, competitive field. Statistics show that more and more people travel every year, in spite of fluctuating economies. Giant jets carry increasing numbers of passengers to distant destinations, and the business of tourism continues to grow. Some nations without vast national resources to export, such as less-developed countries, the Caribbean islands, or some small European countries, depend on travel and tourism as their main source of foreign currency. Tourism feeds the travel industry. Airlines, cruiselines, tour operators and hotel chains provide advertising revenue for magazines and newspaper travel sections. These publications provide outlets for informative, well-written travel articles.

In this book, you'll learn everything you need to know about getting started in travel writing and photography. You'll discover the ingredients for an interesting article and learn more about travel writing styles. We will discuss the necessary discipline to transfer experience and impressions to paper, and we'll cover the problems of realistic writing goals, finding a saleable idea, necessary research, organization and marketing.

Because photography is one of the most important tools for travel journalism, this book will encourage you to learn and use this basic skill. We'll cover cameras and basic photography skills as they relate to travel journalism, as well as the marriage of words and pictures, and how they are inseparable tools of communication and marketing. We can never forget the advantage we gain in being able to deliver to an editor a ready-to-publish package of pictures and text.

Finally, this book will help you place your articles within standard editorial markets and locate alternative markets. It will teach you how to set up your business, including keeping accurate records, negotiating fees, using a word processor, and more.

We have been successful at what we do, and offer this book as a guide to help you achieve that same level of success. The climb has not been easy; we've often learned by trial and error. But if you enjoy traveling and can express yourself clearly with the written word, you have the necessary skill to become a published travel writer.

In addition to the necessary digging and research to get your story, we will stress the importance of, and how to find, strong images to support your words. With the help of modern cameras and the basic photographic skills taught in this book, you can become a published travel photographer.

In becoming a travel writer, you will join an august group of wanderers, such as Marco Polo, Goethe, Lord Byron, Robert Louis Stevenson, Mark Twain, Karen Blixen and Ernest Hemingway. These writers had the ability to paint a picture of a distant place in their readers' minds and they did it without the electronic marvel of word processing. Their words have lived after them. Yours can too.

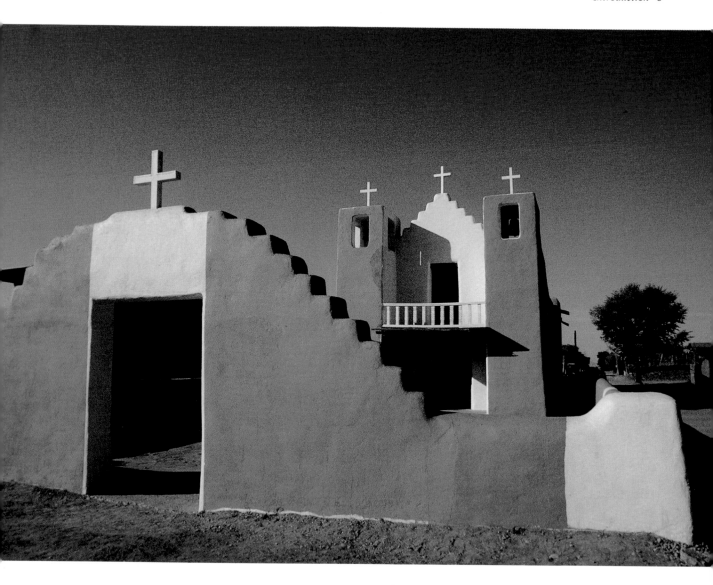

The Taos Pueblo Church in New Mexico is a classic example of adobe architecture. This stark composition uses the graphic elements inherent in the structure, emphasizing the white crosses, blue skies, and harsh shadows cast by the strong desert sun.

Getting Started

Humanity started traveling from point A to point B when primitive people first learned to crawl. When humans stood upright, we became far more mobile creatures, nomads who roamed the plains and forest, the hunters and gatherers. We domesticated the horse and extended the range of our travels. We built ships that opened horizons to an even wider world.

In the twinkling of an eye, at least in evolutionary time, human beings have been transformed into travelers. Steam locomotion provided the power for trains to span continents and ships to cross oceans; the internal combustion engine made possible the automobile and finally the airplane. Now, for much of the population in North America and Europe, traveling has become a way of life. Seventy-five years ago, most people, unless they were extremely wealthy, were more or less confined to a fifty-mile radius around their hometown. This was their world. They read about travel, but actually going to China to see the Great Wall or to Paris to visit the Louvre was far beyond their wildest dreams.

The modern jet has changed all this. People still read about faraway places, but now they may really go there. The assembly line worker in Detroit takes his family to a dude ranch in Texas. The secretary in Chicago goes to a Caribbean island with a friend. The retired couple on Long Island escape the New York winter by traveling in South America. A college student from North Carolina spends his summer hitchhiking through Europe. These travelers devote considerable time in planning and reading about their prechosen destinations. Others read to make the decision about where to go. Obviously magazines, newspapers and books cover the field of travel in great detail. Such articles and books not only describe the beauty and history of a destination, but they often provide practical information on how to get there, where to stay, and how to find the good places to eat.

If you like to write and can express yourself well, you can write about travel. It helps if you have an enthusiasm for traveling, although Robert Louis Stevenson may have carried it too far when he wrote, "For my part, I travel not to go anywhere, but to go. I travel for travel's sake. The great affair is to move." For our part, we also enjoy getting to a destination and savoring the taste, the smell, and the excitement of a foreign city or a new country, and we try to share these feelings through our writing. For us the world is a place of wonder, and our vocation is sharing our travel experiences with others. Our success depends on our ability to convey our sensations and passions to our readers. We use both words and pictures to achieve these goals. As travel is a very visual experience, we also place special importance on pictures. Pictures can convey a sense of place and allow a reader to span continents and oceans in the turning of a page.

Travel photographs are so important because we live in a visually oriented society. We see motion pictures such as *Ghandi* or

The ancient whitewashed village of Casares in the Andalusia region of Spain has the appearance of a cubist painting. White building blocks seem to tumble down the side of a mountain. It is wise to take such a picture in both the vertical and horizontal format. This shot appeared as a full-page picture in the old *Holiday* magazine. More recently a horizontal shot of the same scene appeared as a double-page spread with our story on Andalusia in *TWA Ambassador* magazine. In the latter instance, black type was superimposed in the blue area of the sky. Editors and art directors often choose pictures where they can make effective use of type.

Self-Quiz

Below are a dozen qualities that will, to some degree, affect your success as a travel writer. Ask yourself where you are strong and where you need development.

- *A love of travel*. You probably have this already, as you picked up this book. Would you eventually be able to adjust your life to include one or several weeks of travel a month, or are you thinking in terms of two or three trips a year? The answer may determine whether you will be augmenting your income with your travel writing or whether you will become a full-time travel writer.
- *Self-motivation*. You will not only have to write articles but also market them.
- *Self-confidence*. You have entered a business of harried editors whose deadlines were always yesterday. When you receive a "Sorry, but . . ." form letter, understand that your writing itself may not have been rejected. In some cases, it has not even been read. The rejection letters are useful. They let you know who's buying and who's not, and if your marketing approach is right.
- *Friendly curiosity*. Do you basically like people and do they instinctively know it? Are you approachable in an interview? Are you curious enough to be observant? Can you find a story within a story? For example, when you are interviewing the Chilkat Indian dancers in Alaska, do you find out what they do for the rest of the day?
- *Professional attitude*. We have had many public relations people tell us that they enjoy inviting us on trips because of our professional attitude. When taking a tour, we are not interested in shopping or sleeping or socializing. We can do what we like in any planned free time, but while touring, we are strictly there to do a story and to find other stories hiding in the wings.
- *Research skills*. You will find that not only your destinations have to be researched, but your markets as well. In the course of re-

searching a destination, you will often get ideas for other stories that you can follow up when you get there.
- *Organizational abilities*. You would professionally blow yourself out of the water if you had the same column published on the same Sunday in two papers in the same city. You cannot claim money from a publication for a slide that they lost unless you can identify the picture. You have to keep track of many editors, their quirks, and the stories they've already seen.
- *Foreign language abilities*. It would, of course, be ideal if you spoke all eighteen dialects of Mandarin before you visit China. You should, however, be willing to at least learn "hello," "please," "thank you," and "good-bye" in every country you intend to visit. Your guides will be more than glad to teach you as much as you want to know.
- *Knowledge of geography, history and culture*. If you don't know it, research it! People will love to answer your questions if the questions give evidence of some basic research and thought.
- *Writing facility*. Some people sharpen their journalistic skills by taking writing courses at night at a local college or university. Many people gain an education without college by extensive reading, and reading is useful in any case.
- *Photographic competence*. Watch yourself the next time you are leafing through a magazine. Each page probably won't get more than five seconds of your attention, and you will stop or hesitate only when a title or picture catches your eye. If a picture is good, you might even start reading, whether the title looked interesting or not. That's the kind of picture you want to take.
- *Willingness to learn*. In this book, we provide professional tips to success in using all of the skills we've just described. Time, dedication and patience are the ingredients that you'll have to supply.

Our hometown, Washington, D.C., offers a wide variety of story and picture possibilities. Here, we recorded the towpath along the old C&O barge canal which runs through the historical neighborhood of Georgetown. The late afternoon light created the mood of a warm and peaceful summer afternoon, which is a contrast to the usual busy streets of the city.

Out of Africa that transport us thousands of miles to exotic countries. The moving images on the screen are etched indelibly on our minds. Television also shows us distant lands on the travel channel and in *National Geographic* specials. As travel writers, it is to our advantage to illustrate our articles with effective pictures. We must compete with other travel writers who take pictures, as well as with these other visual mediums.

When you pick up a travel magazine, you are often attracted by a dramatic picture on the cover. As you thumb through it, you will stop for articles with the most colorful and interesting pictures. If the pictures catch your attention, you will often read and enjoy the story they illustrate. This also holds true for editors who review articles. If an editor likes the pictures, he or she may read and consider the story. Getting your story read is the first step in selling it.

IS TRAVEL WRITING FOR ME?

Initially you may ask yourself, "Is travel writing for me?" Certainly you must, at the very least, enjoy traveling. Contrary to the guidebook author in *The Accidental Tourist*, few writers can succeed in this field unless they really enjoy being in new and strange places and can impart this enthusiasm to their readers.

It helps if you have a sense of adventure, an enthusiasm about the world; it is even better if you consider a trip to a new place to be a learning experience.

If good travel writing has a special requirement, it is to establish a sense of "place," to make the reader feel that he or she has been there. You want readers to share your experience, and you must take them by the hand and lead them along a path of discovery. Readers place a trust in your opinion. As the travel experience is distilled and qualified through your values and your point of view, you have an obligation to report honestly, objectively—sometimes even poetically—about your chosen destination.

Some travel writing is designed to motivate the reader to visit the destination and should provide enough practical informa-

Seeing and photographing an elephant in the wild is an awesome experience. One does not really feel protected, even within a safari vehicle. In fact, there is little danger when accompanied by an experienced driver-guide, and you can get excellent pictures through the open sun roof.

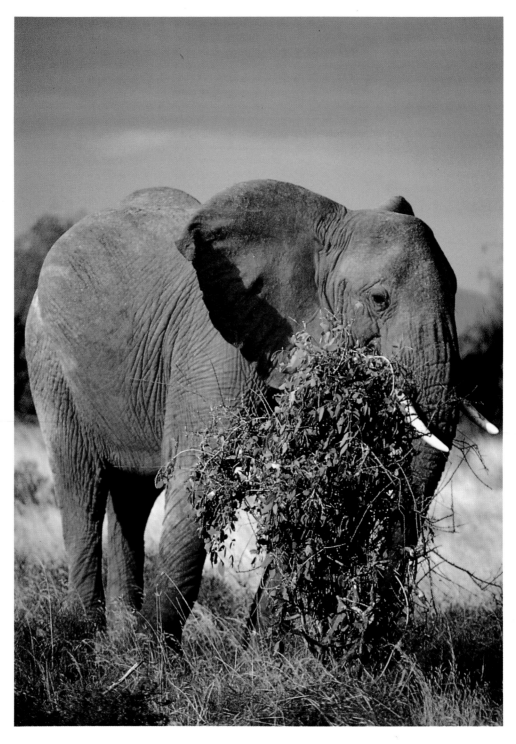

tion to make a visit more enjoyable. Other travel writing is for the armchair traveler, the person who will enjoy the travel experience vicariously through your skill in painting pictures with words. Still other travel reporting is to warn the traveler of tourism scams, potential danger spots, and over-priced hotels. A few skillful writers will combine these different types of travel writing into one article.

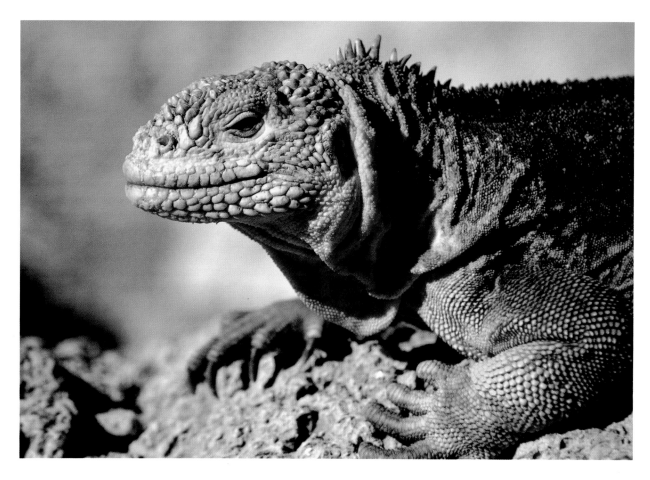

WRITE WHAT YOU KNOW

When starting out, your best bet is to choose a subject or a destination that you know well. While it is tempting to write about your first impressions of Paris, remember that great writers who have lived in the City of Light have written unforgettable prose and poetry about this delightful destination. It would be hard to equal Hemingway when he said, "If you are lucky enough to have lived in Paris as a young man, then wherever you go for the rest of your life, it stays with you, for Paris is a moveable feast."

The trick is to give your travel story a sharp focus and a unique slant. For example, we once wrote an article about one short street in Paris, the Rue Du Mont Tabor between the Tuileries and the Place Vendome. With a little research we learned that the notorious George Sand and one of her lovers had lived on this street in a second-story apartment. We also learned that the elegant Meurice Hotel, where we were staying, had been a convent at one time and Gestapo headquarters during the Nazi occupation of Paris. Further reading revealed that Marie Antoinette had crossed this street on her way to the guillotine. We visited the bookshops, boutiques and cafes along the Rue Du Mont Tabor, finding that this unique street had its own personality. We ate at three or four of the bistros on the street and discovered one that served truly outstanding country cuisine at a reasonable cost. This article, written on speculation, appeared in three major newspapers.

This example of an article about an obscure street in Paris proves that you don't have to write about all the glittering aspects of a major city to come up with a marketable travel article. We would add, however, if you are strongly motivated to write an over-

A land iguana on the Galapagos Islands looks like a miniature prehistoric monster. Since they have no fear of humans, it is possible to get very close to the creatures, which inhabit these remote islands.

all travel story about a city such as Paris, do it. You might even outshine the prose of Ernest Hemingway or the poetry of Gertrude Stein. All great writers were beginners at one time.

Your first travel stories will probably be based on a vacation or an interesting business trip. Also, as a beginning travel writer with a limited budget for travel, you should keep in mind that your hometown is a travel destination for someone who lives someplace else. We live in the Washington, D.C. area, and this is a very popular tourist destination in the spring and summer. The monuments and federal buildings create a park-like environment. The Smithsonian museums on the Mall are free to any visitor and are some of the finest anywhere in the world. Needless to say, we have written about our capital city many times and we have just started to tap the wealth of story ideas in and around Washington, D.C.

Consider the possibilities in your hometown and nearby areas. Texan travel writer Candace Leslie said, "Perhaps because I began travel writing while I still had a couple of children at home who needed me now and then, or perhaps because I really love my state and want folks to know about it, I have always enjoyed working in my own backyard."

Even small communities have attractions that can make good travel stories. Clip articles in your local paper for ideas that, with a little additional work on your part, can be developed into travel features. People love to read stories about people. Maybe there is an old porter retiring from your local train station who has helped transport luggage for politicians and rock stars. Find out what Robert Kennedy said to him during the campaign. Find out what kind of case Elvis Presley used for his electric guitar. Ask your friends for story suggestions or talk to someone at the chamber of commerce. Maybe your town has an annual craft festival that could be the subject of a travel story. Interview the bearded artisan who makes pots, or the Indian woman who displays tur-quoise and silver jewelry. For instance, we have the Cherry Blossom Festival in Washington, an annual event that heralds the coming of spring. Key West has a Halloween party called Fantasy Fest which lasts for a week. Nice, on the Riviera, has a Carnival of Flowers in the early spring. Consider the story possibilities in your own area. Almost every town or city has some interesting tourist attraction. Normally you would not submit such an article to your local travel editor, but it could work very well for national magazines or a newspaper travel section in another city.

Have Idea, Will Travel

The most valuable commodity you can offer an editor is a good idea. Some ideas may be of your own creation, but you can pick up good subjects from many sources. Carefully go over your local newspaper and clip anything that looks promising. Usually news articles only provide the germ of an idea for a travel article, but such an idea can often be developed with further research. We read, for instance, that Las Vegas, Nevada, uses so much electricity for its neon signs and bright lights that as night falls, the lights are turned on by timers, a few blocks at a time, to avoid blowing the circuits! We contacted the Las Vegas News Bureau and learned that animated neon signs are an original American art form, and that Glitter Gulch (Fremont Street) is one of the most famous roads in the world. We had found a first-rate idea for a travel feature.

If you are planning a trip, go to your library and carefully research your destination well in advance of your departure. Check the country or city in the encyclopedia. Read other travel articles that have been written about the destination. It's important to keep your mind open as you do the research. Every destination in the world has a potential travel story.

For instance, Key West, Florida, is famous for its sunsets, and people gather every night at the end of Duval Street, along Mallory

Square Pier, to watch the sun set. Bagpipers parade along the pier in their kilts, vendors sell slices of key lime pie, and acrobats balance on taut ropes against the setting sun. Just as the sun nears the horizon, a full-rigged schooner sails past the enthralled spectators, who then applaud the big red orb as it slips into the ocean. This is the type of story idea you might come across in your research, and we can tell you from experience that Key West offers dozens of excellent story ideas. If you stay in Key West for three nights, you're almost sure to see at least one beautiful sunset from Mallory Square Pier. Take your camera and your notebook, and you should come back with a short but interesting travel article.

Finding Ideas En Route

You won't get all your story ideas at the library. Often you'll stumble across a great idea for a travel article in the middle of your trip. We discovered Dunn's River Falls in Jamaica during a drive along the coast. This multi-tiered waterfall cascades down to the Caribbean under a canopy of tropical vege-

tation. To our delight, it was possible to walk from the beach to the top of the falls. Jamaican guides, expecting only a modest tip, were pleased to lead us along the best path, often through knee-deep pools of water. The experience made a very readable short article. Always keep your eyes open for story ideas on your vacations.

One of our favorite destinations in the world is East Africa and we have traveled there frequently to conduct photo safaris. It is a region filled with exciting story ideas, and we have written quite a few articles about Kenya and Tanzania. Here is a list of our published stories to show you the variety of articles that can come out of one area.

1. Kenya ("Hemingway's Africa")
2. Tanzania ("Is Tanzania Ready for Tourism?")
3. Photo Safari ("Shoot Only Pictures")
4. Photography ("Shooting the Big Cats with a Camera")
5. Mount Kenya Safari Club ("A Club for All Seasons")
6. Governor's Camp ("A Tent with a View")

Look for dramatic travel pictures on your next vacation. This picture, taken in the Kodak Tunnel of Light at EPCOT Center, Orlando, Florida, uses the S-curve composition to lead the eye to the center of the picture. Shifting neon lights offered different color combinations within a matter of seconds. A wide-angle lens was used to encompass the interior of the tunnel and include the figures on the moving walkway. Exposure was automatic in the program mode.

Our goal was to capture the exotic beauty of Bali in Indonesia. We found it along this jungle path where women walked, dappled with sunlight streaming through the canopy of trees overhead. We gave our exposure a plus one setting to preserve picture detail in the foreground, knowing we would lose image detail in the bright background. The women, carrying their produce atop their heads to market, added human interest to the scene.

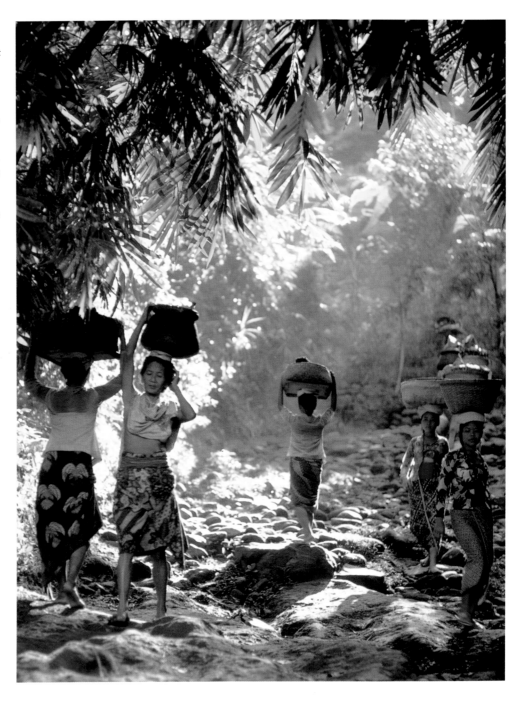

7. Shopping in Kenya ("My Wife Bought Africa")
8. Kenya and Tanzania ("The Best of East Africa")

In addition to all this, we've supplied color pictures to illustrate articles on safaris, Black Rhinos, elephants, and family planning.

In other places, we have unexpectedly discovered and written about such unique subjects as movie posters in Bangkok, a royal cremation on the island of Bali, staying in an underwater hotel, and swimming with dolphins. Whatever subject you choose, make your account lively and entertaining.

PLAYING THE FIELD

The most obvious subjects for a travel writer are destinations: cities, countries or islands. You might also write about events or people connected with a particular travel experience. There are many other aspects of travel. For instance, one of our specialties is writing about travel photography. Other travel writers specialize in food, shopping or cruises. Some focus on an even smaller audience with certain needs, such as the handicapped, those traveling with pets, the elderly, or parents traveling with small children. In any case, the travel article should be written to entertain and inform.

If you keep all of your travel ideas organized in a notebook or on computer, you can draw on this store of ideas when you are talking with editors or sending out queries. It is useful to arrange the files alphabetically according to country and perhaps further subdivide them into types of tourism specialties, such as resort-spas, cruises, bicycling, backpacking, etc.

Most would-be travel journalists think only of magazines, newspapers and books, and while these are the traditional outlets for travel writing, there are many other potential markets for the inventive writer. We urge you to look not only at the major traditional markets; consider some alternatives too.

Traditional Markets

Newspapers
- *columns* (Done on a weekly or monthly basis.)
- *articles* (Hit or miss placement.)

Syndicates (This is a service that provides periodic packages of stories to multiple papers. A sample package of weekly columns might include a food column, two travel articles, two advice or how-to columns, and one humor article, and it might go to 250 editors, nationwide.)

Travel Magazines
- *airline, automobile club, or sponsored* (Some examples of this are the *AAA World, Delta Sky* magazine, and *Chevron USA Odyssey*.)
- *nonsponsored* (such as *Travel Holiday, National Geographic Traveler, Travel & Leisure,* and *Condé Nast Traveler*)

General Interest Magazines that include travel (such as *Woman's Day* or *Good Housekeeping*).

Specialty Magazines
- *sports* (This can include the story about a specific sporting event; it is considered travel writing when the event is in a unique travel destination.)
- *photography* (People who buy photography magazines usually own cameras, and cameras are expensive. The publishers assume that such people can afford to travel; most photography magazines, therefore, periodically publish travel columns on visually exotic destinations.)
- *conservation & wildlife* (Fortunately, wildlife is a global subject.)
- *fashion* (These magazines would probably be more interested in a spa story than in the backpacking trek you took to Nepal. It is worth a query, however, if a big-name New York cosmetics model was trekking with you.)

Travel Industry Publications
- *travel news*
- *travel-agent magazines*

Books
- *guidebooks*
- *general destination*
- *coffee-table illustrated*
- *special interest* (examples: photography, trains or ships)

Alternative Markets

1. *Scripts for Television & Radio* (Someone has to research and write those documentary narratives!)
2. *Slide Show and Multimedia Scripts* (Narratives also needed here.)
3. *Stock Photography* (Note that although a photo may have been taken on your travels, it can be a straight generic stock pic-

Seek a creative angle to take a picture of a well-known landmark. In this instance Carl flattened himself on the lawn next to a tulip bed and used a 24mm wide-angle lens to capture this scene of the U.S. Capitol Building. The red tulips lead the eye directly to the front of the Capitol. Bright colors can turn an ordinary subject into a prize-winning picture.

ture and should be filed accordingly. Suppose you went on a trip to Yugoslavia. Most of the photos would be filed under their headings in Yugoslavia. The photo of dramatic clouds at sunrise would, however, be filed in your generic stock file of "clouds," and the mother's face hovering over her child's skinned knee might be filed under "families."

- *direct sales* (This would be from your stock files at home.)
- *through agencies* (We will be making recommendations about this later in the book.)

4. *Advertorials* (A special travel section or supplement that is supported and paid for by a destination or special-interest group, such as the Turkish Embassy, Nikon cameras, or Eastman Kodak.)

5. *Brochures* (You've received these glossy marketing tools in your mail.)

6. *Seminars and Workshops* (These can be how-to or even straight destination, i.e., talks accompanied by slides.)

7. *Press Releases for PR firms handling travel accounts* (These are the industry equiva-lent to brochures. They are sent to editors and writers, often with photos, for possible publication or to entice the recipient to visit and write about a travel destination or property.)

As you can see, there are both traditional and alternative markets out there that need good travel writing. It is up to you to locate the right market for your talents, and this book has been written to help you do it. (Markets will be covered in detail in Chapters Four and Six.)

BREAKING IN

We suggest you get your start in travel writing through newspapers. This is the way we got started and it has worked well for others. Two young friends of ours from California, Terri and Austin MacRae, were fascinated by our work and life-style. They sought our advice about building a career in travel writing and photography, and they traveled with us on camera safaris in Africa and South America. We encouraged them to write about their travels and submit the

stories and the pictures they had taken to their local newspaper. Soon they were writing a monthly travel feature for the paper and had a contract to produce a travel guidebook.

This doesn't mean that the only way to break into this competitive field is through newspapers. Many different markets and publications use travel material and most of these pay better than newspapers. There is no reason you can't break into these lucrative markets, although getting started with magazines or alternative travel markets (see Chapters Four and Six) requires initiative, luck, and knowing the right people. Quite frankly, the problem with the high-paying markets is getting your travel stories read. If you can reach the editors who make the decisions and get them to read your material, you've gone a long way on the road to success.

How Much Is Enough?

Now let's assume that you are able to sell your first travel article for $100 to a city newspaper for their travel section. If you have provided the pictures, they may give you an additional $50. Don't let the flush of success go to your head. This is peanuts in comparison to your travel costs, time, film and postage. In terms of running a business, you're dead in the water; still, you do have $150 more than you did before writing the article. What can you do to increase your income from that one story?

We take such a travel story and submit it by mail to other major newspapers around the country, taking care not to submit it to any two newspapers that have overlapping circulation. If we're lucky and our story is appealing, we may sell it to ten major newspapers. Suddenly our income has jumped from $150 to $1,500 for that one story. Additional income may result from requests to reprint the article or a rewrite on the subject for a national magazine.

Suppose your travel story was really outstanding and you've brought in more than $2,000 from your efforts. If you spent $3,000 on your vacation or trip, you're still $1,000 in the red. If, however, you were going to spend the money for the trip anyway, you've made $2,000.

A word of warning: that first sale can sometimes be like drinking too much champagne. It is often intoxicating and causes the writer to make errors in judgment. We have known some amateur writers who, after their first sale, have tossed over their regular jobs, hoping to make a living in this glamorous field of travel writing. Initially, we urge you to take on travel writing as a part-time effort, working at it on weekends and vacations. When you have reached the point where you're making at least the equivalent of 50 percent of your regular salary by freelance travel writing in your spare time, you can afford to quit your job and pursue this as a full-time career. Things may be a little rough in the first few months, but after a diet of macaroni and cheese and peanut butter sandwiches, you should eventually make a go of it.

Although this book will give you all the information you need to work your way toward full-time travel writing, you should be patient. It sometimes takes a long time for editors to recognize your skills. Even as a part-time travel writer, however, you will be augmenting your income with one of the world's most enjoyable professions.

Your Initial Investment

Poets used to say that a person needed only paper and pen to become a writer, but then writers became spoiled by the invention of the typewriter. Today a writer is at a decided disadvantage without a word processor, and we believe this new tool is a necessity for financial success. Some die-hard travel writers still struggle with the old manual typewriters, but for us it would be like chiseling a story in stone. To the owner of a typewriter, the advantages of a word processor are almost beyond comprehension. The computer offers a world of completely clean

copy, sheet after sheet of accurate text without smudges or XXXXs used to eliminate unwanted words or phrases. The computer will count your words, number your pages, address your envelopes, and scratch your back. It allows you to edit while writing—electronically cut, paste or rearrange paragraphs or sentences. If you plan to succeed in this business, start to save about $2,000 for a computer or word processor and a printer. Another option is to lease a computer until you've made enough sales to pay for your own. In the meantime, you can try out several computers and you'll know exactly which brand and model you want to buy. We suggest spending the extra $150 or so for an electronic spell-checker and thesaurus.

Later, we will go into more detail about the marvels of computers and word processing, but we want to alert you about the importance of this technology early in our book. Like many writers, we originally felt threatened by something we didn't understand, but we quickly learned that computers could make our lives easier and give us a competitive edge over other writers who don't use computers. The written language has evolved over thousands of years; it is a complex and even archaic way of communicating ideas and describing other places. Computers allow us to organize, store, check, and even transmit written information in the most efficient manner.

Your next expense will be a camera, and this can cost you from $350 to more than $1,000. We don't want to hear anybody protest that they have never taken a decent picture in their life. We will not accept excuses. This book will tell you, in easy-to-understand language, how you can take excellent travel pictures and why you can't afford not to.

All in all, for approximately $3,000 you can purchase the basic equipment necessary to become a travel writer-photographer. Obviously, there are other pieces of equipment we've bought over the years without which we feel we couldn't live (a Xerox machine, light table, tape recorder, etc.), but you have time to worry about that after you're an established writer.

Now, wouldn't it be nice if we could say that all you have to do is put the words in the right order, push the shutter button on your camera at the right moment, and you're on the way to becoming a published travel writer? This takes talent and skill, but it can be done. Write about your next vacation, take lots of pictures, and market your story. You may be in print sooner than you think.

TRAVEL EXPENSES

The major cost of travel, especially overseas, is the transportation by air. Airlines can and do offer free or reduced fare seats to travel writers and travel editors. They also offer these seats to travel agents and their own employees. As a beginning travel writer, you're not likely to have such an opportunity, but once you have become known, and particularly after you've become widely published, you may receive an invitation to fly to a specific destination that the airline wishes to promote. This may even include hotels and meals during your stay.

An important point to make here is that PR (public relations) people have a very strong network. If you display inappropriate or disagreeable behavior on a few trips or even one tour, the reputation you gain may be enough to guarantee that you will almost never be asked again to join a press trip. The opposite is also true. If you are first and foremost a "producer"—someone who consistently sells articles about the destination visited—and a pleasant traveling companion, you will often find yourself invited by PR firms that don't even have a file on you but who have heard their colleagues' opinions of you.

In our capacity as professional photographers, we are often hired by the host to do photography for the other writers who do not take their own pictures. In this way the host gets needed pictures for his own files

as well as filling the needs of writers he has invited on the press tour.

The Ethics of Travel Writing

There is a controversy surrounding free or subsidized travel. Some editors wonder how objective a writer can be about an airline or a hotel that has provided free services. It is a valid concern, and you must take care to keep your reporting objective. Subsidized trips will continue to be offered by the travel industry until publishers and editors decide to raise payment for articles or offer to pay expenses for travel writers. Scrupulous travel writers will include both the positives and negatives of a travel experience, and conscientious travel editors should never abdicate their obligation to select objective freelance writers. A travel editor has a responsibility to edit out those things that are obvious plugs and do not contribute to the story. Writers who create "puffery" for a

destination are quickly identified by capable editors, and their stories are not accepted.

Editors work under a severe handicap if the policy of their newspaper does not allow them to accept a good story based on a free or subsidized trip. Such a policy automatically eliminates almost 90 percent of the published travel writers, irrespective of their talent and integrity. It also places editors in the uncomfortable position of being policemen checking on every writer to make sure he or she is telling the truth about paying for a trip. There are some editors who espouse the no-subsidy policy but accept reduced rates for themselves and their staff writers. This has been compared to being "just a little bit pregnant."

On the other hand, the no-subsidy policy could work to your advantage with these papers or magazines when you, as a beginner, have completely paid for your own trip. If you do some thorough research, you could offer your "unsubsidized" first pieces to all

We entitled this picture of a woman with a roast pig "Fast Food in Ecuador." The pepper in the pig's mouth was an ironic touch. The traveler with a camera must have the ability to see pictures and be quick enough to catch them before they go away. Three seconds later, the woman had turned her face away from the camera.

Afghanistan is not exactly a popular tourist destination, but for that very reason good pictures of this Islamic country are not easy to find. If you have good photographic coverage of remote and hard-to-reach countries, these pictures may become quite valuable in your stock file.

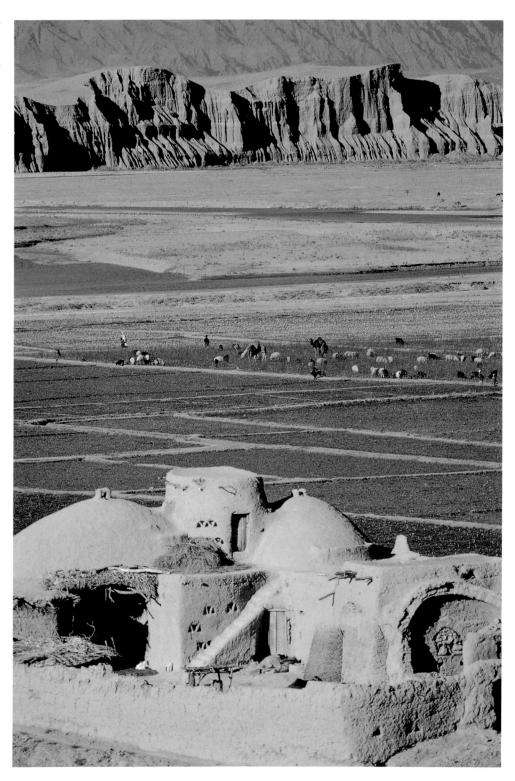

the editors who cannot accept a story from a writer who took a free trip.

We have accepted free or subsidized travel in some cases. In other instances, we have paid full commercial rates for our transportation, hotels and meals. If we know that a magazine or newspaper has a no-subsidy policy, we do not submit any stories to them that we did not pay for out of our own pocket. Our policy in all cases is to write the story as we see it. Our criterion for even mentioning a hotel or airline is "Does it inform readers of something they would want to know?"

As we've said, being a travel writer carries a heavy responsibility. Your first responsibility is to provide your reader with accurate information about the subject or destination. Your story may be positive or negative; more likely it will be a combination of both.

The sponsor of a press trip should recognize your obligation to report honestly and objectively on a destination or a resort. Most professional PR people understand this, but naturally they will make an effort to show their destination in a favorable light. In some cases a host will go overboard. This may mean that you'll be treated to lavish meals in luxurious restaurants, be given a suite of rooms in an elegant hotel, or be chauffeured around in a limousine. Quite frankly, such treatment makes us very uncomfortable, and many of our travel writer colleagues feel the same way.

We would much prefer to stay in a modest room, dine at an inexpensive restaurant, and take public transportation when it is feasible. We prefer to do this because it is the way most of our readers will travel and it is the way we would choose to travel on our own. On a trip to Bermuda, Carl opted to travel throughout the island on a moped and based his story on that mode of transportation. He did not hesitate to point out the dangers of riding one of these motor-assisted bikes, but he added that he enjoyed the experience and that, with the proper safety precautions, riding a moped was the most practical way to see the island. (Ber-

muda, incidentally, does not have rental cars available.)

What is your obligation to write about problems and even potential danger in a particular destination? We strongly feel that you should "tell it like it is." We wrote an article about the chaos of Cairo, an account of rude taxicab drivers, cancelled reservations, and aggressive street hawkers. We wrote another article about traveling all the way to French Polynesia and spending four nights trapped in a hotel room during a typhoon. This reflected the real world of travel, a world where you don't always go sailing off into a picture-perfect sunset. Such accounts might be distressing to a host, but they were based on the travel experience exactly as it happened to us. These adventures were written with a touch of humor because we wanted to show that even bad experiences can be funny.

After the Cairo story appeared, we received a courteous letter from an Egyptian gentleman who lived in Chicago, apologizing for our disagreeable experiences in his country. We wrote in response that it would be people like himself who would bring about the needed changes to make Cairo a more desirable destination.

We are quick to say that we prefer to write positive reports on destinations and choose to travel to places we know we will enjoy. We like Brazil very much, but we would be remiss in writing about this country if we did not warn the traveler about street crime and purse snatching. We love Israel, but we would not encourage a tourist to visit the West Bank.

The travel writer also has an obligation to be fair. We were having dinner at a restaurant in the Florida Keys when a palmetto bug dropped off the ceiling and hit one of us on the head. The startled insect fell to the floor and scurried away. A harsh reporter might have written about the incident and panned the restaurant, but this particular restaurant happened to be very good and we knew that palmetto bugs are very common in the tropics. That one should fall off the

ceiling and hit us on the head was a one in a thousand chance. Since our story on Key West did not focus on dining, we decided not to write about the restaurant in our story. Had we needed to include the restaurant as part of an assignment, we would have had to keep the incident in proper perspective and perhaps try to give it a humorous twist.

Unfortunately, some travel writers have abused their privileges. There have been instances where writers have demanded favored treatment, upgraded flights, or special rooms. The Society of American Travel Writers (SATW) has a strict code of ethics prohibiting such behavior and has, on occasion, taken action against members who break this code. Some SATW members have been reprimanded; a few have been expelled. Some travel writers outside writer's organizations do not feel restrained in making unreasonable demands for special rooms, on flights, or for special treatment. We would point out that most travel editors are very conscientious, but there are a few who abuse their positions by making unreasonable demands on their hosts. In our opinion, such behavior by any editor or writer is a form of blackmail. Such journalists end up on a blacklist with both PR managers in the travel industry and reputable travel publications.

Another abuse is for a writer to claim to have an assignment from a publication, hoping to be invited on a press trip. Any person who would need to use such a subterfuge is probably not a productive travel writer and will ultimately end up on the blacklist. The travel industry is a close-knit business, and word gets around fast. Claiming to have an assignment when you don't is clearly unethical, but there have been reported instances where misunderstandings can arise about assignments. If you are going to tell anyone that you're working on assignment, we recommend getting your assignment in writing to avoid any confusion. As a travel writer, you must remember that your reputation is as important as talent.

Editors expect and demand ethical behavior from writers, but they often don't behave ethically themselves. One major publication asked a leading writer to do a short article and provide a large selection of color pictures on a specific subject with a very short deadline. The writer delivered the story and pictures, only to learn that the editor had asked a number of other writers to do the same thing. Ironically, the publication ended up rejecting all the articles submitted and using a totally different subject in the allotted pages.

Bill Hensley, of Hensley Communications in Charlotte, North Carolina, is an articulate spokesman on the subject of the obligations of press or familiarization ("fam") trip hosts to writers and vice versa. Bill, like many PR people in his business, feels that a fam trip is one of the most effective promotional tools in the travel industry. Bill has compiled a list of do's and don'ts for press tours involving writers.

As a host, Bill feels that he has certain obligations. In short, these are to put on a first-class trip that is not overcrowded with activities, sales pitches, and speeches. He has an obligation to his clients to invite only bona fide writers and treat them with dignity and respect as professionals. He has an obligation to answer questions honestly and to show the writers the area as the traveling public would see it.

On the other hand, Bill feels that travel writers also have obligations. They should not accept a trip if it's an area that doesn't interest them. True professionals accept only trips they plan to write about. A host, however, must realize that some stories just don't gel for a writer. The destination or experience may be disappointing and a writer may come to the conclusion that there isn't a story in it for his or her readers.

Bill also thinks that it is important for writers or editors to be a part of the group as much as possible and to conduct themselves as ladies and gentlemen.

Finally, he feels they have an obligation to write the story as they see it. Writers don't

owe their hosts a good story, and if they bring out negative points, that could actually help the property or destination to understand existing problems and allow them to take steps to correct them.

Unfortunately, some PR hosts are not as experienced or knowledgeable as Bill Hensley. Every travel writer has suffered through interminable speeches, marathon drives through dreary countryside, and dinners of rubbery chicken and barely thawed green peas. For a writer this is akin to purgatory. Bill and his son Bruce also recognize that some writers can come on a trip without an assignment but still do a fine job of placement. They personally know the writers they invite and are familiar with their track records.

On the matter of ethics, one simple rule holds true for writers, editors, and people in the travel industry. Just be honest and do the right thing.

This advice may not be as premature as you might think. If you establish a good reputation for yourself as a writer, get yourself published, and do your homework on marketing, you may find yourself invited on a fam trip before you have finished your second reading of this book.

The splashing water in this fountain in St. Louis seems frozen in the sunlight. *Meetings of the Water* was designed by sculptor Carl Milles to symbolize the merging of the Mississippi and Missouri rivers. The image was preserved by a high shutter speed and strong backlighting.

These bright polyvinyl sails at the International Windsurfing Competition in Nassau look like butterfly wings in the sunlight. Special events such as this one, which takes place each year, often make excellent travel stories. Since you never know what an editor will want, always cover yourself by taking both horizontal and vertical photographs, close-ups and long shots.

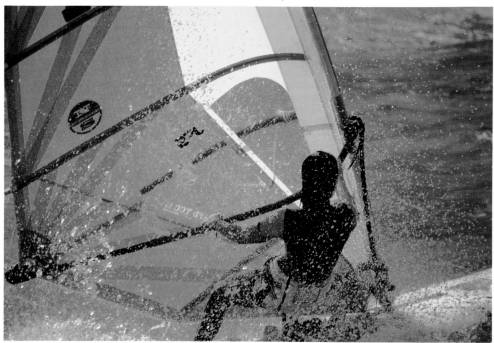

THE PAYOFF

It is awesome to have personal knowledge of the power of travel writing. Many years ago we wrote a travel feature, one of our first, on the subject of camping on St. John in the Virgin Islands. The cost at that time was only $40 a week for two people and included a large tent, bedding, and cooking utensils. We sold the article to *Parade Magazine*, a national Sunday supplement for newspapers, and it appeared on one page with one picture. In a two-week period, the man who ran the campground concession received 12,000 letters. We were very impressed with the response from that one short travel story. Over the years, it has served as a reminder to us that people do read travel articles and act on the information provided.

There are other ways to measure the success of an article. When you send a copy of a published story to the public-relations firm that hosted you, they measure how many column inches it covers and determine how much it would have cost to buy that many inches of advertising in that publication. You'd be surprised how expensive advertising can be. We organize and lead camera safaris around the world, and one year we thought we'd try two inches of advertising in a national magazine. The bill was $2,600, but the ad produced results. If an article, therefore, is given eight inches of space in a national magazine, you can imagine how happy your host will be.

The example we like to quote to illustrate media strength is our coverage of the annual International Hot Air Balloon Fiesta in Albuquerque, New Mexico. It was such an interesting and colorful event that we came back for four more fiestas. The magazine and newspaper articles we wrote covering this event generated approximately one million dollars in media space as measured and evaluated by the fiesta media office.

Such success is not restricted to seasoned pros. As a beginner, you may want to use an idea to do a travel article on speculation and then submit it to a magazine or newspaper. You must be willing to invest your time and often the cost of travel to take an idea and turn it into a finished travel article. A retired engineer from Seattle, Washington, went with us to the Albuquerque Hot Air Balloon Fiesta and subsequently submitted a travel article and color pictures on that event to a new national magazine, *Outdoor and Travel Photography*. The article, his first effort, was published in the premiere issue of the magazine in a stunning layout. Dan Poulin's was an unusual case. He had come on a camera tour with us to learn more about building a stock file of photos and to get tips on marketing the pictures. As always, we encouraged the tour members to think in terms of a package of words and pictures, a far more successful commercial venture than trying to sell either photography or writing alone. Fortunately for Dan, he proved to be as adept at writing as he was at photography.

By now, we assume that you share our enthusiasm for travel and want to write about your travel experiences. The most common question young writers ask us is, "How can I get started?" There is no need—indeed, it would be very ill-advised—to drop your regular job to get started in travel writing. You can do it in your spare time and on your vacations or business trips. Turn out a few good stories with pictures and submit them for publication. Read the section on marketing carefully and know the needs of the publications to which you will be submitting articles.

The editor may or may not be able to use your article, but if he chooses not to, don't be discouraged. Mail it to a magazine or newspaper in another city. If your travel article is good, it will eventually sell and you have taken the first step in becoming a bona fide travel writer. Your first sale is an important step to becoming a professional travel writer.

The Process of Travel Writing

How does a travel writer create a marketable article? Writing in any form is an elusive process. It requires a vast pool of knowledge, careful research, a creative drive, and sensitivity to the subject. While there are many types of travel writing (guidebooks, destination travel, environmental, and travel tips would be a few examples), most articles are based on personal experience, with a little research to back them up.

For instance, a typical destination article includes information about current attractions and recreational activities available in the area. Destination articles also show an awareness of the contemporary political situation, geography, history, art, architecture and cuisine. Your on-location research might include advice on hotels and restaurants that you have personally checked out.

Articles on specialized subjects have different requirements. An article on shopping will list the products and handicrafts available in the country and good places to buy items of the best quality for the least money. An article specifically on food might include local recipes, wines of the region, and descriptions and reviews of the better restaurants. In a story on dining, it is helpful to give price ranges in specific restaurants and include some of the more inexpensive. Comments on service are appropriate and helpful to your readers. A story on architecture should describe the major buildings and churches and the architectural styles they represent. A story about St. Paul's Cathedral in London should certainly include some details on the life of the architect, Christopher Wren.

INFORMATION SOURCES AND LIBRARY RESEARCH

Let's assume that you're planning a trip to Thailand and would like to write one or more travel articles based on your trip. First, you write or call the Thailand Tourist Authority in New York for their brochures about their country. (Most libraries have a Manhattan, New York, telephone book.) Second, you should go to your local library and read about Thailand. Peruse the guidebooks, scan recent articles about Thailand in major magazines, look up basic facts in an encyclopedia, and learn all you can about this Asian country. Thailand is filled with potentially great travel stories, but you're looking for ideas in specific locations to follow up once you get there. Make photocopies of information you need to take home or even take with you on your trip, such as maps, thumbnail sketches of places or sights you don't want to miss, addresses of the local tourist bureau, etc.

As you do your library research, you'll discover that Bangkok is a city interlaced with *klongs* or canals. These klongs are arteries of commerce where people bring their produce to floating markets in boats. You can buy stalks of bananas, mangos, fresh pineapples, and much more. These floating markets are colorful and exotic, seemingly an ideal subject for a travel story. You should know, however, that many travel writers

The full moon rises late in the day, so you may be able to photograph it while it's still daylight. Here, we caught the moon over a building in downtown Tampa, Florida, accentuating the size of the moon by using a 300mm telephoto lens. We intentionally included only one building to keep the composition simple and clean.

We were intrigued by the giant hand-painted movie billboards in Bangkok, Thailand, and decided to research them for an article. Later, we sold the package of words and pictures as a magazine feature. This picture was chosen to be part of the permanent collection of the American Society of Magazine Photographers at the George Eastman House in Rochester, New York.

have written about the floating markets of Bangkok and that the klongs within the city have become congested and polluted. Some tourists do not find the floating markets of Bangkok a pleasant experience.

Careful research, however, will tell you that there are other floating markets outside of Bangkok that are well worth visiting. One of these is at Damneon Sadvak, about 50 miles outside of Bangkok, and bus tours from the city are available.

With additional reading, you'll learn that Thailand is famous for its beach resorts south of Bangkok along the Gulf of Siam. Pattaya, the main resort town, can be reached by bus or car in about one hour. At Pattaya the visitor can windsurf, swim, snorkel, bask in the sun, and feast on broiled lobster shrimp almost as big as lobster tails and basted in garlic butter and spiced with chilis. You can rent a fishing boat for the day that will stop on tiny islands with white sand beaches where your catch is grilled by your boat captain while you snorkel over nearby coral reefs. After dark the resort town of Pattaya comes alive with fine restaurants, discos, and nightclubs.

North of Bangkok is the cool mountain town of Chiang Mai, often called the Flower of the North. The climate contrasts pleasantly with the heat and humidity of Bangkok and southern Thailand. Chiang Mai is the second largest city in Thailand, but it retains the feeling of a provincial city. The people are warm and hospitable, greeting visitors with the graceful Thai gesture of bringing their palms together under the chin. Chiang Mai abounds with story ideas. We were fascinated by the umbrella factories where artisans hand paint paper umbrellas with elaborate colors and designs. It is possible to visit an elephant training camp where Asian elephants are taught to haul giant teak logs. Each morning these huge animals are given a bath in the river by their Thai trainers. In the mountains surrounding Chiang Mai, you can also visit the ethnic hill tribes of Meo villagers. The village women wear their wealth around the necks in the form of heavy silver jewelry. Much of the famous Thai cotton, used in their colorful and decorative fabrics, is grown near Chiang Mai.

There are countless other story ideas in

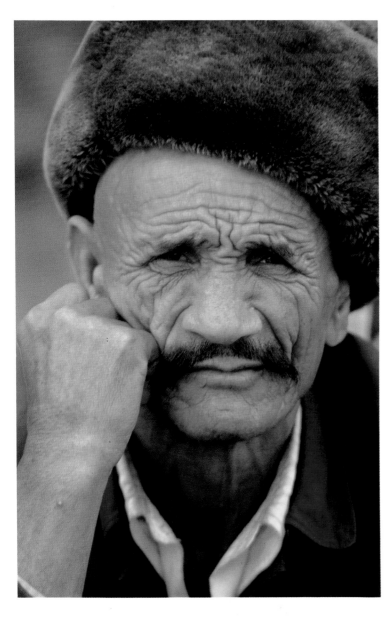

The creased face of this fur-hatted nomad looks more Turkish than Chinese, but actually this portrait was taken in the Gobi Desert in western China. To approach a stranger in a foreign country, it is often helpful to have an interpreter, both for taking the picture and gathering facts for your story. When taking such a picture, your results will be better if you can get close to your subject. If it is not possible, use a zoom telephoto lens. In China we found people usually very receptive to posing for pictures.

Thailand. The Buddhist temples in this tropical nation are ornate and steeped in history. The saffron-robed monks walk barefoot through temple gardens, living in a secluded world of their own with massive figures of Buddha rising above ancient altars.

Some years ago we did an article for *TWA Ambassador* magazine about the colorful, flamboyant movie billboards in Bangkok. These hand-painted billboards are works of art, often four stories high. The giant paintings depict the drama and pathos of the movie plot, including scenes from both Asian and Hollywood productions. It is strange to see a gargantuan couple locked in an amorous embrace above a traffic jam in downtown Bangkok. We took a picture of a diminutive Thai woman walking past a theater with an image of two oriental gangsters towering above her.

In this particular case, we discovered the billboards after arriving in Bangkok. The Thailand Tourist Office was very helpful in providing us with the names of people to interview, and we actually went to the studios, where the artists did the painting in

large segments to be assembled later. We took many pictures of the artists at work in their studios and later photographed the billboards around the city. This story was obviously a package of words and pictures that could not have been sold without good color slides for illustrations.

You can tell that we love Thailand and know it well. In fact, we have two children who were born in Bangkok. We cite this country as a source of story ideas, but just about every other country in the world also has plenty of feasible ideas for travel stories. You just need to be able to find them through advance research or recognize the potential for a travel article when you see it. If you see something or hear about something that intrigues you, it will probably equally intrigue many of your readers. If you want to know more about the Emerald Buddha, ask questions so that you can tell your readers the story of how it was stolen from Laos in 1780 when Thailand was still called Siam. Your readers might also want to know about the change in names; you could tell them about Auguste Pavie, the Frenchman who arbitrarily decided in 1907 to draw a new border for the country he named "Thailand" at the Mekong River, brutally cutting off the four southern provinces of Laos that had been Laos's best agricultural land, the country's rice basket.

TOOLS FOR TRAVEL WRITERS

The basic tools you need as a travel writer are a pencil, a notebook, and the ability to listen and ask the right questions. (Incidentally, we write our name, address, and local hotel on the outside of our notebooks. Losing a notebook can be a disaster.) You may find yourself touring a destination with a local guide, probably a person who has some capability with English. While there are many outstanding guides, you must be discerning enough to find out something about the guide's credentials and check the facts presented to you during the tour. Certain

guidebooks offer solid information for checking facts. Some of the most accurate guidebooks for factual information are the French-published *Michelin Guides,* but these green pocket books tend to be rather dry. We like the illustrated *Insight Guides* for their outstanding color pictures and lively literary style. (*Insight Guides* are sold all over the world, but their main office is APA Productions, P.O. Box 219, Orchard Point Post Office, Singapore, 9123.) In any case, we always suggest using a dependable guidebook to double-check your facts.

Tape Recorders

Aside from the trusty notebook, there are other methods of gathering information on a trip. One of these is the hand-held tape recorder. There are two basic types: those that use the microcassette and those using the standard tape cassette. While the microcassette tape recorder is somewhat smaller, we prefer the standard size recorder for the better sound quality, reliability, and availability of tapes. Under most circumstances the built-in microphone is more than adequate. Some recorders are equipped with a high sensitivity and low sensitivity switch for the microphone. You would use the high setting when recording a round-table discussion with several people speaking and the low setting for one person (possibly yourself) speaking directly into the microphone. In general, the low-sensitivity setting screens out most background noises, while the high-sensitivity setting picks them up.

One of the problems in using a tape recorder in the field is the often disjointed information that is recorded chronologically on the tape. Local guides can be verbose and you usually need to record their entire lecture to catch the nugget of information you need for your story. It is difficult and time-consuming to extract this information from the tape. One method of condensing the most salient information onto tape is repeating the important data and facts into the tape recorder with your own voice in a low

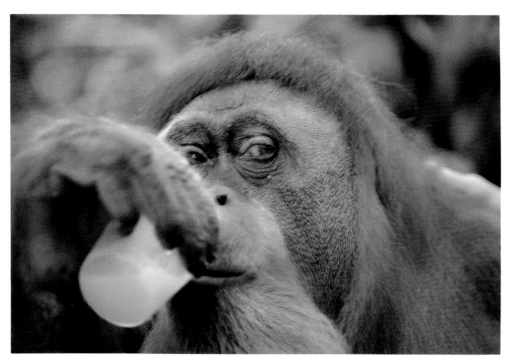

Seek out people, animals, events, or "happenings" that will offer outstanding picture opportunities. We heard it was possible to share breakfast with an orangutan at the Singapore Zoo, and the event provided a series of humorous pictures. (Animal behavior that emulates human behavior often makes amusing pictures.) Above, we waited for the casual, almost bored expression of the orangutan. Left, another orangutan sips orange juice with great enthusiasm.

Sometimes chance will provide a cuter picture than a carefully set-up shot. This little girl, wearing nothing but sunglasses, walked down the beach in Bermuda with complete nonchalance, her doll in tow. Our camera was ready to record this water nymph.

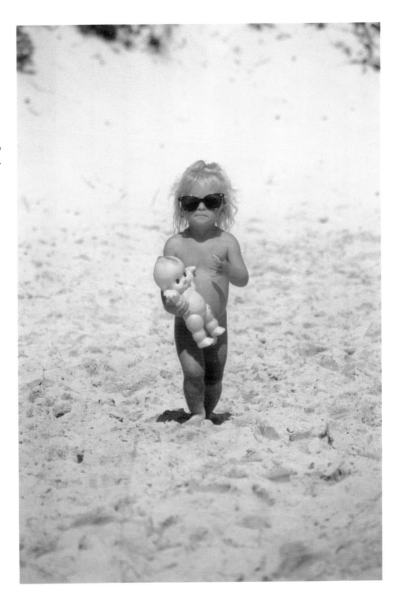

undertone. Other travelers may accuse you of talking to yourself, but you'll come back with the needed background information, anecdotes, and historical data to make your article lively and readable. Whenever you're ready to sit down and write your story, replay your tape, hitting the pause button whenever you wish to transfer a phrase or thought onto your keyboard.

Typewriters vs. Laptops

Approximately twenty-five years ago, seasoned journalists who traveled the world beat out their stories on mechanical portable typewriters. One of the smallest and most popular of these vintage machines was the Olivetti, and we used one of these ancient Italian portables. Today our battered Olivetti has been replaced by the Tandy (Radio Shack) WP-2, a laptop portable word processor about the size of this book. We have added an accessory disk drive to our WP-2, a feature that gives it unlimited storage capacity as we travel. The WP-2 is quite simple compared to more sophisticated models with disk drives and flip-up screens. If you want IBM compatibility, you can get

the Tandy 1100 FD, which also comes with a convenient spell-checker, word-processing system, and desktop organizer. Other laptops have emerged on the scene including the Toshiba and Zenith. Most have optional modems for the transmission of text over telephone lines. The compact computers mentioned are PC compatibles: the Macintosh line also has a laptop. You can frequently bargain for a good price on a laptop if you buy it at the same time you are buying a larger word-processing system for your office. There are so many computer stores looking for customers that you will almost never have to pay the full asking price. You should approach this purchase the same way you buy a car. You should ask for extra software to be "thrown in" and, for a reasonable additional price, a portable machine that can be made compatible with the bigger one. This is important, as you will want to transfer your articles to your main computer from your laptop after a trip.

Obviously there is an advantage to carrying a laptop word processor on the road. With one of these compact devices, stories and letters can be written on long flights or aboard ship. Often a travel story can be finished and ready to transmit to an editor by the time you return from an assignment. As we mentioned, some of these portable word processors are equipped with built-in modems for transmitting text over the telephone. Frequently our stories are almost finished by the time we arrive home from an assignment. We transfer our files from the portable to our regular computer, which allows us to put the final touches on our story before we transmit it to our editor.

Books of Quotations

Another useful tool for travel writers is *Familiar Quotations* by John Bartlett, a wonderful collection of profound and witty statements by famous people. For instance, when writing a travel article about Greece, it is helpful to be able to quote Lord Byron, the English poet who had a deep passion for this country, the cradle of Western civilization. Even Bartlett's helpful tome requires skill and time, however, to find an elusive quotation you can't quite remember. Our Macintosh computer came with a special software program called HyperCard, which has in it a small stack of quotations. It included six or seven quotes from people such as Will Rogers and Groucho Marx. It was possible to add new quotations to this stack. In our spare time, almost as a method of relaxing, we entered hundreds of our favorite quotations in the stack.

The method of using the stack is simple. The Macintosh screen shows pictures of little boxes and their contents. We use the pointer, activated by the mouse, a small handheld roller-box with a "clicker," or button that moves the blinking pointer on the screen. We click on top of the box labeled "Quotations." The first quote in our stack appears. It says, "In the Beginning God Created the Heaven and the Earth." To find out from where this quote came, we move the pointer to another box which reads, "Who says?" The answer flashes on the screen: "The Old Testament." If we want to find a quotation about temptation by Oscar Wilde, we can search the stack in two ways. We can ask the computer to find *temptation* or *Oscar Wilde*. Using the word *temptation*, we get "I can resist everything but temptation" on the first try. Using the name *Oscar Wilde*, we first see another quote by the erudite playwright; but by pressing the Return key several times, we quickly locate his statement on temptation. The advantage of an electronic reference stack like HyperCard is that it allows you to design and customize the reference stacks to meet your specific needs. Using a computer with such a program allows you to save endless hours of research time. You've already seen an example of this in the first chapter. When we wanted to quote Robert Louis Stevenson on his sentiments about travel, we had only to search by entering *Stevenson*. We could have as easily found the quote by entering *travel* on the computer.

PUTTING WORDS ON PAPER

So far in this chapter, we have avoided the real process of travel writing, that elusive technique of joining words together to convey the ambience of an island, the tempo of a city, or the culture of a country. Travel writing, in its finest form, conveys the essence of a place; your goal as a travel writer is to re-create the place in the pages of a magazine or newspaper.

Although there is no perfect formula that will work for every travel story, there are

(Two Leads)

"RIVER OF GRASS"
by Carl Purcell
Chevron U.S.A. Odyssey magazine, Winter, 1989

The Flamingo Lodge in south Florida's Everglades National Park has color TV in the rooms. If your image of Dan Rather on the 6:30 news is seen through a snowstorm of interference, it is the fault of the vultures who perch atop the central television antenna. When the mood suits them, they will depart, and Rather will come through loud and clear.

"BARGING AND BALLOONING THRU BURGUNDY"
by Carl & Ann Purcell
Syndicated column for Copley News Service, 1988

The propane burner belched a tongue of yellow flame into the gaping mouth of the nylon envelope, momentarily giving it the appearance of a paper Chinese lantern in a summer garden. The giant hot-air balloon drifted over the playground of the elementary school at Chablis, and the excited French children chased after us with unbounded enthusiasm. Perhaps we represented the impossible dream, the chance to escape the dreary walls of a boring classroom, flying off to unknown horizons. That, in essence, is what travel is all about, and we had indeed flown away to participate in a dream vacation aboard a barge on the canals of Burgundy.

The balloon flight, an option for barge passengers, was our introduction to one of the finest travel adventures we've ever enjoyed. In our colorful balloon we floated over a green patchwork quilt of vineyards, tipped by the golden sunlight of late afternoon. One of our companions had the impish temerity to say, "Toto, I don't think we're in Kansas anymore!" Gallic dogs of undetermined pedigree barked wildly (like Dorothy's Toto) at this aerial apparition, a latter-day version of the Montgolfier balloon that had been launched with court physicist Pilatre de Rozier in Paris on October 15, 1783. It was somehow appropriate that we also ascended into the French skies during the month of October, 205 years later, as a tribute to this early pioneer of flight. We rode the soft, silent wind, finally coming to rest in a farmer's field. Roger Bishop, our British pilot, uncorked a chilled bottle of Moet champagne just as the sun was setting in the west and the full moon was rising in the east.

some guidelines for good writing in general. You probably remember a lot of them from Composition 101. Examples are: Write clearly. Keep sentences relatively short. Use adjectives sparingly and only when they contribute to the purpose of your story. An article or story should have a beginning, middle and end, or what writers refer to as the lead, body and conclusion.

Your lead, or opening paragraph, should grab and hold the reader's attention, tantalizing him or her to read further. The body of the article develops the ideas introduced in the lead as clearly and directly as possible. The conclusion summarizes major points; but ideally it also interprets the information in the article or draws some new conclusion.

In the following pages, we'll be looking at some good examples of these parts of an article. No matter what practical tips and examples we can give you, you'll want to develop your own style, a combination of personal technique and rhythm that will give your writing a special flavor. You cannot expect to be a polished writer in your first piece. The essence of good writing, as with any skill, is found after much practice and many attempts.

The Lead

Editors usually like an opening paragraph that gives the reader an overview of the subject, but you should always strive for originality, avoiding anything that might be seen as a formula lead or a list of highlights.

We have included a few of our favorite leads (at left and below) that demonstrate how to grab the readers' attention and entice them to read the rest of the article.

Changing A Lead

"The Week of Living Dangerously" (a portion of which appears on the following page) was based on a trip Carl took to Bermuda (we usually travel and write together, but on occasion one of us will go solo). After the story had been rejected a few times (often an indication to us that the story has not even been read), we decided to revise the

"SINGAPORE FLING"
by Carl & Ann Purcell
Syndicated column for Copley News Service

(Lead)

While Singapore remains the quintessential destination of Southeast Asia, it has become a paradox of modern technology and unbridled capitalism woven into an ancient oriental tapestry. The glistening skyscrapers of this city-state tower above narrow streets and twisting alleys from another century. One culture abuts another. The paper lanterns of Chinatown illuminate the work of street scribes as they pen letters to unknown readers in distant Chinese provinces. Perfumed incense creates spirals of blue smoke in the cool recesses of a Buddhist temple, while a few blocks away a Hindu holy man lights a votive candle to the multi-armed deity of Kali. On Arab Street a carpet merchant displays the intricate patterns of his wares in the shadows of the Sultan Mosque. And amidst this exotic setting, this mosaic of cultures, the British expatriates, in white suits and flowered dresses, enjoy high tea in the Palm Court at Raffles.

"THE WEEK OF LIVING DANGEROUSLY"
(Discovering Bermuda on a Moped)
by Carl Purcell

(Original Lead)

The prospect of a week in Bermuda was very pleasant. This neat and proper little island is described by many as a subtropical paradise, and thousands of tourists, honeymooners, and cruise ship passengers seem to agree. The peculiar thing about this lovely island is that you can't rent a car, and that may be one of the reasons it has remained so lovely. You can, however, rent a scooter or moped, and I chose this alternative form of transportation to explore the hidden beaches and back roads of Bermuda.

(Revised Lead)

I found myself speeding downhill on a moped in the narrow space between a concrete truck and a limestone cliff. Just ahead I could see a green churchyard with neat rows of tombstones, a mild reminder that my illustrious career as a journalist might come to an ignominious and sudden end on the winding roads of Bermuda. A friendly Bermudian face peered out of the window of the truck. "Hey, mon, have a good vacation," and I instinctively knew the warm greeting was sincere.

lead. The new lead did a better job of catching and holding the editor's attention; it was less "pat," more personalized, more exciting and humorous. It leaves the reader wondering if the writer did, in fact, survive. On our first attempt to send out the version with the new lead, the Los Angeles *Herald Examiner* used it, and it was later picked up by the *Toronto Star*.

The original lead and revised lead are both shown above.

The Body

After writing a strong lead, you should fill in the body of the story with local color, historical background, solid information, pertinent facts, and anecdotes based on events during the visit. Whatever subject you choose, make your account lively and interesting. We'll be talking about style later in this chapter, but the goal is to both entertain and give the reader as much useful knowledge as possible about the destination. Hopefully the article will motivate the reader to travel to that country or city. Interview local people for "insider tips" about where to eat, where to find a swinging disco, or what to do after midnight.

On the next two pages we present the body that follows one of the leads given earlier. Note that we tried to mention the good with the bad, while getting as much practical information into the article as possible.

The Conclusion

The conclusion of the story should make a strong impression. We try to convey a summary of our feelings about the destination or travel experience, sometimes both the positive and negative. While we may extol the physical beauty of Barcelona, we will also advise visitors to take precautions

"SINGAPORE FLING"
by Carl & Ann Purcell
Syndicated column for Copley News Service

(The Body)

We stayed at the Orchard Hotel, a very convenient and economical hotel, at the head of Orchard Road, which was within walking distance of the major shopping centers along that commercial thoroughfare. We liked the twenty-four-hour restaurant on the main floor which served a wide variety of Western and Eastern specialties. The elaborate Christmas lights and decorations along Orchard Road were very impressive, a new manifestation during the holidays in the last few years.

The visitor should be forewarned that Singapore is about midway between the Tropic of Cancer and the Tropic of Capricorn, a latitude that is invariably hot and humid. This tropical climate, however, has done nothing to dampen the energy and enthusiasm of the entrepreneurs and shopkeepers along Orchard Road, a thoroughfare that rivals Bond Street and Fifth Avenue. You can buy Gucci shoes, Tiffany diamonds, Seiko watches, and tailor-made clothes. The glistening multistory malls are evidence of a prosperity born of talent and industry. Earnest young men will offer you Rolex look-alike watches at incredibly low prices, but they are careful not to claim their products are the genuine article. The Singapore police keep them honest.

We fell in love with Singapore, a teeming city of 2.5 million that can be all things to all people. The city is like a curry feast with a tray of condiments, mango chutney, shredded coconut, bananas, diced onions, raisins, chopped tomatoes, and peanuts. The diner can take his choice, and the mixture is a delight to the palate of adventure.

The traveler and potential traveler to Singapore will be pleased to know that the city is probably the best bargain in the Orient. Comfortable, even luxurious hotels can be had for fifty U.S. dollars per night for a double. A delicious meal for two can be enjoyed for six dollars. Clothes, watches, and oriental artifacts can be purchased at amazingly low prices. Unlike Japan, Singapore is a city for a traveler on a budget. Most shops are pleased and eager to accept major American credit cards.

SINGAPORE IS FOR THE BIRDS

Each day in Singapore offers a new and exciting adventure. We had noted with interest that Singapore was a city filled with singing birds. Bird cages can be seen hanging in doorways and windows throughout Chinatown and happy songs fill the air. Boon Hee, our local guide, took us to a bird concert on Sunday morning outside a coffee shop at the junction of Tiong Bahru and Seng Poh roads. This is a weekly gathering place for bird owners who bring their feathered friends in bamboo cages. The ornate cages are hung from hooks under the roof of the coffee shop, and the tiny performers sing their hearts out for an admiring

audience. We could not have been more delighted with an aria sung by Pavarotti. You can also arrange to have a more formal breakfast with the birds in the Palm Court at Raffles Hotel or at the Jurong Bird Park.

THE GREATEST FEAST IN THE EAST

Singapore enjoys a well-deserved reputation for its widely varied cuisine. Chinese, Malaysian and Indian banquets can be enjoyed in air-conditioned elegance or adventurous gourmets can eat on the street. Dining at food stalls is a Singapore tradition, and you can rest assured that all vendors are licensed and clean. Believe us, when we say that dinner on the streets in Singapore is a travel adventure not to be missed. Our first outdoor dining experience was at Newton's Circus, sometimes referred to as Hawker's Heaven. This is a three-ring extravaganza that certainly rivals anything Barnum & Bailey could put under canvas.

The Singapore street chefs do their thing out in the open—chopping, grinding, grilling, and broiling with an adroit showmanship. You'll see and taste a wide, colorful assortment of both familiar and exotic fruits, the latter including kiwis, star fruit, durian, and mangosteens. There are fresh lobsters from the South China seas, spitting and hissing as they are grilled over glowing charcoal. White china bowls are filled to the brim with simmering noodles chock full of straw mushrooms, shrimp, Chinese celery, and celantro. Satay, charcoal-grilled mutton or chicken on thin bamboo skewers, is served with tangy peanut sauce. Blended fruit juices with crushed ice are served in tall glasses. Our favorite was pineapple and apple. For dessert we tried crispy banana fritters. And best of all, you can stuff yourself on a feast suitable for a king for only a few dollars.

Sometimes you may find the tables at hawker centers crowded. Place yourself near a table where the occupants are nearly finished and take the table as they leave. Also do not hesitate to share a table with other diners. This is customary, and you might make some new friends. We would also add a word of caution about ordering giant prawns. These prawns are very expensive, even by American standards. You'll pay more than a dollar each for these little rascals. Be sure to ask the price on any item when ordering.

against street crime. The last paragraph leaves the reader with your final judgment of the destination and wraps up the experience. It should leave a lingering image; an armchair traveler's daydream; a desire to try the experience personally. The conclusion of the Singapore story is at right.

ESTABLISHING STYLE

For each article, you must decide whether to write a personal recounting of a travel experience or a cooler, more objective look at a destination. We prefer writing in the first person. This makes our travel stories more personal—a direct sharing of our feelings, our reactions, our attitudes, our observations. It is the world seen through our eyes. The reader shares our journey, the ups and downs, the moments of joy and the sadness of leaving.

The power of observation plays an im-

"SINGAPORE FLING"
by Carl & Ann Purcell
Syndicated column for Copley News Service

(Conclusion)

Raffles Hotel is synonymous with the tropical romance and the colonial past of Singapore. It is an oasis of elegance set in the midst of glittering skyscrapers, and when the visitor steps into the lush garden of the Palm Court, he finds himself in another era. Sitting on the wrought-iron garden chairs and sipping before-dinner cocktails, we could almost sense the dour presence of Somerset Maugham in a rumpled white linen suit, jotting illegible notes for the *Moon & Sixpence*. There were other ghosts in the Palm Court. Noel Coward waved his cigarette holder like a baton, commanding the attention of Joseph Conrad and Rudyard Kipling. There are fifteen writer's suites facing onto the Palm Court, each marked by a brass nameplate over the doorway. You, too, can sleep in a room once occupied by a famous writer.

Singapore was everything we had ever hoped for. It is a city washed by the dreams of the past and challenged by the expectations of the future. For us it was a city of discovery, a place of exotic tastes, a destination that stimulates the eye and lifts the traveler on wings of adventure.

portant part in travel writing. Hong Kong is a favorite destination for noted author Jan Morris. She likes to sit on a bench in Victoria Park and watch the world go by. We urge you to also take the time to observe what's going on around you. We like sitting at a sidewalk cafe in Paris, especially in the spring, watching young lovers walk hand in hand, observing elegant women wearing the latest haute couture fashions, and seeing children trailing behind their parents or their nannies on their way to the Tuileries. It is your power of observation that can bring your travel writing to life. It may be nothing more than lavender paint peeling off the siding of a Victorian house, ivy climbing over the chimney of an English cottage, or freshly cut wedges of cheese in a Dutch market. Speculate on the things around you. What do you find washed up on a beach in the Caribbean? Perhaps a bottle with a note, glass fishing floats, weathered wood, or even a gold doubloon. Where did they come from? What lives did they touch? Where

will they go?

Be curious about people. How did the Chinese saddle maker come to live and work in Taos, New Mexico? There is undoubtedly an interesting story behind the American couple you came across living in the Amazon jungle. Where and how did the cook in a New Orleans restaurant learn to prepare Cajun food? Talk to these people and learn about their lives, their hopes, and their goals. You'll find that most people are glad to talk to a writer.

Our colleague Rita Ariyoshi of Honolulu is a writer with a unique style, a person who enjoys her interaction with other people. She knows that readers are fascinated by people, and she paints vivid word portraits of individuals, making them come alive in the pages of her articles and books.

Rita captures our hearts with her charming portrait of Kyle Deevy (on the following page). She uses this poet to skillfully introduce us to the alluring city of Dublin, its enduring architecture, cozy pubs, and green

> ## "IN DUBLIN'S FAIR CITY"
> ### by Rita Ariyoshi
> ### from: *Gourmet Traveler* magazine
>
> Kyle Deevy of Dublin is 89 years old. His poetry is beautiful and his typing atrocious. The latter fact he acknowledges and excuses, saying his typewriter is Italian and knows little English. He wears a respectable dark suit that is neither grey nor brown, a matching vest, starched white shirt, and companionable maroon tie. He has an impressive mane of pure white hair that would cost a pretty penny to maintain had he not acquired it honestly. He blushes when complimented on it. He is a widower who lives in a nice house as a paying guest and drives every day to his country club, a pleasure he places second only to his poetry. He stands tall, angular, spare and erect, rather like a tree that has been stripped of its leaves by the autumn wind.

parks. While Rita is primarily known as a writer, she started taking pictures about ten years ago and has illustrated many of her articles. Her husband Jim is also a talented photographer and they travel together and collaborate on many projects.

Another way to add interest to your article is by using dialogue or live quotes. We use it sparingly, but it does add a lively quality to a travel story. Our friend and colleague Bern Keating of Greenville, Mississippi, is a master of words taken from the mouths of others. He often uses a quote to lead into a travel article. Here is an example from his article "Hong Kong Taste Treats," which appeared in the *Washington Post*:

"The Chinese will eat anything that has four legs or two wings," said Lily Chang, my shapely young guide from the Hong Kong Tourist Board, "except, of course, for a kitchen chair or a Boeing 747."

Bern follows this compelling lead with a description of his tour through the edible snake market and visits to restaurants where he partook of cobra soup and red wine with marinated toad. Bern can transform the mundane into the hilarious. Another article for *Travel & Leisure* decribes the common safari jacket (page 40).

Certain types of articles dictate, at least to some degree, the style of writing. An article about luggage and how to pack will be very information-oriented, with more straight facts than a destination story. This doesn't mean you can't include a personal anecdote or even a story about how someone had their soft luggage cut open by a thief in a foreign airport. It often makes sense to use a real experience to make a point.

You can't force a humorous style. If it comes easily and naturally, it will read easily and naturally. If, however, you tend to be a serious writer, then write seriously. Trying to falsely assume the voice of a comedian or comedienne will only make your article sound artificial.

Describing the charm and ambience of a city requires a special eloquence. Our colleague James Wamsley of Richmond, Virginia, is a Southern gentleman to the core, and his description of New Orleans is an elegant example of how well this can be done (page 40).

Jim may be a Southern gentleman, but he is a journalist first of all. He reports on what he sees with the accuracy of a camera and the perception of a poet.

Writing for *Time* magazine can almost guarantee that the editors will rewrite your piece to fit their style. Even so, a sharp edi-

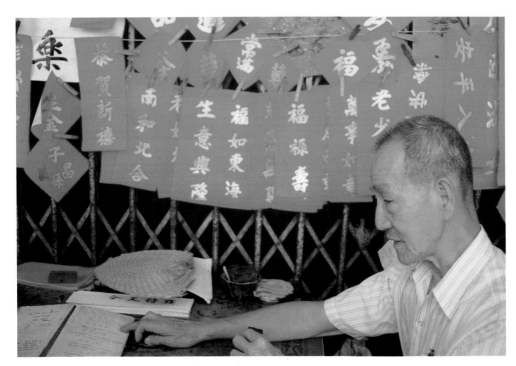

While you are walking around, always be looking at the sidelines for details of the everyday life-style. This is a close-up of a pedicab driver in Chinatown, Singapore, taking a rest between passengers. Other photos we took of him included his bicycle-powered taxi.

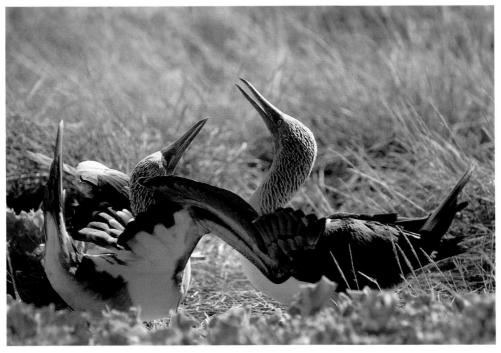

Look for unusual types of behavior in wildlife. These blue-footed boobies, which we photographed in the Galapagos Islands, are involved in an intricate mating dance. To catch such pictures, you must have some knowledge of animal behavior. In our case, a knowledgeable guide pointed us in the right direction.

tor will recognize good writing and leave its flavor intact. Joan Ackermann-Blount wrote an article about RV mobile homes for *Time* which we consider a classic (page 41).

Joan economizes on words, but uses them in a way to paint a vivid picture of a way of life. Another writer doing an article on RVs might take a totally different approach. Christine Morrison with the Recreation Vehicle Industry Association is quick to point out that RVs are also popular with young families and others traveling on a budget.

"THE EVOLUTION OF THE SAFARI JACKET"
by Bern Keating
Travel & Leisure magazine

Darwin clearly messed up with his "survival of the fittest" or else we would all be kangaroos. Imagine the survival potential of having a built-in pocket from birth.

Some tailoring genius lost in the mists of time repaired nature's failure by inventing a clever substitute for the marsupial pouch and sewing one on each breast of a man's shirt. In the act of evolutionary folly, shirtmakers reduced pockets from two to one and to the final absurdity of none, yielding a shirt as bald as a buzzard egg.

For a while, mankind suffered meekly, but no more. The safari jacket has stampeded the fashion field. Why? How about two bellows pockets, two pleated-for-expansion breast pockets, scattered little sleeve pockets as fantasy dictates for sunglasses and writing instruments, and epaulets for holding binoculars, cameras, purses, and tape recorders.

"INCOMPARABLE NEW ORLEANS"
by James S. Wamsley
for *Meeting Destinations* magazine

(Lead)

Let us not suggest that New Orleans renders all other towns insipid by comparison, but put it this way: The Big Easy will never be mistaken for Gopher Prairie. Here, indeed, is our folklore city, an exquisite paradox woven of beauty, toughness, folly, compassion, and make-believe. Some visitors like to view the New Orleans style as European, a picture not merely inadequate but downright patronizing. New Orleans may in fact be our most American city. Here, where class, clique, and race were marooned, the melting pot almost worked.

(Conclusion)

As I walked down Bourbon Street in early evening, one of the celebrated strippers was grinding away, beaming sample flashes through an open barroom door to the sidewalk gawkers of every stripe, from shaggy motorcycle outlaws to silvery retired ladies. I watched for a few minutes, and then walked over to Royal and St. Louis, where an ethereally beautiful young woman stood under a gaslight playing her violin. Mozart, I think it was.

Somewhere between the two women, between the coquette and the enigma, clear as could be, was the real New Orleans.

Like gaslight on the fog.

"PARKED IN THE MIDDLE OF NOWHERE"
by Joan Ackermann-Blount
for *Time* magazine

"Here you can do as you diddly darn," says Gerry Bloomquist, 65, a retired dress-shop keeper from Minnesota who is wintering in the outskirts of Quartzite, Ariz. She sips a drink, relaxing in front of her 33-ft. Holiday Monitor recreation vehicle, or RV, on a lawn chair set on a piece of Astroturf. "My grass," she calls it. While the sun, rattlesnakes and tarantulas bed down, Bloomquist and tens of thousands of other tanned retirees enjoy another happy hour parked out in the desert, gazing at the mountains, puttering around their mobile homes, filling hummingbird feeders, thriftily sidestepping the cruelties of winter and old age in as mercurial and rambunctious a community as the Wild West ever saw.

WRITING A GUIDEBOOK

On our bookshelf at home we are proud to have a complete collection of the books recounting the travel and photographic adventures of Burton Holmes, based to a large extent on his famous slide and film lectures. In the early 1900s, Holmes brought the world to the hometowns of America. If you choose to become a writer of guidebooks, you can bring the people of America to the world.

Guidebooks can be a substantial and steady source of income. After you have written a successful edition on a particular destination, it is practical for the publishers to assign the updated versions to you as well.

Writing a guidebook requires special skills and aptitudes. It also carries a heavy responsibility and takes a considerable block of time. The reader looks to you as an authority on a particular country or city, and it is vital that all your information is accurate and up-to-date. (Accuracy is always important to a travel writer in any publication.) Some fine guidebooks such as *Fodor's* are packed with information about hotels and restaurants. Naturally such guidebooks need to be updated periodically, providing the authors with a continuing income. The illustrated *Insight Guides*, on the other hand, stress history, culture, and provide vivid descriptions of the countries. They are designed to have a long shelf life and not be dated by hotel rates and restaurant critiques.

Most guidebook publishers will provide an advance for the author, followed by a commission or a lump payment at the completion and acceptance of the manuscript. Realistically the advance cannot cover the actual travel expenses for air fare, food, and hotels, but a clever author or photographer can obtain some subsidies from the country being covered in the book, or piggyback magazine and newspaper assignments while traveling to complete the guidebook. For instance, we have just been assigned to do the photography for the *Bermuda Insight Guide*. Spin-offs might be newspaper or magazine articles on Bermuda. Eventually, the slides will go into our stock file and picture agencies.

Jean Postlewaite of Kenilworth, Illinois, was a desk-bound book editor for Rand McNally when she decided to break out of her cubicle and write a section of *Hidden Mexico* for Ulysses Press of Berkeley, California. Jean is an attractive, energetic young woman who tackled the project with enthusiasm. She rented a car and spent seven

The historic harbor area of Bergen, Norway, reflects the traditional architecture of this fascinating city. The orange fishing boat adds an accent of color.

Not all travel pictures are happy. These people await food at a relief camp in Ethiopia. Reporting honestly on potential travel destinations is an ethical responsibility. Will the traveler want to see poverty in India or Ethiopia? It is not an easy question to answer, but documentary pictures report the reality of travel in Third World countries.

The Birth of a Guidebook Series

In the sixties Hans Höfer was a young German photographer with a motorbike, a camera, and a notebook traveling through Southeast Asia. He was a young man driven by wanderlust and a keen intellectual curiosity. When Höfer wrote his first *Insight Guide* on Bali in 1970, he broke from the dull format associated with many guidebooks being published during that period. He stressed the excitement of the travel experience, giving his readers measured doses of culture, history, and politics of the country or region covered. The books were lavishly illustrated with color photography, images that were both graphic and photojournalistic. He showed his readers what a destination looked like and filled in the details with lively, readable text. It had been thought that color photography in guidebooks would be prohibitively expensive, but Höfer proved otherwise by printing his books in Singapore.

The Bali book was the first of many, and soon Höfer was hiring talented international writers and photographers to produce other guidebooks that followed his editorial style and would fall under the Höfer Media *Insight* banner. While printing and some typesetting is still done in Singapore, more than 100 titles of country and city guides are now masterminded from editorial centers in Singapore, Hong Kong, Munich, and London. *Insight Guides* appear in English, French, German, Italian, Chinese, and Spanish language editions.

The writing in the *Insight Guides* is rich and informative. The following excerpt from their *Insight Guide: Thailand* is an example:

"A Buddhist monk, according to one authority, 'must not only abstain from stealing, lying and idle talk, taking life, indulgence in sex, intoxicants, luxuries, and frivolous amusements; he must also obey no less than 227 rules that govern all the minutiae of daily conduct and manners. He can have no possessions except the yellow robe, the alms bowl, and a few personal necessaries. He eats only two meals a day, the first in the early morning and the second before noon.' "

weeks driving the west coast of Mexico, checking out beaches, hotels, restaurants, nightlife and transportation. During an interview, Jean was candid in admitting that she was motivated by the desire for adventure. She drove more than 3,500 miles and had a few uncomfortable encounters with macho Mexicans in uniform toting automatic weapons, but she came back tanned and unscathed. She wrote for readers in the twenty to thirty-five age bracket and was paid a flat fee and expenses for her coverage of the west coast.

Writing is an intangible, often baffling process. It is a language skill that flows easily for some of us, but is extremely difficult and even painful for others. We have included excerpts from the works of other travel writers we know and admire. Obviously there is virtue in showing examples of fine writing, but we have also tried to analyze the creative process of writing and reporting on a travel destination. On some future book like this one, our examples might be excerpts from your work.

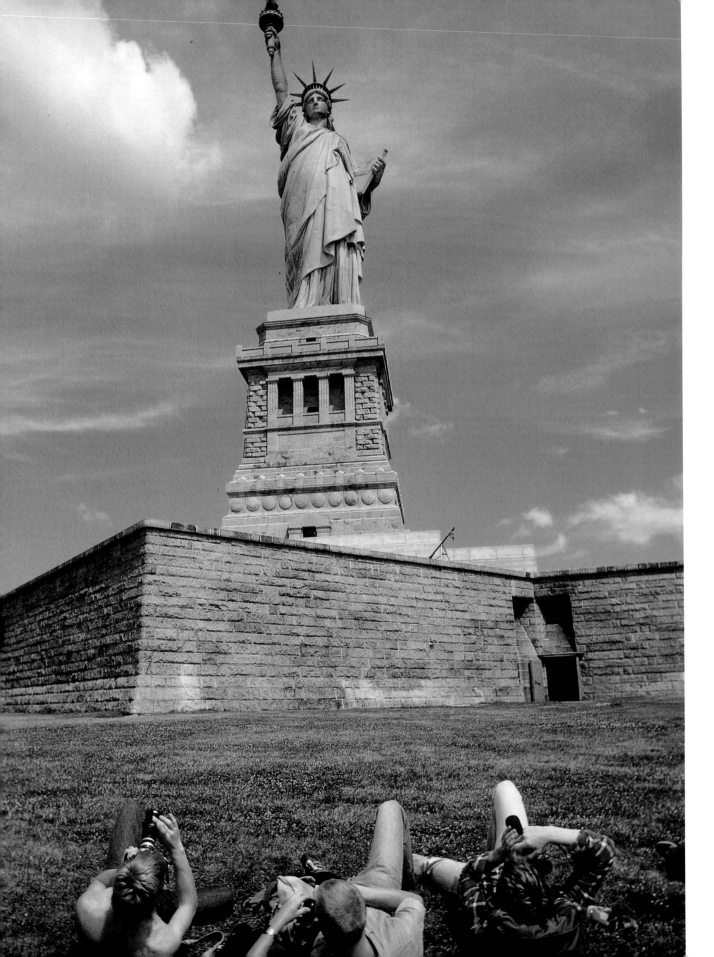

Taking Travel Pictures That Sell

As you thumb through this book, it will be evident from our pictures that we consider photography a vitally important part of travel communication. We are visual types who enjoy expressing ourselves through photography; quite frankly it also contributes substantially to our financial success. Aside from that, however, we find that photography is more fun than writing. There is a very tangible artistic gratification in taking pictures and seeing the results almost immediately. In a portfolio, it is nice to be able to display a photo that excites an editor at first glance. We get even greater pleasure from seeing our pictures in print, especially those used to illustrate our travel articles.

If you are a travel writer or hope to be one, photography is a tool you will need to use, even if you don't take the pictures yourself. We intend to convince you, however, that you *can* take pictures of professional quality to illustrate the articles you write. Taking pictures with a modern camera can be as simple as pointing and shooting. We might even be able to instill the creative urge for you to take photography very seriously. After all, this is a valid art form, hung in major museums throughout the world.

In the first part of this chapter you will learn about the modern camera; such basic necessities as film, camera bags, tripods, etc.; and how to use them to illustrate your stories. Later in this chapter, you'll discover how to take great travel pictures. Once you've mastered the tricks of using light, lenses and filters to manipulate your composition, you will be exposed to the heady power of creativity and the thrill of capturing, wordlessly, a special moment or magic mood.

GETTING STARTED IN PHOTOGRAPHY

For the sake of discussion, let's assume you're a novice with a cheap fixed-lens camera. You are capable of taking decent pictures, but ones that are not up to publishing standards and are often not the precise picture you want. (People often call these cameras "Instamatics," but that is an Eastman Kodak trade name; we call them "simple cameras.") Naturally, you want a camera that is easy to use, something uncomplicated that will give you clear, sharp pictures to illustrate the articles you intend to write. You'll be pleased to know that finding such a camera is quite easy. You should expect to pay $150 or more for a camera capable of capturing images of sufficient quality for publication. The "or more" is a catch phrase that means you can pay thousands of dollars for a fine camera system, and many of us do. Realistically you'll probably spend about $300 to $500 for a camera that can meet your basic needs.

When purchasing your first camera, you will need to know the types of cameras available. As professional travel photographers, we have strong opinions about cameras, film, and shooting techniques; in these pages we will share these opinions. Different cameras will suit different people and

These three young men are trying to get a different point of view of the Statue of Liberty. However, the resulting pictures may show some distortion when taken from such a low angle. The lady in green will have a more normal appearance when photographed with a telephoto zoom lens from the ferry boat to the island.

When taking pictures of a well-known landmark, shoot it from a normal angle or view and then go for the unusual, creative shot. You may prefer the latter, but most picture editors choose the former.

different situations. We are a two-camera-system family. Carl likes to use the Minolta 8000i cameras when he is on assignment; Ann uses the Nikon 8008 cameras as her workhorses. Each of these two systems has very definite advantages, so by having them both we can do a lot of creative maneuvering. We also use the Olympus 300 Superzoom and the Ricoh Mirai when we want a light, one-piece camera for easy shoots.

First of all, let us assure you that a camera is much less complicated than a word processor. In spite of knobs, buttons, and digital windows, the modern camera is simple to use, usually with automatic settings for exposure and autofocus. These marvels are highly dependent on batteries, so it is vital to keep an extra supply on hand.

Cameras of professional capability use either 35mm-size film (you are used to seeing this on grocery shelves) or the larger formats, ranging from 2¼″ × 2¼″ on up to 8″ × 10″, which you'd probably see only in a studio. The cameras using 35mm film are much smaller, more compact, and have the advantage of very sophisticated electronic features. Supposedly the larger film gives better image quality (Ansel Adams used it), but for modern reproduction in most publications, there is little difference. For travel, we definitely recommend going 35mm. After walking city streets all day, your back will thank you for choosing the smaller, lighter camera. It may be interesting to note that the Japanese have pretty much cornered the market on high-tech 35mm cameras, with one notable holdout by the Germans with their expensive Leica.

Most modern cameras are equipped with autofocus and automatic exposure, sometimes with the option of manual control. Autofocus is a wonderful invention which offers the key to crisp, sharp, perfectly focused photos. (Especially important as you get older and your eyes begin to age.) Automatic exposure reads the light on your subject and decides for you what the shutter speed and aperture opening should be. If you are a beginner, this will save you grief

from overexposed or underexposed pictures caused by your forgetting to set some dial. On the more traditional cameras, you bought a certain speed film (slow for good light and fast for poor light) and then set the ISO number on the camera to correspond with the film speed. Today, the new breed of cameras are usually equipped with sensors to read the DX bar coding on film cartridges and set the proper film speed. (Film is rated with ISO numbers according to its light sensitivity, and the appropriate rating is in the bar code.) While we think automatic features offer distinct advantages to any photographer, we feel it's important to at least have a plus and minus exposure control, even if, as with some simple cameras, you cannot manually choose aperture settings and shutter speeds. That way, you can choose to overexpose and underexpose photos for special effects. We will cover this in more detail later in this chapter.

The Simplest Camera

Next you must choose between a simple camera with a non-interchangeable, fixed focal length lens, a camera with a noninterchangeable zoom lens, and a camera with fully interchangeable lenses. This sounds pretty technical, so allow us to interpret.

The simple camera with one lens is the least expensive, but it has a serious limitation in that you can photograph the world only with one moderate wide-angle lens. You cannot reach out or "zoom" to the head and shoulders of a person in a crowd, you cannot closely focus on a red flower, and you cannot encompass the wide-angle view of a football stadium. These cameras usually have a small, built-in electronic flash that can illuminate a subject up to six or seven feet away. We often chuckle when we remember the little old lady we saw in Egypt who tried to take a flash picture of the pyramids at night. We could predict that her resulting picture had about six feet of empty light and then a murky black background.

The simple camera will fit in a pocket or

Travel photography is often a case of waiting for the right moment or the best light. We arrived at the Temple of Poseidon at about three o'clock in the afternoon and waited until sunset to capture this dramatic scene of the pillars against the sunset and the Aegean Sea.

It is said that, "Fools' names and fools' faces often appear in public places." But even Lord Byron carved his name into this impressive Greek temple. The interesting aspect of the graffiti is that the writing is in ancient Greek.

In order to have both the foreground and the background in focus, we used a wide-angle lens closed down to f/16 and shot the picture from a low angle.

Architectural details can be excellent subjects for your camera. Walt Disney's Caribbean Beach Resort near Orlando utilizes an island colonial style with strong Victorian influence. This image was used in the catalog of a European picture agency as a generic shot.

evening bag, but one of the only times we would probably consider using such a camera would be when we're tired of carrying our heavy equipment and all we want are simple, straightforward pictures.

The Non-interchangeable Zoom Camera

This type of camera represents a fairly new innovation in the market and it offers the travel writer a camera with a power zoom lens ranging from moderate wide-angle to moderate telephoto. In addition these cameras have many professional features such as macrofocusing (an example of macrophotography is a photo of a bee's eye), daylight fill flash (used to illuminate the deeply shadowed areas of your subject caused when the sun isn't behind you), and built-in motor drive (this automatically advances the film after each picture so that you are always

ready to snap another.) Such a camera is simple to use and is capable, in the right hands, of doing serious photography. At the current writing there are two such cameras on the market: the Ricoh Mirai and the Olympus Infinity Super Zoom 330. The Ricoh Mirai has the option of two additional screw-on lenses, one a wide-angle 28mm lens and the other a 200mm telephoto lens.

The 35mm SLR With Interchangeable Lenses

The ultimate professional choice is the 35mm single lens reflex (SLR) with interchangeable lenses. This is the camera you are accustomed to seeing in the hands of professional photographers. The major brands, such as Nikon, Minolta, Canon, and Olympus, all offer the automatic features we discussed in the less expensive models, but these cameras also provide the option of

several modes, including "manual," which you'd use if you didn't want the camera deciding the exposure and aperture settings. The major advantage to these cameras is that the lenses can be changed and the manufacturers offer a wide range of fine lenses, from ultrawides to strong telephotos, as well as excellent, high-resolution zoom lenses. Zoom lenses are designed to let you quickly change the focal length or magnifying power of a lens. For instance, you can zoom from 70mm to 210mm with a simple twist of the lens mount. Matched electronic flash units are available for all of these cameras and can be used off-the-camera with extension cords for more pleasing lighting on a subject.

Later in this chapter, we'll discuss how to take travel pictures, but right here we would like to stress the importance of knowing and understanding the mechanical and optical features of your chosen camera. The next statement may seem obvious, but it is vitally important. Quite simply, read your instruction manual and shoot a test roll before starting off on serious picture taking or a long-awaited trip. Many cameras today come with an auto-load feature, but in any case be sure the film is inserted properly and feeding over the sprockets. Even if they don't want to admit it, every photographer has at least once taken thirty-six shots on a roll of film that wasn't loaded properly. It can be heartbreaking if those lost thirty-six shots can't ever be retaken. Once the film is in the camera, taking pictures is as simple as point and shoot if you have a good eye for composition and know how to pick the right subject.

You'll have to be willing to experiment. Photography is a little like diving. If you hit the water at the wrong angle, you can do an awful belly flop; but if you have practiced enough, you'll be able to predict your results even before you reach the water. At some point, you'll feel such ease with your skill that you will dare to be innovative. You'll know how to pick your subject and the best moment to take the picture. (The hardest thing to learn is that by the time you've seen the action and your mind has processed the information about it, the optimum split second has often passed and it's too late to press the shutter button. You'll become ultrasensitive at predicting an action and being ready for it before it happens.)

Another skill that becomes almost second nature with practice is composition. You will almost subconsciously move your body slightly so that the telephone pole is not "growing out" of your subject's head. You will automatically "crop" the picture, zooming in until all the peripheral garbage is gone, leaving just a clean picture of the subject you want. Your knees will bend almost involuntarily so that you can take the picture against the sky when the background is too busy or distracting. When you start taking photos, you will need to study your results critically and then consciously change your approach. Soon it will be second nature and you will be able to concentrate on new aspects of creative control.

Living or Not Living With Your Old Camera

Some photographers get used to an old, out-of-date camera. It can be very comfortable, like a favorite pair of shoes; such photographers usually take pride in the vintage of their photographic equipment. But while many older cameras are capable of taking perfectly good pictures, it is easier, faster, and more dependable to use one of the modern, automatic cameras. It is a pleasure to shoot roll after roll of perfectly exposed and needle-sharp pictures. We don't encourage photographers to rush out to trade in their cameras every time a new model is announced, but if your camera is more than ten years old, it would be to your advantage to buy a new one. You don't need to pay the retail "asking price" for a camera; shop around for the best discount on the model and brand of your choice. You'll find the best prices through the mail-order camera stores in New York, but there is an advan-

tage in getting your camera through a local camera store in case you have problems or need advice.

When people go with us on camera safaris, they often bring an old camera as their second or backup camera body. If the lenses are compatible with their new cameras, then these people won't have to pack a lot of extra equipment. (Nikon is a system, for example, with which we can use the old lenses on the new autofocus cameras. That is not true of the Minoltas.) We have found, however, that it is less confusing to have both of the camera bodies we each carry to be identical. Suppose, for example, that you had one camera body that sets the ISO rating automatically as the film is loaded, and another camera body on which you have to set the ISO rating manually. If a baby leopard is trying to drag a piece of meat into a tree and you need to change film, the excitement of the moment could so rattle you that you forget to do the manual adjustment. Your entire roll of once-in-a-lifetime pictures would be lost.

THE BASIC EQUIPMENT

We consider it very important to have two camera bodies in case one breaks down while you're exploring the upper regions of the Amazon. (Repair shops are hard to find in the jungle.) Actually, you don't want your camera to "go down" anywhere, even where you can get it repaired in two or three days. A travel writer can't afford to lose the time. When you are just getting started, a simple point-and-shoot camera could be your backup. Even if you don't have the creative range that you get with your 35mm SLR, you should be able to come home with a few good photos to illustrate your piece.

If you plan to take travel pictures and you have a 35mm SLR camera with interchangeable lenses, there is a basic list of lenses and accessories you should have. We suggest two zoom lenses, one from about 28mm to 85mm and the other about 70mm to 210mm. If your budget allows, you should also have a 20mm or 24mm fixed focal

length wide-angle. In addition to the lenses, you will need a solid, lightweight tripod, a cable release, and an electronic flash with a coil extension cord.

Understanding Lenses

In the previous section we suggested the different lenses you might use as a travel photographer; but while we mentioned wide-angle, zoom, and telephoto lenses, we didn't really explain what these different lenses could do. The chart on pages 52 and 53 will help you understand and select lenses to meet your needs. Four asterisks after a lens indicates that it is very useful; a triple asterisk indicates that we recommend it if and when you can afford it. We will start with the widest angle lenses and go to the long telephotos. On the top of each lens mount are the f-stop numbers which you can adjust by turning the ring. It is helpful to know that the largest lens apertures are indicated by the smaller numbers, such as f/1.4. The smaller apertures are indicated by the larger numbers, such as f/22. (It is helpful to think of aperture as a pupil of an eye and the f-stop as a light level. When the light is dim or dark, you need the f-stop low so that the pupil of the camera's eye can open to its widest. When the sun is glaring, your f-stop will need to be very high so that your aperture closes down.) Note that zoom lenses do the work of several fixed focal length lenses.

The preceding can be useful as a guide, but the information it contains must be tempered by understanding the nature of wide-angle and telephoto lenses. The very wide-angle lens encompasses a great deal of visual information, but elements in the picture appear small. A distant mountain will look like a molehill. A wide-angle lens is ideal for the interior of a room or the inside of a cathedral. It can also work very well for the exterior of a building, especially when shooting on narrow streets. Be aware that a wide-angle will create distortion of vertical lines, like those in a building, if the camera is not

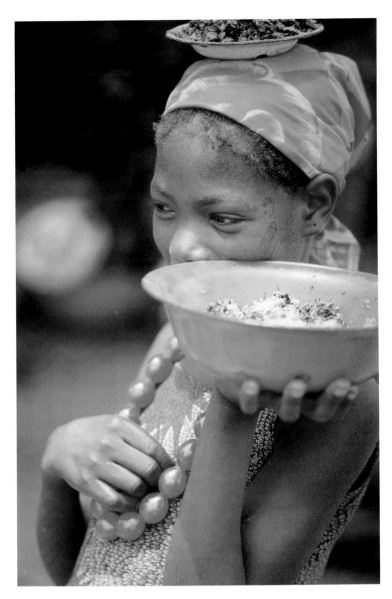

A cluttered background behind your subject can be confusing and distracting. In this candid picture of a girl at the market in Niamey, Niger, we threw the background out-of-focus by using a 200mm lens at the widest aperture. The blurred background does not distract from the face and details of the girl.

kept level to the horizon. (This is not always bad, depending on the desired result.)

Care must be taken if using a wide-angle lens for taking close-up pictures of people, as these lenses will cause unflattering distortion of the facial features. The wider the lens, the greater the distortion. Moderate telephoto lenses (70 to 135mm), however, are quite good for taking portraits of people. Such lenses render the facial features in a pleasing perspective.

All telephoto lenses have the unique ability to reach out and catch a subject from a distance. With a 200mm or a 300mm lens you can pick out an eagle on a branch or a person's face in a crowd. Telephoto lenses will also compress elements in a picture, making them appear closer together. A line of cars shot from the front will seem jammed together. A crowd of people on a street will appear closer together than they really are.

We are strong advocates of zoom lenses for the travel photographer. A zoom lens allows you to change the focal length of the lens while it is on the camera. You can actually zoom a lens to compose your picture from a fixed position, such as standing on

Guide to Camera Lenses

**** Plan to purchase with basic equipment
 *** As soon as you can afford it
 ** On your wish list for "someday"
 * When you are rich

Round fish-eye. This specialty lens takes a round picture that covers 180 degrees. It is used mainly for photographing cramped interiors such as the cockpit of an aircraft. Image distortion or line curvature is extreme. For instance, you could stand in the middle of a street and take a picture that looks as if the buildings on either side are curving over your head and nearly touching. Unless you aim straight up, you may get the toes of your shoes in the frame.

**Full-frame fish-eye.* This is also a specialty lens, usually with a focal length of about 16mm. We have found ours to be very useful for both interiors and landscapes where extreme wide-angle coverage is important. While this takes a rectangular, full-frame picture, there is linear distortion at the outer edges of the picture. You can use this distortion purposefully for some very artistic results; for example, you could bend a straight picket fence or distort the size and shape of a doorway.

**20mm wide-angle.* Architectural photographers use the 20mm rectilinear lens for interiors. It can keep both foreground objects and background in acceptable focus. If kept level, it is distortion free.

***24mm wide-angle.* This highly versatile lens is our favorite of the wide-angles.

It is available with apertures as wide as f/2, making it capable of shooting in marginal interior light. It works well for wide-range landscape shots, people in conjunction with their environment, and interior shots showing most of one room. An example of a shot taken with this lens would be a bank of blossoms in the foreground and the flower merchant vending his wares in the background. In good light, both foreground and background could be in sharp focus.

**28mm wide-angle.* This is a good lens, but in the fixed focal length, we feel that it falls short of the 24mm and does not have the merits of the 35mm. We may occasionally use this focal length with our 28–85mm zoom lens.

***35mm wide-angle.* This lens has often been called the all-purpose lens and is the focal length on many simple fixed-lens cameras. It usually has a wide aperture (f/2 or f/1.4, meaning that it can take pictures in marginal light) and can focus at close range. The 35mm became the choice of professionals in the early days of photojournalism.

***Perspective Correction or PC lenses.* (35mm or 28mm) These lenses are designed primarily for architectural photography where linear distortion must be corrected. They have manual controls for shifting the elements, similar to larger view cameras. (If you tilt your camera up, a tall building will look as if it is leaning. The PC lens allows you to raise the camera element while you hold the camera body level.)

the deck of a cruise ship as you photograph the shoreline.

Creating Your Own Light

Photographers usually depend on the sun as their primary source of light. There are cir-

cumstances, however, when some form of artificial (supplementary) light is necessary. For a travel photographer, this is usually electronic flash. The simple cameras have a built-in flash that is very easy to use: just point and shoot, and the exposure is automatic. Direct on-the-camera flash, however,

50mm normal lens. The 50mm lens often comes with a 35mm SLR camera when it is purchased. It usually has a wide aperture and works well for head-and-shoulder portraits, although it will also take an average scene without a broad scope. We almost never use this lens because its range is covered by the 28–85mm zoom. You could purchase a camera body without a lens and use the price difference toward the purchase of the zoom.

****28–85mm zoom lens.* This is a very useful lens. It covers a wide range from wide-angle to moderate telephoto and can often meet all of your needs in taking pictures to illustrate a travel article. The advantage in having a zoom is that you can carry one lens instead of three. The disadvantage of a zoom is that it often doesn't have the lens speed (or aperture opening for dim light) of some of the fixed focal length lenses.

****70–210mm zoom lens.* This is the natural extension of the 28–85mm zoom. It is long enough to meet most telephoto needs and short enough to do fine portraits. With this lens, for instance, you could fill the frame with the head of a cheetah lying twenty feet away.

****100–300mm zoom lens.* This lens is becoming increasingly popular, in some instances taking the place of the 70–210mm. Its slightly longer reach would, in the above example, allow you to fill the frame with the cheetah's face.

300mm ED lens. This wide-aperture lens is very useful for wildlife photography. It is best used on tripods or with bean-bag support. Tele-extenders are available which can convert these lenses to 600mm, but with one stop loss in aperture. We're still watching the cheetah, but now we're taking a close-up of its eye. If we attach the tele-extender (basically a double magnifying device) the cheetah may be too close to photograph and the picture looks darker. (That aperture stop loss means that we need the equivalent of one f-stop more light to get the same results that we had without the tele-extender.)

500mm mirror reflex lens. A mirror reflex lens has a fixed aperture, usually f/8. This is somewhat limiting, as it must be used in extremely good light or with fast film. With our cheetah example, you would want to move backwards so that you could focus.

600mm ED lens. This expensive lens is mainly used for sports coverage and wildlife. Such strong telephoto lenses must be tripod mounted, and they have limited applications. We prefer using a 300mm with a tele-extender when we need 600mm. The reason you need a bean bag or tripod for this type of telephoto lens is that at such a strong magnification, even minuscule movements (breathing, vibration, a breeze, muscle fatigue) can cause your picture to be fuzzy.

works well for some pictures and not so well for others. It can sometimes result in "pink eye," in which the eyes of your subject will appear as bright pink dots in the picture. Direct flash will also cast a dark shadow on the wall behind your subject.

The major disadvantage of the built-in flash is that it cannot be held off the camera on an extension cord to provide a more interesting or flattering angle of light. Most SLR cameras give you the option of attaching an accessory flash that will allow the use of an extension coil cord to hold the flash off the camera. For taking pictures of peo-

Very wide-angle lenses will often create image distortion in a picture. The distortion is acceptable or even desirable when it contributes to the desired visual effect. Here, we used a full-frame fish-eye lens to shoot the interior of a shopping mall in Singapore. Note the barrel distortion of the vertical columns, but we still feel the image worked well to illustrate the subject.

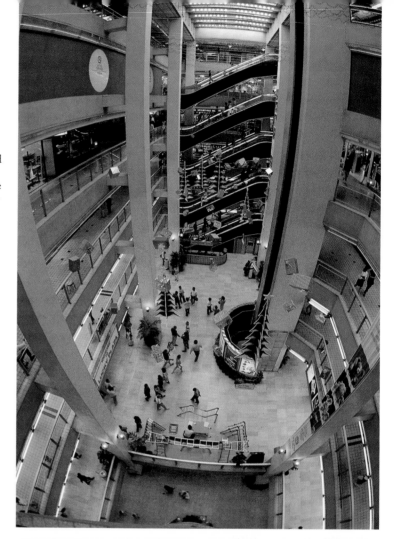

A macro lens or even a zoom lens with a macro mode will allow you to move in very close on some subjects. In this case we photographed these lovely orchids in a botanical garden in Singapore with a 28-to-85mm zoom at the macro setting.

ple, hold the flash above and to the left of the camera. This will throw the wall shadow down and out of sight as well as eliminate "pink eye." With direct flash off the camera, always be sure that the flash is pointed at the subject and not to one side.

There is another flash technique that can be very effective. This is called *bounce light* and it works well in smaller rooms with white walls and ceilings. You can direct your flash toward a white wall or ceiling, letting the light bounce and illuminate your subject with a soft, pleasing light. There are slip-on attachments for flash units that provide a slanted white, flat surface for bouncing light in large rooms or ones with colored walls. One we have found satisfactory is called LumiQuest.

Finally, you may be surprised to learn that flash can be used to your advantage outdoors in sunlight. Bright sun, especially at high noon, creates harsh shadows on a person's face. Flash can fill in those shadows, giving you a more pleasing picture of your subject. Read the instructions for your particular camera about shooting "flash fill."

Choosing the Best Film

Film comes in three basic types: color-slide film, color-negative film, and black-and-white film. There are compelling reasons for the professional travel photographer to use color-slide film. Consider the following:

1. Printers prefer color-slide film for making color separations. (Separations must be made before a color photograph can be printed.)
2. Color slides are easy and convenient to store.
3. Slide mounts provide a convenient surface for labels.
4. Slides can be projected in a slide show.
5. Color prints can be made from color-slide film.
6. Black-and-white prints can be made from color slides with an internegative.
7. It is possible to clearly see the subject by holding a slide up to light. (You must

make a print from color-negative film in order to see the subject clearly.)

We feel that color-slide film is very close to universal film. It can be all things for all people and there is virtually no compromise on quality. Color-print film (color negative) can also achieve these goals, but for certain functions, such as making slides and black-and-white prints, the quality is not adequate. There are two basic types of color-slide films in 35mm. These are the widely used Kodachrome dye structure film, and Ektachrome and Fujichrome grain structure film. (The difference between these two types of film would probably be hard for you to see until the first time you get some of your photos blown up to poster size. Comparing the two films this way is like comparing the skin surface of two faces with a microscope. Looking at the picture shot on Kodachrome, you will see miniscule pores, if any, while the picture shot on Ektachrome and Fujichrome will have a very slight sandy graininess.) Most color-slide films are available in different ISO speed ratings, which refer to the film's sensitivity to light. Slow speed (examples: 25 ISO, 50 ISO, 64 ISO) equates with the best quality; high speed (examples: 400 ISO, 1000 ISO) will get the picture in marginal light, but quality and grain structure will suffer. Our favorite all-situation films are Fujichrome 100 and Kodachrome 200.

While some experienced photographers prefer to process their own film in their home darkrooms, let us assume that you, as a new travel writer-photographer, will have your slide film processed by some type of commercial service. This is a logical decision and even we, with our high volume of work, use a commercial service. To save money, we purchase our film through discount centers in New York City along with Kodak processing mailers. (You'll find full-page ads for these stores with 800 telephone numbers in the pages of photography magazines.) For the last few years, one of our favorites has been B&H Foto, 119 West Sev-

This sea gull was frozen in flight using a high shutter speed. Autofocus on modern cameras makes difficult action shots possible.

enteenth Street (phone 1-800-221-5662). The Kodak processing mailers are honored by the Kodalux processing plants throughout the United States (addresses are shown on the back of the mailers), and on large shoots you can arrange to have all your processed film returned to you via United Parcel Service in one batch. Kodalux can process Kodachrome, Ektachrome and Fujichrome. Quality control is quite good, and the slides are put into cardboard mounts, which we find more convenient for captioning and better for filing than the plastic mounts.

We gave up shooting black-and-white film more than fifteen years ago, because we found that we could get excellent black-and-white prints by making an internegative from the color slide. This saved us having to carry extra film and shoot with two cameras. While an internegative can be made in your own darkroom, it is a highly specialized process, and we have it done professionally in Washington, D.C., by Asman Custom Photo Service, 926 Pennsylvania Avenue, SE, 20003, or by Garrett Laboratories, 1110 Vermont Avenue, NW, Suite LL-1, 20005. (One way to find the best lab in your own city would be to ask several camera stores to recommend a quality custom lab and then choose the one most often mentioned.) A 4″×5″ internegative costs about ten dollars, and prints run a few dollars each, depending on the quantity. The preferred size of black-and-white prints is 8″×10″, and most editors like a glossy surface, although a nontextured matte is acceptable. Captions and copyright should be on a sheet of paper, slightly smaller than the print and attached to the back of the print by one edge with tape. These prints should also be protected by cardboard.

The only advantage to shooting in black-and-white comes if you have your own darkroom and can make your own prints. If you enjoy the convenience of your own darkroom, you can save a considerable amount of money by making black-and-white prints and can even make your own internegatives from color slides. Color processing of slide film can also be done in your darkroom, but mounting the individual frames by hand is time consuming and tedious.

GETTING TO KNOW YOUR CAMERA

Your goal is to use your camera as a way to visually record your travel experiences. The camera should become an extension of your eye. You don't want the mechanical aspects of the camera to obstruct the process of seeing and recording. The automatic features of modern cameras make them easy to use, but the better cameras have a variety of options and you must make some choices.

We recommend that in starting out, you put the camera on the fully automatic settings. If you have purchased a 35mm SLR (single-lens reflex), you will note that, in all probability, your camera comes with several exposure modes. These might be Program, Aperture, Shutter, and Manual. We suggest using Program for your first pictures, but you should know what these different modes can do. Some very simple cameras offer only the Program mode.

1. *Program*: Automatically selects your shutter speed and lens aperture to provide the correct exposure. The selected shutter speeds and apertures will vary depending on light conditions and lens used.

2. *Aperture*: You set the aperture of your choice and the camera automatically selects the shutter speed to provide correct exposure. This mode is used to control depth-of-field or zone of sharp focus.

3. *Shutter*: You set the shutter speed and the camera automatically selects the aperture to provide correct exposure. This mode is used when it is necessary to select a fast shutter speed to stop action, a slow shutter speed for a time exposure, or to use a specific shutter speed to synchronize with electronic flash.

4. *Manual*: In this mode you set both shutter speed and aperture. With some cameras there will be a "correct exposure" indication in the viewfinder when you have the right combination.

We rarely use the Manual mode on our cameras because we can achieve the creative control we need with the other three modes and still have the full advantage of automatic exposure. Our cameras, like most SLRs, are each equipped with a plus (+) and minus (-) exposure control setting which allows for over- and underexposures when desired. When a camera does not have a specific exposure control, this can also be adjusted by manually changing the ISO setting. As we have mentioned earlier, most modern cameras set the ISO or film speed rating through a bar code on the film cartridge, but the over-under control or the manual ISO setting lets you expose according to your personal taste. (This is more easily understood if you will look at some past photos. Are the colors a little washed out? The sky rather pale? Now look at the illustrations in *National Geographic* magazine. Do you see how deep and saturated all the colors are in those pictures?) When using color-slide film, we like to underexpose by about a half stop on all of our cameras for richer, better color saturation. If you have never tested your particular camera, look at item 6 in the section called "Your First Pictures," on the next page.

In Control

Cameras come with electronic controls, manual controls, or a combination. Manual controls are set by hand, while electronic controls are set by pushing buttons to change a digital readout on top of the camera. The readout will show ISO rating, shutter speed, and aperture.

Your camera is probably equipped with autofocus, a feature that we consider a real advantage. Autofocus allows you to point at a subject and let the camera focus as you press the shutter button. A small rectangle in the center of your viewfinder is the active area for focusing and that rectangle must be on your subject. When using a camera with autofocus, you'll actually see the camera snap into focus as you press lightly on the shutter button. When you press harder, the

shutter will open and close. It is not possible to use autofocus on some subjects without sharp lines, such as diffused clouds or flat walls without a pattern or design. In these circumstances, you will need to switch to manual focus. For some of us it is painful to admit that a camera can focus more quickly and accurately than we ourselves can, but believe us when we say this is true. If the autofocus feature can be turned off and on with your camera, make sure it's on, and you're ready to go.

Your First Pictures

Please bear with us if you already have a camera and know how to use it. The first part of this section is for the beginner, but as we progress, there is useful information for the practicing photographer as well. We will offer many professional tips for getting better pictures as you travel.

Once again, we will assume that you have just put your first roll of film in your new camera and are ready to shoot. These first pictures may be taken in your own backyard, downtown in a park, or at a children's petting zoo. The principles for taking good pictures are the same anywhere in the world. We would like to suggest some basic guidelines for this first roll of film.

1. Keep your pictures simple, with a clean composition. Be aware of graphic designs in everyday scenes around you. Crop in the camera; that is, make sure peripheral things you don't want in your final picture (that half a body on the left, the trash can on the right) are not in your frame when you push the shutter button.
2. Shoot both people and buildings. A portrait of a city is incomplete without the people who inhabit it. The buildings are a cultural manifestation. People bring in the human element.
3. Avoid cluttered, confusing backgrounds. Busy backgrounds are distracting and will lessen the strength of your composition. Drop down and take the picture against the sky. If the sky is very bright,

try $+\frac{1}{2}$ exposure so the subject in the foreground doesn't become a silhouette. Some other simple backgrounds are water, a plain wall, and the green expanse of a lawn.

4. Take this first roll on a sunny day with the light behind you. You can experiment more with light when you feel comfortable with your camera.
5. Move in close to your subject. Nearer is almost always better, unless you are trying to impress the viewer with a sweeping landscape.
6. Try one subject with the exposure set on one-half over and with one-half stop under ($+\frac{1}{2}$ and $-\frac{1}{2}$); this is called *bracketing*. Be sure to turn the knob back to 0 when you are finished experimenting. At night, you bracket to make sure that you have one shot that is the perfect exposure. Right now, you need to determine on which setting your camera is going to give you the color saturation you want.

Getting Your Film Developed

Have your film processed by a dependable lab in your area. We suggest that you avoid the fast-service labs in favor of a lab that devotes more time and care to developing your film. Evaluate the results by looking at the slides in a viewer or projecting them on a screen. We like the Agfascop 200 as a viewer and favor the Kodak Carousel as a projector. We consider the viewer a more accurate way to evaluate exposure, but it is both fun and impressive to project your slides in a large size. In case you don't have a screen, a white wall will do nicely.

With this first roll, you need to decide if you like the exposure. If most of the pictures are too dark or too light for your taste, look at the shots you made at one-half stop underexposure and one-half stop overexposure. Pick the one you like best and use that setting for your normal shooting. Editors tend to like pictures with deep color saturation, i.e. slightly underexposed. Also look at your composition. How could you have

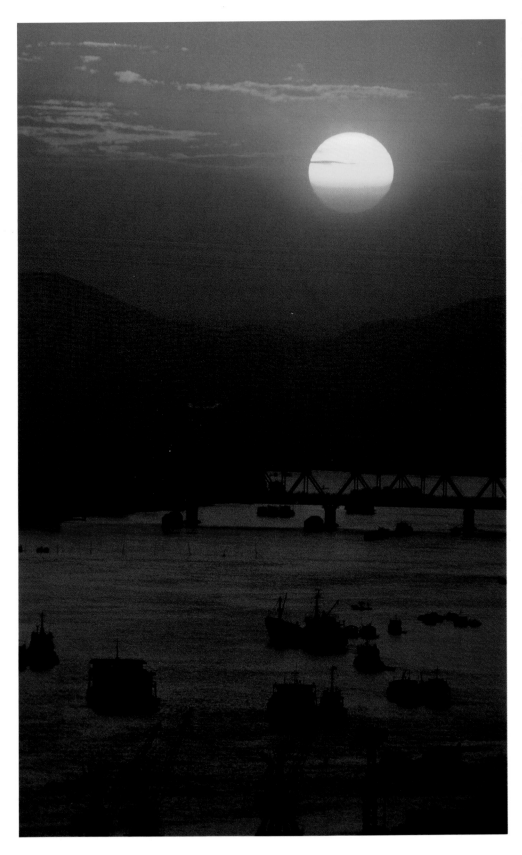

Try to start a series of evening photos while there is still ambient light in the sky. Using a tripod and leaving the camera on Program will give you good pictures even after the light situation becomes marginal. This photo of the Pearl River in Guangzhou, China (formerly Canton) was taken from our room in the White Swan Hotel.

We took this picture of the fruits and vegetables in the Nairobi, Kenya, city market from a balcony above the main hall. The display of fresh food created a patchwork quilt of textures and colors. The figure of the man adds human interest and scale.

improved the pictures you took? Is there a good sense of design? Color? Shouldn't you have turned that figure to face into the picture instead of out of the frame? Is the background right for the subject? Did you frame, or crop, the picture correctly in the camera?

After you carefully evaluate these slides, it's time to go out to shoot another roll, and this time you'll be imagining the finished pictures as you are pushing the shutter button. Your goal is to come home with slides that match the pictures you were composing in your mind when you took them.

SHOOTING TRAVEL PICTURES

Once you've shot a few rolls of film, feel comfortable with your camera, and know

what it can do, you're ready to really start using it as a creative tool. You're trying to capture what you see and, to some degree, what you feel on film. You must be aware of the quality of light. What happens to sunlight when it dances on the surface of water? How does light create a halo of gold in a girl's hair? Why does the setting sun turn the evening sky into a painter's canvas?

You need to see the world through the viewfinder of your camera, to create each composition in terms of that frame. Make the elements of a picture work together to tell a story or to please the eye. Sometimes you will want your pictures to be bold and graphic like a poster; at other times they should be subtle like a pastel drawing. Photography is a versatile medium for creating

images, but it is your eye and your imagination that will translate what you see onto the emulsion of the film. We are convinced that you will find it simple to take pictures with a modern, automated camera. As you get into photography, we hope you will share our passion for making images. Even with automatic cameras, there is much to learn about the art of photography.

What makes a good travel picture? Travel photography is difficult to define, but your goal should be to produce images that create a sense of place. You should provide a visual interpretation of a travel destination and give the viewer the vicarious experience of being there.

Obviously different picture editors and art directors have their preferences in photographic style, but we strongly believe that the first critic you must satisfy is yourself. Some photographers take travel pictures that are all style and no substance. (For instance, the picture of a sea gull's eye would not illustrate an article on Seattle, Washington.) You will want to achieve a balance between the two. (In the previous example, you might try a sea gull sitting on a coil of rope in the right foreground, with a fishing boat and its nets in the left background.)

The Marriage of Words and Pictures

Your obvious goal is to take pictures that will serve to illustrate your travel stories. As the writer, you have a big advantage, since you can take pictures of the specific people and places you intend to cover in your article. If an editor had to assign another photographer to take pictures after your story was written, it would be very difficult for that photographer to visually reconstruct your experiences. If the editor went to a photography stock agency to find pictures for your story, it would be even more difficult. The editor would be forced to choose generic pictures of the destination, losing a vital link between pictures and text. As a writer-photographer, you have the best of all worlds. You've got a package of words

and pictures to supply to busy editors. In fact, we know some editors who look at the pictures first, and, if they like them, will read the story.

If you interview a smiling barmaid at the Hofbrauhaus in Munich during Oktoberfest, you should take a picture of her holding a tray of foaming beer mugs. Quote her in the article and include her picture with the story. If you write a story about bass fishing in Canada, you'll want to include a picture of the airplane on pontoons that delivered you to your fishing site. The picture of your spouse in his or her scuba diving gear will make a good illustration for the story you plan to write about learning to dive at a Caribbean resort. Never forget that you, as the writer, can take the most appropriate pictures for your story. By the way, for editorial use, as in the examples above, you wouldn't need a model release. We get one anyway because we intend eventually to put all photos in our stock file so that they can get out there and earn their living.

Traveling With Your Camera

In order to take photos for your article, you need to get your camera there and back again, safely. There are many cases available for carrying cameras, but we prefer camera bags that are lightweight and durable. One of the best we've found is the partitioned Domke bag, designed by a professional photojournalist and available in most camera stores. While the Domke bag comes in different sizes, even the largest will fit easily under an airline seat or in the overhead compartment. When actually shooting, some photographers like to wear a jacket or vest with many pockets for holding film, lenses, and other accessories.

To insure our cameras while we travel, we have added a floater policy to our homeowner's insurance. We are also very careful not to advertise that we have lots of valuable equipment. In a hotel lobby, our cameras will be in the bags, not around our necks. When we get to our room, we unpack our

Safari

As camera safari leaders, we have been to East Africa more than a dozen times and have written about Kenya and Tanzania many times. It is one of our favorite parts of the world, and we have taken thousands of pictures of the animals, people and geography. We have used these pictures to illustrate our own articles and to fill stock picture requests for magazines, newspapers, textbooks and calendars. We return each year, leading groups of photographers on field seminars during which we teach photographic technique and picture story marketing.

(Right.) Getting close to the natives of East Africa is not easy, but under some circumstances it is possible. We took this stunning portrait of a young Masai girl at a dance ceremony. We were struck by the simple graphic quality of her brown skin and the vivid color of decorative beads. The silver chain draped across her face was a perfect touch.

(Far left.) The sun rises over the Mara, a dusty orange globe in the arms of an acacia thorn tree. We accentuated the size of the sun by using a 200mm telephoto lens.

(Left.) We posed for this self-portrait in front of the campfire at Governor's Camp in Kenya. The picture was taken just at dusk while there was still some ambient light in the sky. We took three exposures on the automatic setting, but bracketed with one stop over and one stop under. In many ways, we feel this picture captures the romance of Africa and the sense of adventure that every traveler feels about a safari.

These cheetahs stopped for a cool drink at a pool of water on the Masai Mara and unknowingly posed for a picture. It is often interesting to show wild animals involved in their lives and not only reacting to the presence of the camera. An amber filter was used to give the picture a golden tone.

clothes and put them on closet shelves. Then we put our camera bags into our hard-sided suitcases with combination locks. When we leave the room, we turn the TV on with the volume at a low level, and we leave a Do Not Disturb sign outside our door. It's not foolproof, but it has worked for us in more than four million miles of traveling.

While we have never tried to recommend luggage, we should mention the new Samsonite Carry-on Piggyback. It is small enough to be carried on the plane, large enough for your camera bag, film, small tripod and word processor, and, with its wheels and pull-out extendor handle, it converts into a luggage cart. We've seen other writers using the full-size Piggyback suitcases, but we haven't tried one yet. Our requirement for any suitcase is that it must have wheels, be hard-sided, and have a sturdy combination lock.

Will X Rays Harm Your Film? Many professional photographers have become concerned about whether the X-ray machines at security checkpoints in airports can damage their film, both exposed and unexposed. X rays can damage your film, but they probably won't if the ISO rating of your film is under 400. Within the U.S., you have the right to request hand inspection of your film, but it should be in a clear plastic bag, out of the boxes, and out of the black plastic cannisters. Overseas, there is no guarantee that security guards will not put your film through the X-ray machine, but one pass through a low-dosage machine usually won't damage your film. Be aware, however, that exposure to X rays is cumulative, and if your film goes through six checkpoints on a long trip, your pictures will probably be fogged. A solution is to remove your film from the plastic cannisters, put them in clear plastic bags, and place them inside SIMA heavy-duty lead foil bags, which can be purchased at camera stores.

Breaking the People Barrier

One of the major problems for the novice photographer is overcoming the "people barrier," that psychological roadblock which makes it difficult to approach a stranger and take his or her picture. It is even more difficult in foreign countries where you can't communicate with your potential subject due to the difference in language.

Many photographers have the misconception that most people don't like to have their pictures taken. We must destroy this myth. The fact is that most people love to pose for pictures. That you're interested enough in a person to want their picture, possibly for publication, is flattering. We are quick to acknowledge that there are some countries and some cultures where, for various reasons, people have strong objections to being photographed, and you should respect their wishes. (You might even be in danger, for example, trying to photograph a woman in a Muslim country. You would also be offensive if you tried to photograph the Amish in Pennsylvania. Learn to smile and walk away if someone is not willing to be photographed.) We want to stress, however, that even in these difficult areas, it is possible to get people pictures with tact and sensitivity.

People pictures fall into two broad categories:

1. Posed situations where your subject is aware of the camera.
2. Candid situations or taking a picture of a subject who is unaware of the camera.

Posed Pictures. Most pictures you take of people will fall into this first category. Usually you will communicate with your subject and have his or her verbal or tacit agreement for you to take the picture. The subject will often agree to pose in the manner you wish. In some cases you may prefer him to continue with the work or activity in which he is involved. It is better, for the purposes of illustrating a travel article, to have a Greek fisherman mending his nets rather than smiling and looking straight at the camera. This may require some modest direction on your part, but even when you can't speak Greek, you can indicate what you want and

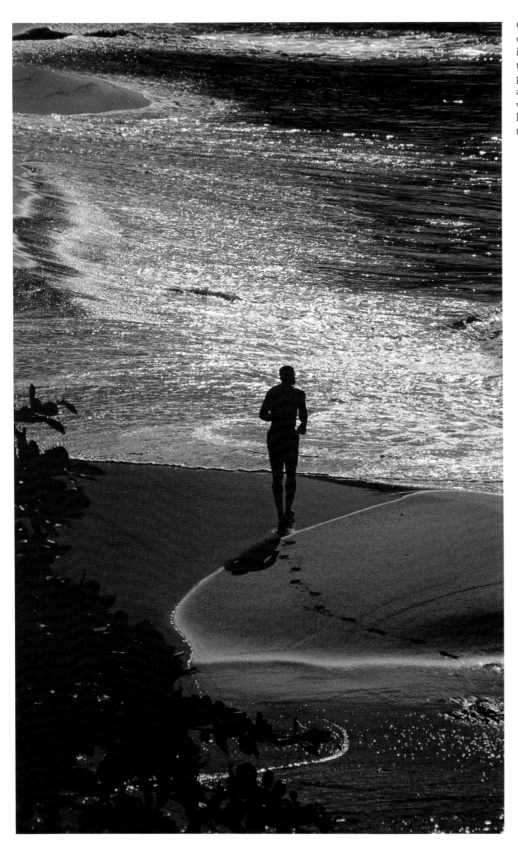

One of the pleasures offered by an island beach is solitude. We captured this elusive feeling in this picture of a man running along the edge of the water. Strong back lighting added drama to the image.

need. Most people understand when you hold up your camera inquiringly. A warm smile is worth a hundred words. If you gesture enthusiastically to the hands of the fisherman, he will understand that you want to do a close-up of his knots and it will be with some pride that he will fall back to work.

We would not necessarily discourage you from taking pictures of people looking directly at the camera. Such portraits, depending on the interest of your subject, can be very strong and compelling, especially when they are shot at close range. With a good lens, you can see every detail, the color of the eyes and the creases in the skin. Also be aware that you can get other interesting and usable pictures by pulling back to include the head and shoulders. This might even show some aspects of the person's clothing. Pull back even further and you show your subject in the setting. You may have created an environmental portrait, perhaps a Masai warrior on the vast plain of the Serengeti or a Buddhist monk in a Thai temple. The fascinating aspect of travel photography is that it offers almost unlimited creative options.

The Candid Picture. There are many ways to take candid pictures of people. Candids are most often associated with zoom telephoto lenses, which allow you to stand back and photograph people from a distance. You can also take candid pictures by shooting at waist level without bringing the camera up to your eye or by putting the camera on the flat surface of a table in a restaurant and taking a picture of the couple sitting at the next table. Candid photography is the art of taking pictures without letting people know that you are doing it. And an art form it is. No matter how relaxed a person pretends to be in front of a camera, there will still be a stiffness in any formal portrait that will be missing in a candid photo. Children, especially when they are too young to understand cameras, are delightfully natural

when they are preoccupied with their environment and oblivious of your presence.

Selecting the Single Picture

If an article is to be illustrated by a single picture, a primary requirement of that picture is to visually inform the reader where it was taken. Many travel editors want pictures of famous landmarks to illustrate their stories. Such a picture clearly identifies the city being featured in the story. A clear shot of a famous landmark may not be the most creative picture you can take, but it often fills the need of the travel editor.

Another concept for a single picture could be a person dressed in a manner unique to the country you are writing about. This could be a Japanese woman in a kimono, a man in Germany wearing the traditional leather lederhosen, or a native American in a feathered headdress. Such predictable pictures also help to establish the setting for the article. Unfortunately, these pictures—both of people in native dress and of landmarks—perpetuate the visual clichés connected with people and countries, but we have found that such pictures sell.

The hints you've been given here for successful photography are necessarily limited, given the space available for the subject in this book. We describe in greater depth various professional methods for photographic success in *The Traveling Photographer*, our book published by Amphoto and available through bookstores and camera stores.

We have always believed that many professional photographers make a big to-do about hiding their secrets for taking great photos because they feel threatened. Our personal belief is that any person with the insatiable curiosity of the true traveler and the sharp, inquisitive eyes of a child will be able to capture a memorable image with a minimum of technical know-how and a modern camera with automatic capabilities.

On assignment for the Irish Tourist Board, we used models to portray the equestrian pleasures of Ireland. The trick in using models for travel photography is to make the pictures "believable." Our technique is to have the models actually engage in the activity we wish to depict.

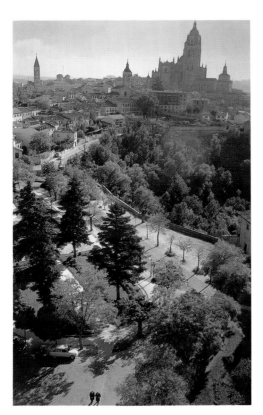

To capture the ancient city of Segovia, Spain, we climbed to the ramparts of Ferdinand and Isabella's castle. The two black-clad figures at the bottom of the picture add scale to the scene. It would have been tempting to take pictures only of the castle, but we are glad we glanced back at the city from atop the castle to find this memorable scene.

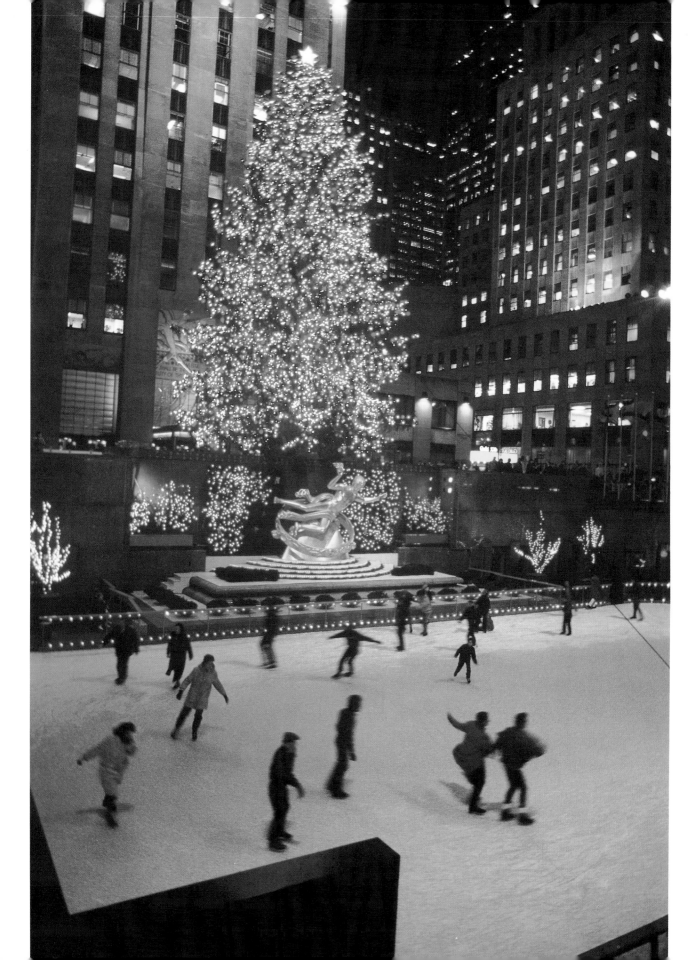

Marketing Your Work

Professional writers often get assignments simply on the basis of an idea. They query the editor; the editor gives the go-ahead; and the writer makes a sale before writing a word.

A beginner, however, doesn't have the track record or the reputation of the pro, let alone the relationship established by working with the editor over time. If you're a beginner, you will need to prove yourself. To do that, you must write complete travel articles and submit them "on speculation" ("on spec"). In a nutshell, this means that you write the articles, hoping that editors will be interested in your work, but you understand that no editor is obligated to buy.

THE SUBMISSION PROCESS

The first rule of manuscript submission is to know your market. This means that you need to be very familiar with the publication, to know it so well that you have a sense for the kind of articles the editor needs. For instance, you wouldn't send an article on hunting to *National Wildlife*, a magazine that stresses conservation and the protection of endangered species. Don't send an article about vacations geared for people in their twenties to *Modern Maturity*. These may sound like ridiculous examples, but you'd be surprised how often amateurs make this kind of mistake. Do your homework to avoid embarrassment.

Traditionally, you can send packages to most newspapers with a cover letter, but magazines should be queried before you send anything. In real life, we have found that it is helpful to query by phone before sending to either newspapers or magazines. Your newspaper article might not even be read if you haven't laid the groundwork and aroused the editor's interest. Don't feel that disinterest is personal; think about what an editor's office is like. The pile of manila envelopes on the floor that is closest to the editor's legs and towers about three feet above the desk is probably submissions from the morning's mail.

Obviously, your cover letter is extremely important. It should be brief and to the point, explaining what your article is about and why it will be interesting to the readers of the publication. Mention that you've enclosed some sample photographs and that more are available. Be sure to send SASE (with a self-addressed and stamped envelope) if you want any part of your submission back. If you have recently been to several places, you may want to include an additional sentence: "Stories on (subjects) are also available." That way, if you coincidentally send a cruise article two weeks after an editor did his annual cruise section (out on first base here!), but you also suggest a story on swimming with dolphins, the editor's favorite creatures, there is a chance that the editor will be calling you to see the dolphin article (home run!).

The letter should be written to a specific editor of a specific publication; never photocopy a "Dear editor" form letter; this makes you look lazy and guarantees that your package will meet the inside of a waste-

Some pictures are "destination specific"; others are generic and can be used to illustrate concepts or themes. This scene at Rockefeller Center in New York City is "destination specific." While it can be used to illustrate a travel story on Manhattan or Rockefeller Center, it cannot really serve other purposes. It is also worth noting that the picture is "season specific" and best used for a winter or Christmas story.

This yawning lioness in Kenya is also a generic shot of a lioness. It could have been taken anywhere in Africa. The animals of Africa are often generic within a species.

basket. You can find the names of the current newspaper editors in the *Editor & Publisher Yearbook*; magazine editors are listed in the travel periodical section of *Writer's Market*. (More on this later in this chapter.)

If you have a computer, you can create a form letter with specific addresses and salutations and with a friendly note within the body of the letter, to give it that personal touch.

After you've written for a publication several times, i.e., established a working relationship, you'll be able to compose the kind of letter that we now send to most of our editors. It says that we would like to suggest various subjects and destinations for travel stories. An asterisk indicates the places on which we already have pictures and the current information needed to write an article. The others are places we have the opportunity to cover in the future. We may then give a list of titillating titles, followed by the sentence, "If any of these one-line ideas intrigue you, we can provide you with an illustrated story or a proposal." We are less informal with editors we don't know. Because they don't know us or our writing style, they need more description and we need to pique

their interest. We may send them a few photocopies of our best published stories. In a proposal to write an article on aerial photography, for example, we wrote, "The adventures we have are well worth telling. For instance, on a recent assignment on water sports in the Caribbean, we took a camera aloft while parasailing and accidentally dipped two cameras in salt water, but the resulting picture was worth the loss. We hooked a camera to the wingtip of a glider to record ourselves soaring over the Virginia countryside, and we've carried a camera with us on a hang glider over Rio. We have repeatedly covered the Albuquerque Hot Air Balloon Fiesta and, in one instance, fastened a special camera harness to the rim of the nylon envelope to photograph ourselves in the basket. As your publication always says, the proof is in the pictures, and we have them to document our adventures."

Submitting Photos With Your Story

The process of submitting pictures with your travel articles is simple on one hand and complex on the other. You would normally send an editor either color slides or

black-and-white prints. (As mentioned earlier, we have black-and-white prints made from our color slides by a local custom lab.) You must be very careful, however, in submitting original color slides to an editor. Originals are very valuable; the American Society of Magazine Photographers places an estimated value of $1,500 on each original slide, based on an average probable earning power over the lifetime of a top-quality professional slide. (When a case like this goes to court, the ruling is usually in favor of the photographer if he or she can produce records showing that the slide in question is unique and has money-earning potential.) Therefore, never send unsolicited original color slides to an editor or art director without approval in advance. High-quality duplicates can be submitted without prior approval, but you will have to include a self-addressed, stamped envelope for their return if you want them back. Original color

slides should be accompanied by a delivery memo stating the $1,500 value in case of loss or damage.

In many instances a publisher or a magazine carries insurance to cover the loss or damage to originals, but even in these cases some editors will go into litigation rather than pay a large claim. Nevertheless, publishers often don't want to use 35mm dupes when making their color separations for a high-quality book. For long deadline book projects, one viable solution is to use repro-quality 70mm duplicates for reproduction. (These are shot on 35mm and duplicated on 70mm Ektachrome duping film.) The photographs used to illustrate this book were reproduced from 70mm dupes. Noted photographer Galen Rowell also used 70mm dupes for his coffee-table book *Mountain Light*, published by the Sierra Club.

There are very few places in the U.S. that have the high-quality duping process mas-

The Tower Bridge of London is a famous, historical landmark. We took this late afternoon shot from the Embankment of the Thames when the light had a shimmering golden quality. The silhouetted towers are reflected on the surface of the water.

Even people can be "destination specific." This Indian woman stands in a rice paddy during harvest time in central India, her scythe resting on her shoulder. She could be seen as a symbol of the eternal struggle of this huge country to feed its burgeoning population.

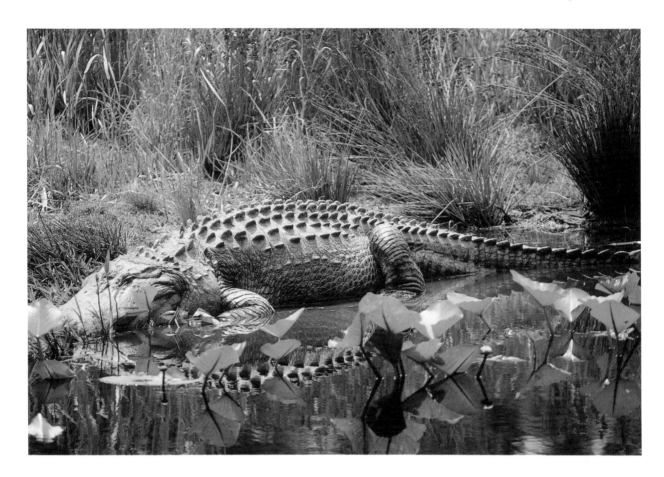

tered. We have our 70mms made by Repro Images, Inc., 243 Church Street, NW, Vienna, Virginia 22180 (phone 1-800-783-DUPE). The cost of a 2¼″ × 3¼″ 70mm duplicate is about $2.50 in quantities of five or more from each original, with a minimum order of $500. This company, which has been on the cutting edge of duping technology, also makes 35mm dupes. High-quality dupes are also useful to the travel writer for multiple submission of color to newspapers.

Whether you are sending out dupes or originals, the caption information, credit lines, and copyright should be printed directly on the slide mounts or printed on self-adhesive labels that can be attached to the mounts. Some computer software programs have been designed for printing slide labels, and you should look in your photo-supply catalog to see if one of these programs has been written for your computer. Insert slides you are mailing in clear plastic sheets with individual pockets, which are available at most camera stores. Protect the manuscript and slide sleeves with pieces of cardboard cut to the proper size and inserted in a strong manila envelope with a metal clasp. We provide the added protection of filament tape over the clasp. Unsolicited pictures and manuscripts should always be accompanied by a self-addressed, stamped envelope. We also include a self-addressed postcard so that it is easy for the editor to let us know if he or she wants to hold the article for possible use in the future. The postcard will have statements on the back that the editor can merely check off, for example:

☐ Yes, we plan to use this article and these pictures.
☐ No, we cannot use this story.
☐ We can't use this story now, but would like to keep it for possible future use.

This picture from the Okefenokee Swamp in Georgia can serve as a generic picture of an alligator. It could also be used to depict an alligator in the Florida Everglades or other locations in the southeastern United States. Take care not to use it to represent a crocodile, which is a very different reptile with a different appearance.

☐ We would like to see more photos to go with this story.

Finally, we use a colorful, self-adhesive mailing label with the image of a stylized camera in one corner and our return address. We also stamp the outside envelope with a large rubber stamp that says PHOTOS – DO NOT BEND.

These are the basics of manuscript submission and apply to both newspaper and magazine markets. For the rest of this chapter, we'll look at these specific markets in detail.

SELLING TO NEWSPAPER MARKETS

Almost all major newspapers have travel sections with advertising; many of these sections have a travel editor. Smaller papers may have feature or Sunday editors, but for simplicity we will call them all travel editors. Newspapers' travel sections are not known for their generosity in paying freelancers, but they do pay and they do offer a potential market for your stories. Partly due to networking between travel editors, the newspaper travel market has been changing recently. If Editor B has done a story about a trip to China, he may offer it at little or no charge to Editor C in exchange for his story on Egypt. This makes sense. It means good stories at little cost. This is the old-boy network of "you scratch my back and I'll scratch yours."

Naturally such arrangements are displeasing to the freelance travel writer and even to the syndicates and wire services, but they represent a practice that is not likely to go away. As a freelancer, this means you have to compete with the very editors who might buy your stories. In addition, you have to compete with the syndicates and the wire services.

Don't throw up your hands in despair. Newspaper travel editors still publish well-written, well-illustrated stories done by freelance writers. These suggestions will help get your stories published in newspapers:

1. Pick an interesting subject in a popular destination.
2. Keep your stories short (under 1,000 words).
3. Include high-quality photographs.
4. Enclose SASE.
5. Follow up with a phone call in about four weeks.

The Personal Touch

Personal contact can be important and helpful, but remember that travel editors are often overworked and almost always fighting deadlines. You can contact the travel editor of your local newspaper by phone and briefly describe the subject of your story. In most cases, however, it is better to mail the query letter, particularly as editors of big newspapers usually work with at least a four-month lead time and are often irritated by phone calls from writers they don't know. They obviously cannot commit space in their travel section to you if they've never seen evidence of your writing skills. Even with a small paper, the editor will usually ask you to mail in a query letter or a finished manuscript. If the editor agrees to meet with you, consider that a stroke of luck and make every effort to create a good impression. Try to find out what that travel editor wants and needs. To some extent, you can do this ahead of time by reading past travel sections in the files of your local library, but don't hesitate to ask about preferred style and approach. Some newspapers have special sections on such topics as Europe, cruises, or winter sports. If possible, find out when these sections will be published and the deadlines. Articles are often purchased or assigned months in advance.

Of course, the primary purpose of your visit is to sell the most recent travel story you have written (hopefully it will fit the needs of the editor). Don't waste time by talking about the virtues of your article; let your story and pictures speak for themselves. Have some ideas for other articles on hand, as well. You can often leave an office

with an assignment even if the travel story you took in was inappropriate for some reason.

The editor may or may not be able to use your article, but if he or she chooses not to, don't be discouraged. Mail it to another newspaper in another city. If your travel article is good, it will eventually sell, and you will have taken the first step in becoming a bona fide travel writer.

On your first few attempts, we suggest that you let the editor set the rate of payment. After a couple of sales to one paper, there may be room for negotiation. Some new writers, eager for publication, offer their travel stories free of charge. You should never be guilty of this serious mistake. It sends a clear message to the editor that you consider your work to be worth absolutely nothing.

The inevitable question arises. How much

will a newspaper pay for a travel story? This depends on many factors, including the travel section budget, length of story, and number of pictures used; but the final factor is how much you're willing to take for your story. On a first sale to a new paper, we suggest you accept their offer unless it is simply too low. For instance, $25 won't even cover your postage, telephone calls, envelopes, and other expenses. Even small papers usually pay at least $50 and often as much as $100 for a travel story. That doesn't seem like much, but if you sell that story to twenty-five newspapers, you're going to make a decent profit for your talent and effort.

Multiply Your Sales Potential

Be aware that you can make multiple submissions of a particular travel article to different newspapers all over the country. The

The portrait of Mao still hangs ominously over the entrance to the Forbidden City in Beijing's Tian'anmen Square. This giant square will live in infamy after the student massacre of 1989. Partly due to this tragic event, this image—taken the previous year—becomes a more valuable stock picture. It not only depicts the square, but becomes a symbol of the suppression of democracy in China.

While this architectural detail is very graphic in quality, it was taken on the Greek island of Mykonos and is a specific location. It could be used as a theme picture on Greece, such as the cover of a travel brochure. It should not be used, however, to depict any specific location other than Mykonos.

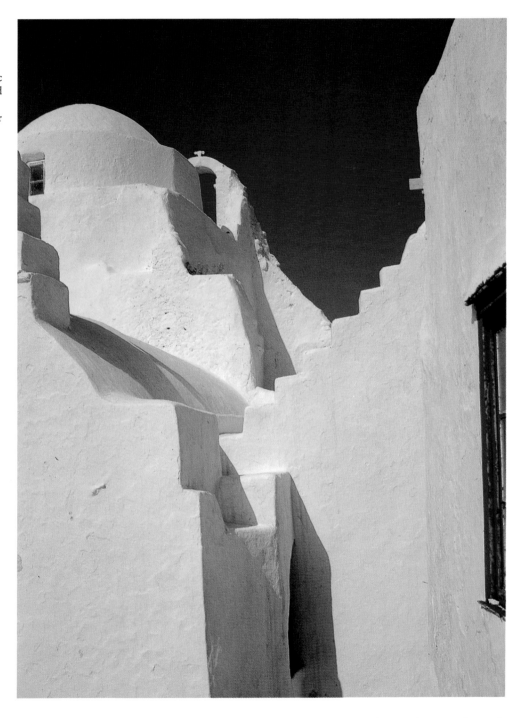

article can even be submitted abroad with minor revisions, but it is important that you do not send the same story to two newspapers whose circulation overlaps! Obviously it would be embarrassing and professionally damaging to you if the same article should happen to appear in two competing newspapers. For instance, if you submit to the *Dallas Times Herald*, do not submit the same story to the *Dallas Morning News* until and unless the story has been rejected by the *Dallas Times Herald*. If a story is rejected by the *Chicago Tribune*, then it can safely be submitted to the *Chicago Sun Times*. Some

writers keep a flow chart of their submitted articles that indicates which articles have been submitted to which papers, which papers are holding a story for possible use, and records acceptance and payment or rejection and return. This can be done on an office chart, in a loose-leaf notebook, or in a computer. We recently started keeping our newspaper clients in a data-base file in our computer. This enables us to quickly find out who has a particular story and its current status. It also stores useful information about travel editors. We can tell at a glance if a particular editor buys freelance stories, is overstocked, wishes to be queried, has a preference of style, wants an SASE with submissions, gives assignments, etc.

Please realize that you'll have to be persistent in order to make sales. For instance, expect to submit to forty or fifty newspapers to get ten acceptances. You're going to have to develop a thick skin, obviously, because rejection goes with the territory. But although writing for newspaper travel sections is not a way to get rich, it is one of the best ways to get started and establish your name.

Dealing With Newspaper Editors

As we mentioned earlier in the chapter, you should always address an editor by name. The most dependable guide for newspapers in North America is the *Editor & Publisher Yearbook*, which lists newspapers according to state, city and circulation. The listing also provides the name of the travel editor if there is one. You can often find this yearbook at your local library or you can order one directly for seventy dollars from *Editor & Publisher*, 11 West Nineteenth St., New York, New York 10011 (phone 212-675-4380).

Another good resource book is *Travel Writer's Market* by Elaine O'Gara published by Harvard Common Press in 1989. This is a comprehensive market survey that includes magazines and newspapers, listing travel editors, rate of pay, picture needs, publication policies, etc. This book is periodically revised and updated.

One of the problems facing a freelancer submitting articles to newspapers is the lack of response from travel editors. Most travel editors have the responsibility of traveling, writing, editing and layout, and they usually work alone without any secretarial support. It is little wonder they find it difficult to respond to the hundreds of queries and manuscripts they receive every week. Mim Swartz, travel editor of the *Rocky Mountain News*, puts it very succinctly: "Our paper is flooded by unsolicited travel articles and pictures, and I have no clerical help to even open and screen these submissions. A self-addressed stamped envelope must be included if a writer wants his or her material returned."

In 1924, Ring Lardner wrote a book on *How to Write Short Stories*. He stated that "A good many young writers make the mistake of enclosing a stamped, self-addressed envelope, big enough for a manuscript to come back in. This is too much of a temptation to the editor." Mr. Lardner's tongue-in-cheek comment has an element of truth to it. If you don't actually want the photocopy of your article back, don't send an SASE. If that copy of your story sits around on the editor's desk long enough, someday he or she may pick it up and publish it. On the other hand, if you have enclosed unsolicited color slides or costly black-and-white prints, by all means include an SASE. From the standpoint of economics, including SASEs can be costly, especially when you're making multiple submissions. We have found that if an editor knows us and knows our work, he or she is usually willing to send back our stories and pictures at the newspaper's cost. There are a few exceptions, such as the *Rocky Mountain News*, and we have noted these in our computer.

If there is any single tool that can help you succeed as a travel writer in the newspaper market, it is the telephone. Long-distance calls cost money, but they can also make you money. We have explained that most travel

editors are not anxious to talk to writers whose work they don't know; this is understandable, but once an editor has published your work, a relationship has been established. It can save you time and effort to check with an editor on a particular subject. For instance, we know that the *Chicago Tribune* is not interested in travel stories on Japan because they have a correspondent stationed in Tokyo who provides them with travel stories on that country. You may learn that another editor doesn't like travel stories written in the first person. Possibly you'll learn that one editor likes humor, another editor likes negative reporting, and still another wants detailed reporting on hotels. Such information should be entered in your logbook or computer. It can save you considerable time and money.

Joining the Computer Age

Initially newspaper travel editors must be approached by mail or on the phone, but once they get to know you and like your work, they often prefer to have your articles transmitted via modem from your computer to theirs. This saves them having to retype your story into their system. Transmitting by modem sounds complicated. You need to talk with someone in the newspaper computer room (recommended by the travel editor) who is familiar with their system. They will give you the parameters of their system and you can set and save these parameters under the name of that paper on your disk. They will also give you a "slug" line and the editor to which it will go. In some cases, it will be necessary to put a computer code symbol at the end of each paragraph. When getting ready to transmit a story, turn on your modem, call up the relevant parameters, open your text file, and dial the number for the newspaper computer. With some software, you'll actually see your story appear line by line on your screen as it flies over the telephone lines. At the end of the transmission a message will appear on your screen: "Transmission Successful." Nevertheless, it is wise to call the newspaper computer room to make sure that the file has been received without being garbled. You have now entered the age of electronic publishing.

Making Your Own Breaks

Hopefully you will establish a friendship with your travel editors. They will look forward to hearing from you if they know you produce good stories and can meet deadlines. The key to success is quality, service, speed and dependability.

If you do your homework, you may find opportunities beyond your wildest dreams. For instance, travel writer Victor Block of Washington, D.C., noted that the *Washington Times* did not have a travel editor. He approached the *Times* with a suggestion of writing a weekly column on travel, and he established a regular market for himself. Victor has found outlets for this same column in other cities outside of Washington.

After your articles appear in various newspapers, it is very important to start a clip book or portfolio. Most editors will automatically send you tear sheets (printed copies) of your story, but sometimes you must request them. On major stories you may want to ask for several. This is a record of your achievements as a travel writer and helps to establish your credibility as a professional. The clip book is a valuable tool for showing to editors and public relations executives in the travel industry. We suggest purchasing a large portfolio at your local office or art supply store. The larger size (about 18″ × 22″) gives you enough room to display newspaper pages and magazine layouts. Any explanatory captions can be added with printouts from a laser printer or a high-quality dot matrix printer. It is useful to make photocopies of important tear sheets and file them together. When you are trying to arrange free or reduced-rate travel or accommodations, you will need to be able to send tear sheets to show that you are a qualified, published travel writer. If you are proposing a regular column or an expen-

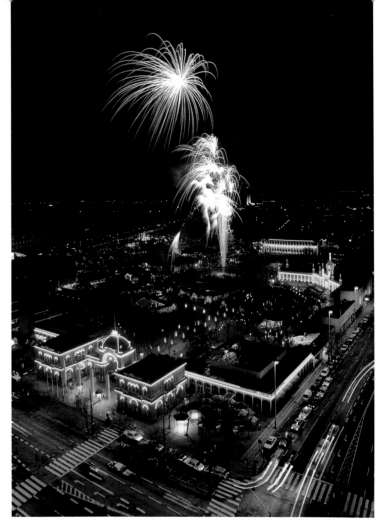

This scene of fireworks exploding over the illuminated Tivoli Gardens in Copenhagen, Denmark, is an example of coordinated time exposure, not a difficult technique when you have your camera on a solid tripod and use a cable release. Shooting from our hotel room, we set up our tripod about thirty minutes before the fireworks were scheduled to start. We used Kodachrome 64 film with an aperture of f/5.6 on the aperture priority setting, waiting to open the shutter until we saw a rocket going up. The shutter stayed open from about seven to ten seconds, giving the camera time to record the lights in the amusement park and also catch the fireworks.

sive assignment to an editor, you will have to send tear sheets to show your writing style. You will also need tear sheets when you decide to apply for membership in a writer's association. We suggest keeping all travel stories about a particular country filed under that heading in standard file cabinets. This will enable you to put your hands on any story very quickly.

SELLING TO THE MAGAZINE MARKETS

The magazine market is an enigma within an enigma. The publishing business is a volatile minefield where careers are created and destroyed overnight. Often an editor who is in charge today can be gone within a week. It is difficult for the freelancer to know and understand the machinations of what goes on within the staff of a specific magazine,

much less understand what goes on in all the major travel magazines. A freelancer may not know, for instance, that the editor-in-chief and the managing editor of a particular magazine are having a power struggle or a turf battle. If that managing editor has assigned a writer to do an article, that story may be killed or canceled at the last minute for reasons the writer may never understand. A freelance writer can spend weeks and even months cultivating a relationship with an editor, only to have that editor promoted to another position or fired.

The new travel writer will not find it easy to get published in the major magazines. We've said all along that the easiest place to get started is with a newspaper, but this is also the lowest paying market. Writing travel for a newspaper does have the advantage of establishing your credentials. Once published, new doors can open, and you

We rose before dawn to record this icy scene of Central Park from our hotel window. It captures the essence of New York on a winter morning.

hope they will be the doors to magazines.

Getting Your Foot in the Door

To be successful in writing for leading travel magazines, you'll need talent and dedication. You must be dependable, accurate and ethical. These puritanical virtues are helpful for success in any field, but the element of luck also has a lot to do with making it as a magazine travel writer.

The trick is getting a top editor to read your best writing and like it. On the surface that sounds simple. Put your best article in an envelope and mail it to the editor. Alas, in most cases, that editor will never see your article, especially if he or she isn't familiar with your name. It will either go into the circular file (wastebasket) or be returned with a form rejection slip.

Contrary to popular theory and stated policies, most travel magazines are not very open to queries. These magazines know what they want and they most often go to writers they know, respect, and have worked with before. It is occasionally possi-

ble, however, to score with an over-the-transom (unsolicited) mail submission. If you can supply a well-written article that is tailored to the needs of that specific magazine and illustrated with breathtaking photos, someone on the staff is going to take notice. Those are a lot of variables, however, so it's important to do your homework.

For instance, most magazines work at least four months in advance, which means that their December issue may be at the printer by September and could have been completely written by mid-July. Thus, if you sent your article "Christmas Skiing in Vail" to a magazine as late as October, you'd look pretty naive and it would be obvious that you don't understand how magazines operate.

Likewise, most magazines have a policy not to repeat the same subjects for two or three years; some leading magazines don't repeat for four or five years. Research your target magazine before submitting an article and don't send a subject they've covered in that period. You can check this at your local

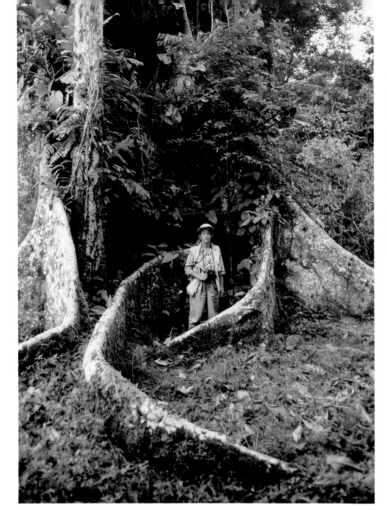

We usually use people to give a sense of scale and to be a point of interest in the photograph. Had we shot this picture without the person, it wouldn't have been a useful illustration of a rain forest. There is never strong sunlight inside a rain forest, but new, high-speed films make color photography possible even in dim light.

library via the *Reader's Guide to Periodical Literature*, or by quickly scanning the table of contents of back issues of the magazine. The *National Geographic* publishes its own index of articles.

Two of the most important tools for breaking into the magazine market are the annual books *Writer's Market* and *Photographer's Market*. These books not only provide a comprehensive listing of magazines that accept freelance articles, but they give tips on how to effectively market your articles and pictures. These *Market* books are sold in bookstores or can be ordered from Writer's Digest Books, 1507 Dana Avenue, Cincinnati, OH 45207, (800)289-0963.

How can you make sure that editors pay attention to your queries and travel articles? There is no sure way. The technology of fax machines has been abused by some writers, sending unwanted queries and even articles to magazines. Our suggestion is to send a query letter or article via standard UPS (United Parcel Service) with a return receipt requested. This flags your envelope as something of importance. Most editors will at least read something that is sent to them in this manner, and the small additional cost is well worth the investment.

Climbing Up the Magazine Market Ladder

When writing for magazines, any writer would naturally love to start at the top. *National Geographic, Travel & Leisure, Condé Nast Traveler, Travel Holiday*, and *National Geographic Traveler* are all travel magazines in which any writer would be pleased to see his work appear. We have already stressed the importance of being able to offer a magazine a package of words and pictures. This does not always hold true with some of

Westminster and Parliament with the clock tower of Big Ben symbolize the city of London. We took this night picture by setting up our tripod on the far bank of the Thames and taking a time exposure.

these top travel magazines. The editors on several magazines have a tendency to categorize a journalist as either a writer or a photographer. For five years we wrote a camera column for *Signature*. Because of the subject, the text editors thought of us as photographers. The art director and photo editor, on the other hand, thought of us as writers. If you are a person who combines both talents, it is to your advantage to convince the editors that you can do both. If we are assigned to write an article by an editor who intends to look for the photos elsewhere, he or she will find that our text will come in accompanied by top-notch pictures that are closely related to the text.

It is worth noting that many leading magazines have their own staff writers and do not accept travel articles based on free or subsidized press trips. These magazines usu-ally pay expenses for freelance writers they assign to a destination. There are many other types of magazines, however, that are receptive to good ideas for travel articles. *Woman's Day*, *Modern Maturity*, *Fifty Plus*, *Ford Times*, *Friendly Exchange*, *Smithsonian Magazine*, the AAA motoring magazines, and the in-flight airline magazines are just a few publications that provide good travel markets.

We have mentioned the advantages of using computers for record keeping. One of the most important records you can keep is a documentation of your dealings with magazines. There are many software programs that can include data with the name of the magazine, the editor, address, phone number, and a short field for comments. (Comments, for instance, might indicate that this magazine pays all travel expenses.) The final

field should include all data of queries and transactions with the magazine. This file program becomes a permanent record that allows you to look back and see what has transpired. Did you query a particular magazine on the idea about a camera safari in East Africa? Did it respond? The record allows you to review and follow up when necessary. It can also save you the embarrassment of suggesting the same idea to a magazine more than once.

Most of these file programs are also designed to type mailing labels for the editors and magazines on your list. It is vitally important to periodically make a backup disk of this information in case your hard disk crashes. (A "crash" is a malfunction that causes a loss of data.)

We also use our computer to create a list of story ideas. We target the magazines that are most appropriate for a specific idea and start circulating queries, one at a time. After an idea listing, we name the magazines that have been queried, and indicate rejection or acceptance.

Building Relationships With Editors

As you gain experience writing for the magazine markets, you'll find yourself getting to know some editors well. This can actually prove to be a major breakthrough in your career, as editors will give you assignments once they know that they can count on you for quality and timely writing.

The following is one example of how we developed a working relationship with an editor of a leading magazine. Jim Gebbie, editor of *Chevron U.S.A. Odyssey* asked Jack MacBean of the New York Convention and Visitors Bureau if he knew of any writers qualified to write an article about using a video camera to record their vacation experiences. Jack, who knew us through SATW (The Society of American Travel Writers) and from our many visits to New York, suggested our names. We wrote the article and delivered it ahead of deadline.

The relationship might have ended at that point since our article on video was very specialized, but Jim also needed an article about the Florida Keys. He called Stuart Newman in Miami who has handled the public-relations account for the Florida Keys for many years, wanting to know which writers had covered the Keys. Stuart mentioned our names among others. Our article about video was still on Jim's desk when he called us with a second assignment, this time a destination article on the Keys.

Our next assignment from Jim Gebbie came when we were attending an SATW chapter meeting in Orlando, Florida. Jim called us in our hotel room from his office in California. Could we do an article for him on the Florida Everglades? We had been to the Everglades only once during the summer and had almost been eaten alive by mosquitoes and seen little wildlife. Nevertheless, even though we were almost totally inexperienced in this particular destination, Jim trusted our work in general and gave us the assignment without hesitation. He knew that the article would be in by the deadline; it would be informative and entertaining; and it wouldn't need any rewriting. After the SATW meeting we rented a car and drove south to the Everglades. This was winter, the mosquitoes were gone and we saw an abundance of birds and animals. (See the opening excerpt in Chapter Two.) We wrote the article on our laptop computer during the ride on AMTRAK back to Washington.

A month or two later Jim called and casually asked if we had visited Spaceport USA at Cape Kennedy. We had toured that facility just before doing the Everglades story. Could we write another article on Spaceport USA?

Of course we could.

The point we want to make is that we were introduced to Jim Gebbie by other people in the travel industry who knew us and knew our work. You are often known by your reputation. It is also important to note that, in this instance, all the destina-

tions and subjects were selected by the editor. He knew what he wanted. We have suggested several other subjects, but these did not fit into his editorial plan, which obviously included a geographical balance of U.S. destinations.

Our friend James Wamsley of Richmond, Virginia, is a well-established travel writer. He says that 85 percent of his work comes from assignments initiated by editors. In addition to writing books, Jim writes for such distinguished magazines as *National Geographic Traveler* and *Architectural Digest*. When you start, it is usually just the opposite. At least 85 percent of your work will come from assignments that you propose to the editors or write on speculation.

MARKETING YOUR PICTURES

Writers who are starting in photography are often surprised when they receive more for their pictures than they do for the article they have written. We like to remember the example of a young writer who did an article for the *Ford Times* and received $500 for the text and $2,000 for the pictures, one of which was used on the cover. Of course, payment for pictures varies widely, depending on the magazine or newspaper.

So far, we have talked about pictures as a method of marketing your travel writing. You should be aware that an outstanding picture can often be much more profitable than a travel story. A cover picture on a major magazine will bring you a check for $400 and up. An inside picture, even a small one, is worth $135. Pictures for travel brochures normally run about $100, much more if the picture is used in a large size. We have dozens of calls every day from editors and art directors needing specific pictures, and we make a substantial income from filling these requests.

The problem is getting the right picture to the right editor at the right time. This requires editors and art directors knowing your name and respecting your photogra-

phy, but much more is necessary to be really successful. You must be prepared to deliver the needed picture to an editor in time to meet his or her deadline. As we deal with editors all over the country and even abroad, we make extensive use of Federal Express, UPS, and other overnight delivery services. We have two staff members, Marlene Lane and Ludwine Hall, who work with us to fill picture requests and to refile color slides when they are returned. We knew that we needed Marlene when important money-earning requests for photos were coming in regularly but we had to be out on the road just as regularly, fulfilling other money-earning travel writing or photography assignments. The rule of thumb for hiring a researcher, or office manager, is that his or her salary ideally should not exceed 25 percent of the gross income you make from your stock file and your travel writing combined.

Getting Known

As a travel writer-photographer, how do you get your name to the editors who buy pictures? One of the best ways is to type up or print a stock picture index, listing the subjects and countries you have available. (Your stock file at this point should probably include no less than 2,000 really good images.) Send this index to editors and art directors for whom you would like to work. It helps if you include a color flyer or even a tear sheet to show the quality of your photography. When these are not available, some photographers make color prints or duplicate slides to send with their picture list. If you have an extensive list and the samples of your work are good, you will probably get some calls. If you cannot fill a specific request, it pays to refer the editor to another photographer who has the subject. That photographer will probably return the favor whenever possible. If you can help your client fill a picture need, even when the picture is not one of yours, that client will come back to you with future picture re-

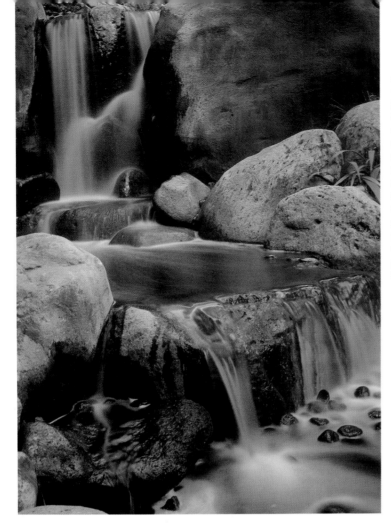

A waterfall on the island of Maui is recorded by putting the camera on a tripod and taking a time exposure of several seconds at a small aperture. The long exposure blurs the moving water to a smooth consistency, but the tripod records the rocks with needle-sharp detail. An amber-colored Cokin filter was used to give the image a golden tone.

quests.

As your work is published and seen by editors, your name will become known. It often takes years to build a reputation as a travel photographer, but the payoff can be great.

Dealing With Picture Agencies

Some writers are too busy to spend a great deal of time marketing their pictures. An alternative method is to work with stock-photo agencies who will market your photographs for you. On the surface, it doesn't sound complicated: You submit your pictures to an agency and it selects the ones it would like to have in its files. The agency sells rights to reproduce these pictures to its clients, and you receive approximately 50 percent of the fee charged. To many travel writers, this sounds like an ideal arrangement since they don't have the time to mar-

ket their own pictures anyway.

Stock sales through an agency can be quite good, but picking the right agency and having it pick you is just the beginning of a long, hard road. If an agency likes your photography, it will probably ask you to sign an exclusive contract. This means you cannot work with any other agency and, in some cases, cannot even market your own pictures directly to an editor or art director. We advise against signing an exclusive contract. Many agencies will agree to a nonexclusive arrangement if you agree not to work with another picture agency in their city or region. In our case, we currently work with an agency in New York, one in Washington, D.C., one in Salt Lake City, one in Missouri, one in southern California, one in London, one in Tokyo, one in France, and we are negotiating contracts with an agency in Australia and another in

The St. Maria Della Salute dome in Venice becomes a shrine of mystery as seen by the creative eye. The photograph, taken in normal morning light, is purposely underexposed to create an image that appears to be taken in moonlight. The large area of "blank" space makes this an appropriate shot for the cover of a magazine or book.

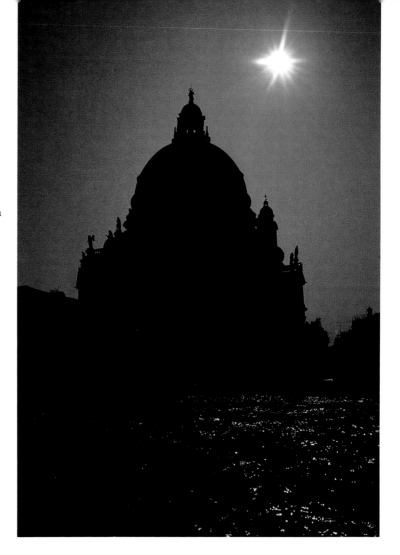

Italy. You may decide to start with one agency, but we advise leaving yourself the option of trying others.

Your initial question as a beginner may be, "How can I persuade an agency to handle my work?" You need to send or take about 500 of your very best pictures to the agency for review. If you send your pictures, we suggest delivery by Federal Express or UPS, and you should include a check, made out to the picture agency, to cover their return by the same service.

These 500 slides must be good; they must be clear; and they must be accurately captioned or labeled. If the agency likes your photography, you need to convince it that you will continue to produce and submit at least that many pictures every year.

Getting your color slides or black-and-white prints to an agency and into its files is a time-consuming project. We spend hours editing and captioning our travel slides before we ever show them to our agencies. We feel fortunate if they take 10 percent of what we submit. Once a slide is in an agency file, you can normally expect an income of about $1.00 per slide per year. That may seem low, but there are happy exceptions. The worldwide use of one of our pictures was sold through our Tokyo agency for more than $9,000.

We are not always willing to let an agency have our original slides. If we have only one frame of an outstanding subject, we will make high-quality dupes of that particular frame and send them to our agencies. (That procedure should be part of your contract.) If we took ten or more frames of that subject, we are usually willing to send an original slide.

How to Find the Right Agency. In the last few years stock-photo agencies have proliferated throughout the country and abroad, so if you decide to work through an agency, it is important to select one with a good reputation. One method of evaluating an agency is to get the list of photographers who use that agency, call some of them at random, and ask their opinion. It is also wise to seek the opinion of a photographer who has a large body of slides on file with that agency, as opposed to one who has only a few hundred. We cannot recommend one agency over another, but we can suggest some guidelines for finding the best agency to meet your needs.

Signing a contract with a picture agency is something like a marriage—it requires a compatibility of temperament, style and personality. We have already discussed the method of submitting slides to an agency, but we would add that there is an advantage to going to the agency personally and meeting with the principals. This often facilitates a quick reaction to your photography and its suitability for stock. It also gives you a chance to evaluate the agency, the personnel, and the offices. Obviously you would prefer to be represented by an agency that makes a favorable impression. We would also mention that there is an advantage to having your major agency in New York City, the world capital of the publishing and advertising industries. The competition in New York is keen, and getting accepted by one of the top agencies requires both talent and perseverance.

We advise choosing an agency that sends quarterly checks and statements and reports gross sales instead of just listing the photographer's share. (This will let you know if the agency is taking out its overhead before it makes the 50 percent division.) You should be informed of sales and amounts at the time the agency invoices the client. Your contract should state how long you will have to wait for a check after the agency has received payment for use of your pictures. It is also important to select an agency that will ac-

cept some high-quality duplicates for those originals you wish to keep in your own files.

One of the most comprehensive lists of stock photo agencies can be found in *Photographer's Market*, the annual reference volume we mentioned before, published by Writer's Digest Books.

What Subjects Are Most Suitable for Stock?

Successful picture agencies have an unerring eye for what types of pictures will sell from a stock file. Travel is not always the best subject, but it does sell if the client needs an image from a particular destination. Our experience shows that the favored stock images of travel subjects are the well-known landmarks shot in a conservative, straightforward style. Such subjects might be the Statue of Liberty in New York, the Eiffel Tower in Paris, the Colosseum in Rome, the U.S. Capitol in Washington, and Big Ben in London. We have sold these subjects, both directly and through agencies, over and over again. They are the postcard clichés of travel, but the client or editor often wants a picture that is symbolic of a city or country, and such pictures fill that need. We once took a shot of the White House through the fence, the same view that is taken by thousands of tourists. That picture sold to an editor for $400 just because we had it on his desk when he needed it.

We don't suggest that you confine yourself to shooting these stock subjects in this straightforward style. If you derive the same artistic satisfaction we do from taking pictures, you'll want to also take the picture "your way," from a different angle and in interesting light. Photography is an art medium and should be treated as such. Just remember to also shoot your subject for the stock file. Once you find the best view for a stock shot, it is a good idea to shoot five or six frames so you'll have that many originals for your file and for your different agencies.

On your trips, you'll also have the opportunity to shoot generic travel pictures,

Model Release

I hereby give photographers Carl and Ann Purcell, their legal representatives and assigns, the right and permission to publish, without charge, photographs of me, _____ , taken at _____ . These pictures may be used in publications, audio-visual presentations, promotional literature, advertising, calendars or in any other manner. I hereby warrant that I (or undersigned parent/guardian) am over 18 years of age, and am competent to contract in my own name in so far as the above is concerned.

Model _____ Date _____
<small>Signature of Model or Parent/Guardian</small>

Address _____ Phone _____

City _____ State _____ Zip _____

Witnessed by _____ Date _____
<small>Signature of Witness</small>

scenes that could have been taken almost anywhere. One subject might be a young couple walking along a beach, their footprints in the sand at the water's edge. We took such a picture in Hawaii and it was later used as a magazine cover to illustrate the theme of beach vacations in states on the Gulf of Mexico. You can get generic stock shots anywhere as long as the background does not reveal the identity of the location. Generic pictures might show a typical family on a picnic, people with their pets, children playing together, close-ups of wildlife, people in an office setting, or a man and woman having dinner in a fine restaurant.

When taking pictures you hope to use for stock, it is important to obtain model releases of the recognizable people appearing in the photographs. Model releases are not normally necessary if the pictures are to be used for editorial purposes in magazines, books or newspapers, but they will be required for advertising and promotion. Since you cannot always know in advance how a

picture will be used, it is usually advisable to get a model release.

The wording of a model release can be short and simple. Our model release form is printed on a 3″ × 5″ card, as shown above.

Some model releases are much longer, more complex, and filled with legal language, but the above should meet the legal requirements without making a person nervous about signing something he or she does not understand. Unless we have specifically hired professional models, we do not usually offer money to gain the cooperation of people in posing for our cameras, but we often offer prints from the pictures and mail them to the people who have posed.

Our experience shows that most people are pleased and flattered if you ask them to be in your pictures. We have also found that these individuals will usually be willing to sign a model release. Slide mounts should be marked with an (R) in the upper right hand corner to show that they are released.

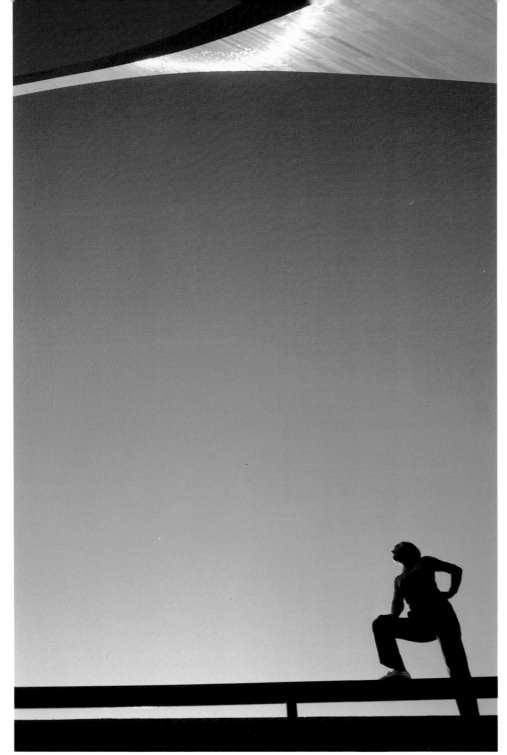

Ann Purcell stands under the famous St. Louis Gateway Arch designed by Eero Saarinen. This makes a good cover shot because the sweep of the arch above her head provides a frame for a possible magazine logo or book title. Such a picture works well in terms of graphic design, but it is not easily identified as a specific structure or in terms of location without a caption.

THE MOST IMPORTANT PART OF MARKETING

Effective marketing is often a matter of timing. You can send an editor the best travel story ever written, but if he or she doesn't need that subject at that particular time, the story will probably be rejected. Don't be discouraged by rejection. It happens frequently to the best writers and photographers. Query magazines with clear, concise proposals, and eventually you'll get positive results. Our advice is to just hang in there and keep plugging.

The Business Side of Travel Writing

Some of the most illustrious writers have been lousy at managing the business side of their endeavors. Balzac, for instance, lived in a garret as a young writer. When he finally became successful, he squandered his money on high living and the pursuit of titled women. This French novelist was a talented writer, but he wasn't a good manager. Balzac was plagued by a shortage of money throughout his life.

A few travel writers inherit money and never concern themselves about house payments and grocery bills. That sounds like an ideal life, but too often such writers are not driven by the financial need to produce. Necessity hones the sharp edge of creativity. The need for money is a strong source of motivation; talent alone is rarely enough. Some people who travel for other purposes dabble in travel writing as a part-time effort. These might be doctors, foreign service officers, college professors on sabbatical, missionaries, and others. Many of these people are talented writers, but they fortunately do not depend on their travel writing for their bread and butter when they start their writing careers. In the beginning, the travel writing may pay for a new sofa or a better word processor. Eventually, it will cover the cost of the trip. The goal is to have the profits pay the rent, and the dream is that they could also buy a new sports car.

We depend on our travel writing and photography to meet all of our financial needs. Even if you have other sources of income, it's still important to manage the writing effort as a separate business. This entails keeping accurate records of your expenses, submitting invoices for work completed, and following through to make sure you get paid. That sounds simple enough, but it is all too easy to fall down on handling such business details. Often you'll discover that the publishers you work for can invent numerous reasons for not paying for your work on time.

To start, you need some method of keeping your business records. The most common way is to use two ledger books, one for income and the other for expenses. This works quite well, but if you have a computer, such records can be kept on disks. Storing electronic records on a data base has the advantage of providing you with specific information such as income from writing versus photography and allows you, almost instantly, to compare income by month or year. The computer can also tell you which publications are your most profitable clients and how much money you spent this year for postage, film, or office supplies. Computer disks store information and data electronically. Of course, unlike ledger books, they have been known to crash and lose data. It is vitally important to make backup disk copies of your business records at the end of each business day. This is quick and easy to do. When taxes are due, the computer can make a printout to show your profit or loss. With the help of the information in this book, we hope yours will be a statement of profit.

Our recommendation for record keeping is to use a computer if you have it. If not,

Zoo or animal and bird shows can often provide excellent opportunities for wildlife pictures, especially close-ups. In this case we got an excellent portrait of the great horned owl at the Jurong Bird Park in Singapore.

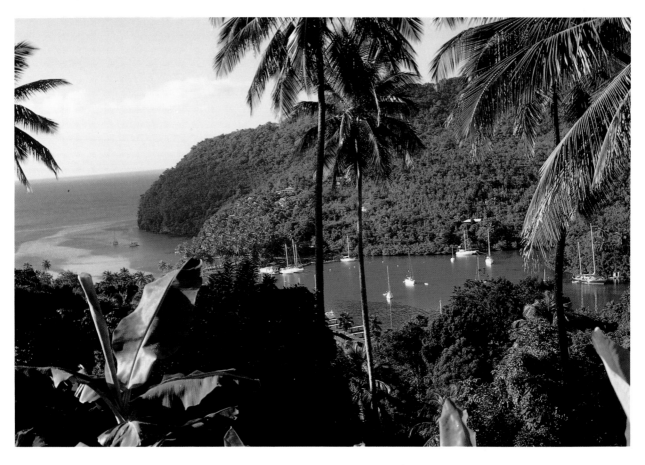

A quiet cove in San Lucia appears as a tropical paradise in this picture taken from a vantage point on the road. Originally used in a travel magazine, it was later requested for use in a travel brochure.

use ledger books and save your "vacation money" for a computer. (After all, a travel writer is supposedly on "vacation" all year long, and we dare you to try to convince your neighbors that you were too busy getting your story in Tahiti to put on a bathing suit!)

YOUR OFFICE

As a freelance travel writer, your office will most likely be in your home or apartment. It may be as simple as a chair, card table, and typewriter. Ours has grown over the years, taking over three rooms on the second floor of our house. We have acquired certain basic office equipment and furnishings. One of our most important tools is our answering machine. Our office is usually covered during business hours by our assistant, even when we're away on assignment, but important phone calls can come any time. Our brief outgoing message is clearly recorded, but as travel writers we have indulged ourselves with a little background music on the tape. It is "Around the World in Eighty Days." Fortunately, most modern answering machines come with remote capabilities, so if our office is not covered by our assistant, we can periodically check in for messages.

Some people use an answering machine to provide uninterrupted working time by turning off the phone and letting the machine handle calls. We have found, however, especially with last-minute writing assignments and photo requests, that an editor is all too quick to go elsewhere for immediate needs if the call doesn't get personal attention.

Another indispensable item is the copy machine. This allows us to make multiple copies of a story for simultaneous submissions to newspapers in the U.S. and Canada.

We also use the copier to duplicate tear sheets from magazines or newspapers so we can send them to people whom we have interviewed. We also send copies of articles to hosts who have provided support in helping us cover a destination.

Buying a copy machine takes almost as much shopping around as buying a car. You should check the Consumer's Union for service records, and you must try out several brands of machines to satisfy your personal needs. Mini-photocopiers cost around $400, midsize models can retail for about $3,500, and color copiers can cost between $7,000 and $10,000. We wanted a compact copier that could render good facsimiles of photos and about 8,000 copied pages per year. Our Sharp 756 cost $1,500 several years ago and is still satisfying our needs. We have a service contract (which we renew for about $230 per year) that covers all maintenance and expenses for the machine, except paper.

One of our recent acquisitions has been a facsimile machine. "Fax" has become an office buzzword, but we waited quite a few years before buying one. It is a convenient and instantaneous way for a writer or photographer to communicate with a magazine editor. But the main advantage of fax is that you communicate in more detail. Text can be sent and revised in time to meet a deadline. An art director can transmit a page layout or sketch. A photographer can transmit a black-and-white print suitable for layout purposes. Fax technology has been around for a long time, but full utilization came after enough offices had machines to make it a practical way to transmit information.

In choosing a facsimile machine, there are several things to take into consideration. A photographer will want a fax capable of transmitting fine-grain black-and-white images with a wide range of tone. Purchase a machine that you can use on your regular phone line. Some machines utilize a switchbox that can differentiate between a voice call and a fax transmission. We balked for months when we saw the $1,500 price tag on our Toshiba 3600, but this fax machine has paid for itself several times over within the first year. Several last-minute letters-of-agreement and assignment contracts have been delivered at a fraction of the cost of overnight services. Multiple urgent and extended photo requests have come to us because of our fax capability. You will want to wait until editors and clients are contacting you regularly before you invest in a fax machine; but at that point, you will find it a boon.

In setting up your office, you'll need some place to put reference books. One wall of the main room in our office is a built-in bookcase filled with reference books that we need to use on a fairly regular basis. It contains dictionaries, encyclopedias, computer manuals, back issues of *National Geographic*, guidebooks, and such specific volumes as *Writer's Market*, *Photographer's Market*, *Editor & Publisher Yearbook*, *Associated Press Style Book*, and *World Facts and Figures*, just to mention a few. We also have neatly labeled brown cardboard file boxes filled with brochures and literature from various countries, usually collected on a particular assignment to that country. Eventually these get transferred to our basement for storage in alphabetical order.

When getting started, a single file cabinet will be sufficient, but over the years your files—like ours—will proliferate. We currently have seven standard four-drawer file cabinets to hold correspondence, client files, tear sheets, computer printouts of our articles, picture agency records, black-and-white photographs, newsletters, promotional materials, submission forms and invoices, office supplies, and instruction booklets for photographic and office equipment.

In addition to all this, we have fifty-six five-drawer Neumade slide filing cabinets to hold our collection of 500,000 slides from ninety-three countries, and we also have a light table for editing color slides.

There are many advantages and a few disadvantages to working full time out of your

An assignment from the Irish Tourist Board called for us to portray the elegance of Ireland for advertising and brochure use. We used these professional models to pose in the living room of a manor house turned hotel. In this instance we chose a formal pose with the two subjects looking directly at the camera.

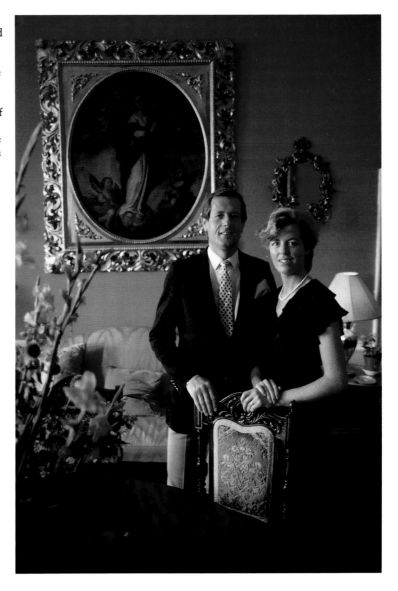

home. It's very convenient not to have to commute to a downtown office, especially in bad weather. It is also nice not to pay rent for space you may already have in your house. Not only that, but you can write off the expenses for this space when you do your taxes! (See: "Keeping Square With Uncle Sam" later in this chapter.)

When not traveling, we can rise at the civilized hour of 8:00 A.M. and wander downstairs for toast and coffee where we share the newspaper. By 9:00 A.M. we are back in our office working at the word processor, captioning slides, or preparing stories and pictures to be mailed to our editors.

The main problem of having an office at home, and this is part of being self-employed, is that it is sometimes difficult to get away from the office. When work is waiting to be done, we tend to do it even if that means staying up late, getting up early, or working on weekends. If work were *not* waiting to be done and if our travel-writing income were more sporadic, the stress and worry would become even greater, and we would both be hustling even longer hours to produce and market new pieces.

Tom and Joanne O'Toole are freelance

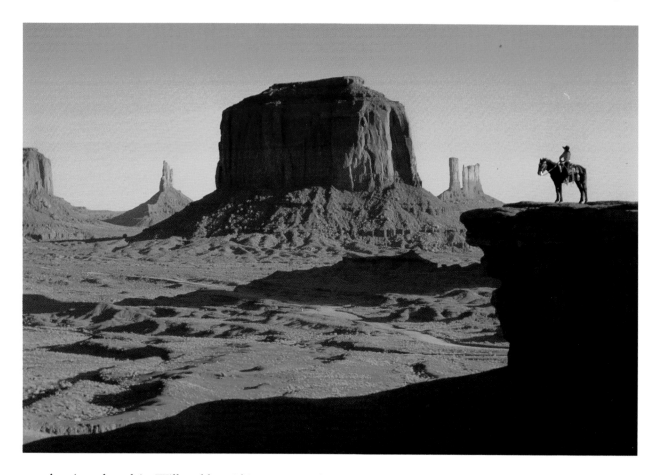

travel writers based in Willoughby, Ohio, who are masters of organization and marketing. Their success is reflected in their recurring by-line that appears in newspapers and magazines throughout North America as well as England and Australia. The O'Tooles, who now work out of their home, are proof, like ourselves, that husband and wife teams can be successful. The O'Tooles have also found that editors prefer a package that includes both text and photography. They have also learned that such packages must continue to circulate to every possible market to achieve an acceptable level of sales. Tom and Joanne keep in contact with their editors by telephone with queries, and follow up on stories that have been submitted. They have all their editors on file with details on each person, ranging from use of articles to specific editorial requirements. Like us, the O'Tooles have graduated from a level of sporadic income

to a realistic expectation of substantial income for financial security. Also like us, most of their hours at home are full of frenzied activity.

WORD PROCESSING FOR TRAVEL WRITERS

Many myths have sprung up concerning computers, and nontechnical people, especially those who have never used a computer, get very nervous when the subject comes up. As a writer, there are just two facts you must recognize:

1. Computers are labor-saving devices.
2. Anybody who can use a typewriter can use a computer for word processing.

The time you save is immeasurable. You can compose and write almost as fast as you think. You can delete, insert, cut and paste

A solitary Indian on the edge of a bluff in Monument Valley looks like a painting by Frederick Remington, the artist who portrayed the American West. Today this vista is so popular that the Indian on horseback is often available to pose for a moderate fee.

at will. The computer will check your spelling and offer synonyms for selected words. The printer will deliver clean, letter-perfect copy that will delight your editors. Obviously your main concern is to deliver a neat and readable manuscript, but a word processor can also provide a selection of typefaces in a variety of sizes. In addition to all this, the text can be transmitted via modem over the telephone directly to your editor's computer and then, with the flick of a finger, straight into typeset. Some newspapers insist on receiving articles from their freelance writers in this manner.

Writers tend to be traditional, and many have strong opinions. We have one travel-writer friend, a competitor, who has resisted word processing for years and still beats his stories out on an old manual typewriter. This friend is a very talented writer, and we have taken care not to persuade him to switch to writing on a computer. If he were to do so, his productivity would increase by 50 percent—and he writes for many of our markets. We have not pointed out to him how much time he would save in correcting and retyping. He already is aware that some major publications will not even accept copy unless it can be transmitted to their computers, but he ignores those markets and sticks with his old-fashioned methods.

There are two major systems on the market today: Apple Macintosh and IBM. There are many IBM-compatible computers available that will accept the IBM software programs, as well as Mac-compatible computers, such as Amiga, which can be upgraded to use both IBM and Apple software. ("Hardware" is the physical piece of equipment sitting on your desk. "Software" is the disk you insert to give the computer its intelligence; it tells the computer what to do when you turn it on.) In our opinion, an IBM or IBM-compatible is a more powerful computer, but the Macintosh is more "user friendly," or easy to use. The Macintosh utilizes a small control device called a "mouse" while the IBM depends on keyboard strokes for commands. Both systems work very well

for word processing; the Macintosh is stronger in art and desktop publishing, while the IBM is stronger in programming and calculation.

There are some word processors designed only for typing or word processing. These come with a built-in letter-quality printer, a sort of glorified electronic typewriter with a limited memory, but we suggest purchasing a computer-word processor with a separate printer. In addition to word processing, this will allow you to take advantage of the thousands of software programs designed for the major systems. These programs, ranging from spreadsheets to desktop publishing, can be effective tools for your business.

Whichever hardware system you select, you'll need to choose your word-processing software carefully. There are many available, but some of the more widely used are Microsoft Word, WordPerfect, and WordStar. Never buy word-processing software without having had some experience trying it, some selective advice from people who use your brand of computer to do your kind of work, some extensive shopping around, and some clever bargaining. At this time, there are more computers and word processors on the market than there are buyers. The dealer will often come down in price considerably if you tell him of another "better bargain" that you are considering. It is common to have several software programs thrown in to sweeten the deal, and you should know what kind of software you want when you go to buy the hardware.

We feel that some computers and computer programs are difficult and frustrating to use, but this is not usually true for word processing. Your dealer can help you set up your computer and printer, set the margins for your paper, answer software questions, and sometimes provide service facilities for repairs if they are ever needed. Most large software manufacturers have a toll-free number that you can call when you need assistance. Also remember there are many computer user groups in most cities if you run into problems. There is a strong frater-

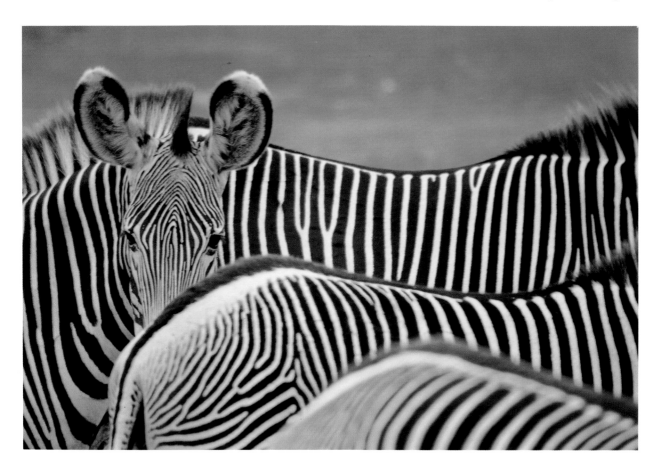

nity among computer buffs, and they enjoy helping other people get started.

Creativity With Your Computer

Word processing is only one small aspect of computers. These incredible machines offer the business-oriented travel writer much more. You can design and laser-print your own newsletters or brochures with a variety of typefaces and banner headlines, and insert illustrations in the appropriate places. You can create lists of editors and their addresses on data bases, and these can be merged with a letter designed to be sent to all of your newspaper editors. The computer can print a hundred letters, inserting a separate address and salutation on each one.

We have a list or "stack" of several hundred clients and business contacts on a Macintosh data-base program called Hyper-Card. Among many other things, it can serve as a sort of electronic Rolodex that shows up on the screen, looking very much like a regular Rolodex card. We can browse through this file or we can search for a particular client by typing in any key word—a last name, company name, or even town or city. If our list contains more than one listing with the key word, these listings come up on the screen one at a time. A listing contains name, company, address, and phone number. This program alone has been worth its weight in gold and has saved us hours searching for misplaced business cards or phone numbers. By pushing one button, we can have our computer automatically dial for us the number of any person on our list.

We are currently working to develop an electronic data base that will keep track of where we have sent which color slides and how many with which articles, when and how many slides have been returned, which articles and which slides were selected for

The lines on these zebras make a dramatic and graphic composition that borders on being abstract. The one zebra whose head is turned brings the picture back to reality. This image has been used in magazine articles, calendars, and as a Hallmark postcard. Constantly be aware of the design elements in the pictures you take. Strong graphic qualities will appeal to editors and make the picture more valuable in your stock files.

This picture could also illustrate an advertising concept such as "standing out in a crowd."

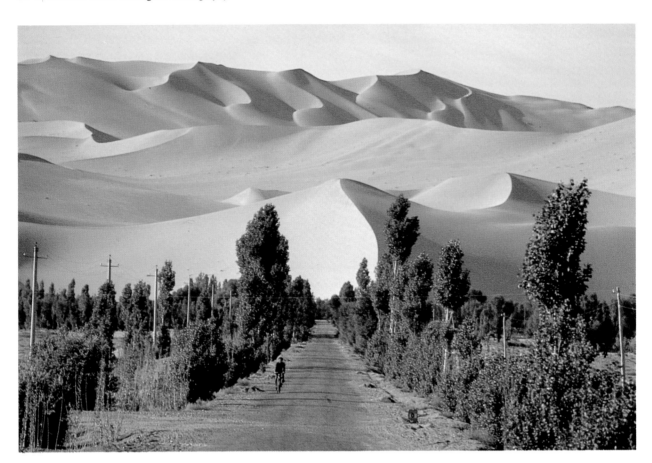

The Mountain of Singing Sand in the Gobi Desert is one of the world's most striking desert scenes. The photograph depends on slanting afternoon light that models the massive dunes, giving them shape and substance. A picture from this sequence won a gold medal and $300 in the SATW (Society of American Travel Writers) Photo Contest.

publication, clients wanting to have articles resubmitted at a certain time, and records of payment. This information is vitally important, especially due to the high value of original color slides. If an original color slide or transparency is lost or damaged, a client is normally charged $1,500. Our new data base will provide a highly accurate tracking system for slide submissions.

DEALING WITH EDITORS

The cliché image of an editor is a professorial gentleman in a three-piece suit with round, metal-rimmed glasses and a kindly manner. Blot this image out of your mind. While you will probably work with some very decent editors, there are many who are unreasonable, ill-tempered, and irrational. Some editors seem to specialize in dumping on freelance writers, losing queries, manuscripts, and even valuable color slides. They

rarely return phone calls but become hysterical when a writer is one day late on a deadline.

The sad fact is that, as a freelancer, you must take this boorish behavior with good grace. The editor is a person you cannot afford to offend if you wish to continue writing for that publication. We once received a set of expensive black-and-white prints back with an unused article, coffee stains over both the prints and the manuscript. All we could do was take comfort in the fact that such editors create their own environment and they have to live with it. As a freelancer, you do have the option of walking away from a really bad situation and focusing your efforts on another publication. We hasten to add that other editors can be a joy to work for. We had wonderful senior editors at *Signature* and *Popular Photography*, women who understood style and had the ability to deal with writers, both on a per-

A circular fish-eye lens is very specialized and works well only on some subjects. Here we used one to record the atrium of the cruise ship, *Sovereign of the Seas.* This giant atrium features glass elevators and rises five floors, providing access to shops, dining rooms, and public areas. In photographing new cruise ships, we look for unique interior design.

sonal and professional level. We were incredibly fortunate with our editor for this book and the editor on our last book, *The Traveling Photographer*, both of whom made the births of these books a real pleasure.

Establishing and maintaining a good working relationship with editors can be the key to success. You must walk a fine line between being professional and friendly. Your first goal is to make a favorable presentation of yourself and your work, and this can best be done by making a personal appointment to show your clip book or portfolio. Such a book should contain the best examples of your work, clippings, and tear sheets of your published articles and photos. A portfolio should be a work of art, put together with the care and thought that a graphic artist would give to his most important layout, whether you are visiting an editor in Hush Puppy, Kansas, or doing the rounds in New York City. You must realize that an editor, glancing through a portfolio, will probably not read your text in any detail. He or she will note the names of magazines you have written for, glance at headlines, the photographs, and occasionally read a lead paragraph. The editor may read in more detail if you leave the portfolio overnight. If you are mailing photocopies, it is important that they are crisp and clean copies with an interesting cover letter. We've found that it is more likely that the editor will attend to your package personally if you send it by one of the express mailing services with a return receipt requested.

DESIGNING YOUR PORTFOLIO

We purchased our portfolio from a local art supply store. It is a zipper vinyl case that

measures 23″ × 18″ with a forty-ring binder for holding large acetate sheets with black paper inserts. The large size allows us to display a full newspaper page if needed. We did our layout by placing published articles and/or photos on the black paper, leaving some breathing space between the elements in the layouts. We often used the logo of the magazine to identify where specific articles had appeared, especially in the case of prestigious publications. If we wanted to include additional information, we designed it (line drawings and type) on our computer and printed it on a laser printer. Don't use rubber cement for pasting articles and photos in your portfolio, as it will eventually discolor your clippings. Some writers use double-stick tape, but we use regular Scotch tape, making a tight loop so both sides will stick to the black paper inserts.

Our portfolio is the first and most important impression of the Purcell Team when we go to a new editor. It conveys the professional level of our work. Building an impressive portfolio may take years, but you should start with the published articles you have available. It is legitimate to include photographic prints of your favorite travel pictures that may not have been published. A portfolio is the first step in establishing your credibility as a travel writer. When visiting an editor, you may also want to take along a plastic sheet of your finest travel pictures to demonstrate the quality of the slides you will be submitting with your articles.

NEGOTIATING FEES AND RIGHTS

Beginning travel writers often feel awkward when it comes to discussing money with editors. Some writers like to charge by the word; others prefer to charge a set fee for an article. In any case it comes down to the fine art of negotiation. The most important thing to remember is that if an editor wants to publish your story, that story is worth money. New writers are sometimes tempted to offer their travel stories at bargain prices or even for free, just to see their work in print. This is a serious mistake and should never be done. If this book can teach you any one thing, it is never forget that your estimation of your worth is the one that counts the most. You must believe in your talent and ability before anyone else will.

In marketing a story, you need to be aware of what rights you are selling. For most domestic magazines, the standard is first North American rights. This means the magazine can be the first to publish your story in North America, but you still have foreign rights and can rewrite and sell the story again after it has been published and been out for six months. Photographer Brian Brake once did a marvelous photo essay and story on the monsoon in India with many unforgettable images. Brake sold the story to *Life*, *Paris Match*, *Stern*, and several other foreign magazines for simultaneous publication. This was creative marketing and he made a lot of money from his effort.

In certain cases magazines may want additional or even exclusive rights to your story, but they should be prepared to pay a higher price. Some writers are not overly concerned about rights if they do not intend to submit their story to other markets, but our advice is to keep as many rights as you can and resubmit a good story to as many markets as possible.

Regional magazines and newspapers are a different cup of tea. Most newspapers don't care if the same story appears in another newspaper outside their circulation area. You should be aware, however, that some papers such as the *New York Times* and *The Christian Science Monitor* consider themselves national publications. The *Los Angeles Times* likes to have exclusive rights in southern California. A regional magazine usually wants exclusive rights within its circulation area.

Negotiating a book contract is more complex than reaching an agreement to write an article for a newspaper or magazine. With a book, much more is at stake and we suggest retaining a lawyer who deals exclusively with book contracts and knows how to get

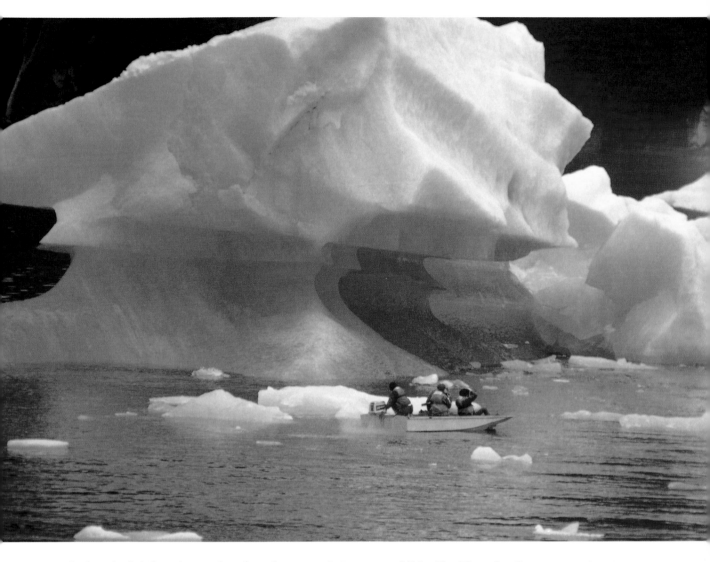

you the best deal. A first-time author doesn't even know what to ask for from a publisher. Issues that will come up are percentages on sales, advances and stages of payment, number of free copies to the author, author's price for purchasing books, book club deals, foreign rights, and more. There are even attorneys who specialize on travel books, and you can get a list of names through the Society of American Travel Writers, 1155 Connecticut Avenue, NW, Suite 500, Washington, D.C. 20036. Our attorney, Gail Ross of Lichtman, Trister, Singer & Ross in Washington, D.C., has saved us thousands of dollars on our book contracts. Ronald Goldfarb and Gail Ross co-authored *The*

Writer's Lawyer, published by Times Books, which gives solid legal advice to writers about the business side of writing and discusses what constitutes a good writing contract.

Do You Need an Agent?

Agents can serve a useful purpose for established, financially successful writers, especially book authors, but our experience shows that most travel writers, even busy ones, don't make enough money to share their limited income with an agent. The financial realities are clear. Suppose a publisher gives you a $5,000 advance on a book

A tiny outboard powerboat is dwarfed by a massive iceberg that had broken off from Sawyer Glacier in Alaska. In doing travel articles about Alaska, it works well to pick subjects that are associated with the state such as icebergs, huskie dogs, lumberjacks, or oil pipelines. In travel pictures, quick identity of an area is important.

Look for humor in your travel pictures. A funny image can help sell an article. We came across this picture of a Chinese woman getting her hair curled by a Rube Goldberg machine in the remote city of Urumji. Embarrassed, she covered her eyes, but we could not resist taking one quick shot with flash.

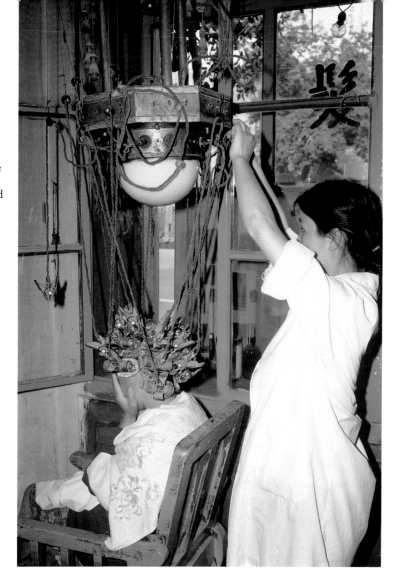

about Alaska that will take you four months to research and write. Off the top you pay a lawyer $500 to negotiate your contract and an agent a 15 percent commission, or $750. This leaves you with $3,750 to cover your travel and living expenses, and you can't live and eat in Alaska for that amount. Even with a very successful book, it normally takes more than a year to earn back the advance, and then you must continue to share 15 percent of the royalties with the agent. In the unlikely case that your book earns a million dollars, you probably can afford to give your agent 15 percent, but we don't know many travel writers who make a million on a book. A possible exception is James Michener.

Now, let's consider another possibility.

Suppose you've decided not to get an agent. Your lawyer is sharp and negotiates a $7,000 advance for you, and you are able to piggyback some assignments from several newspapers and magazines on various aspects of Alaska. The project has suddenly become more financially rewarding.

The Profit of Travel Writing Is a Joy

The act of being creative will give you great pleasure, but you will find that making money being creative is an even greater delight. It is nice to be recognized for your talent. Unfortunately, recognition doesn't come automatically when you create an artistic product. Recognition will come when your work is published.

RESALE OF YOUR STORIES

A good story should have a long life. Some years ago we wrote a short article called "Bargain Basements of the World," illustrated by pictures of inexpensive artifacts we had purchased during our travels. We advised our readers on what to look for in foreign countries and how to bargain in bazaars. We sold the story to a newspaper with a national circulation. About a year later, we rewrote the article and used other pictures to sell the piece to *Holiday* magazine. After another year, we rewrote it again and sold the story to about ten individual newspapers. Three years later we rewrote this subject again and sold it to another national magazine. It is still a good subject and can be done again.

Other possible outlets for your travel stories that have sold in North America can be found in places like Australia, Europe, Latin America, and Asia. This takes some creative marketing and you can find listings for major foreign newspapers in *Editor & Publisher Yearbook*. You'll find more possibilities in the *Travel Writer's Market*, mentioned in Chapter Four.

RESELL YOUR PHOTOS

We live in a visually oriented society. Look around you. Almost every advertisement, article, magazine cover, calendar, greeting card, and even toy wrapping has a bright design to catch your eye, and it is usually a photograph.

Over the years, we have taken many photographs that have sold time and time again. One example is a graphic picture of zebras that was used for a calendar, as an illustration in an article on Africa, in a national parks magazine, and it will soon appear on the chests of some T-shirts. Another example is a photo of the Singing Sands Mountain on the edge of China's Gobi Desert. It has been used as a magazine cover, as an illustration for several articles, as a calendar picture, as a poster, and as an exhibit print. It isn't always possible to predict which will be the photos that will resell frequently. Some of your favorites may never find their way onto a printed page. Others will surprise you. In Egypt Carl took a photo of the sphinx and its smashed nose. It was used to advertise the services of a plastic surgeon. Ann grabbed a candid shot of a Tanzanian child standing in a ray of sunshine. It appeared on the cover of a religious magazine. If you like the shot, take it. Sometime, someone may need it and will pay to use it. If the picture has particular appeal, it may become one of your big earners. Just remember that you must keep track of the photos that resell often. If a photo has sold as a calendar picture, you certainly cannot allow it to be used by a competitive calendar company for the next two years. The same is true for greeting cards. You would hurt your reputation if you sold the same photo to two competing magazines for both to use as a cover, and you might even find yourself being sued. You could, however, simultaneously sell the use of that picture for one regional magazine cover, a travel agency brochure illustration, and an airport poster.

Jim Pickerell of Bethesda, Maryland, is a professional photographer who specializes in shooting stock, and he works with hundreds of clients. Jim has written a book, *Negotiating Stock Photo Prices*, which offers guidelines for pricing pictures. This valuable book is available for $17.50 plus $1.50 for postage and handling from Pickerell Marketing, 23441 Golden Springs, Suite 241, Diamond Bar, California 91765.

KEEPING UP TO DATE ON TRAVEL MARKETS

A strong network of colleagues in your field can be a great asset. From fellow professionals you will hear about projects in which you can get involved, people with whom it is a pleasure to work, and publications that can afford to pay a decent price for your services. You will also be warned about editors who like to eat travel writers for breakfast, publications that refuse to pay your fee after

THE
american
baptist

MAY/JUNE 1989 $1.75

Alive in Mission:
The Vision Continues

INSIDE

1988-1989 Program Board Reports
- National Ministries
- International Ministries
- Educational Ministries

they've used your article, and travel editors who verbally assign stories and then change their minds without offering a kill fee. Work-for-hire, the worst offense, is a practice in several large, rich publishing houses, and you'll need to know which magazines offer these kinds of contracts so that you don't waste your time trying to get an assignment from them. Work-for-hire means that you are giving up the copyright for your writing or photography. The magazine pays you some fee or salary, and then it owns the copyright to all the work you did on the assignment. It makes the purchaser the legal "author" of your work, and you would lose the right to use or reuse any part of that creative effort without your client's written permission or perhaps even paying your client. It's a form of modern-day publishing slavery.

Going public with such facts is brave, and we know of only a few publications that dare. The *Travelwriter Marketletter* ($70 per year) is an informative and influential newsletter that provides information on press trips and up-to-the-minute information about the freelance needs of travel publications. Publisher Robert Scott Milne is also to be commended for reporting on work-for-hire contracts and other abuses of writers and photographers by publications. It is possible to subscribe to this newsletter by sending a check to *Travelwriter Marketletter* at the Waldorf-Astoria, Suite 1850, New York, New York 10022.

Another publication, *Photo District News*, is a forum for news in the photography world. It gives reports on copyright reform laws, photographic litigation, tax changes, photographer abuse, and general-interest articles for photographers. This illustrated publication is available for $30 per year from *Photo District News*, 49 East Twenty-first Street, New York, New York 10010.

SYNDICATION: IS IT FOR YOU?

Newspaper syndication is a possible outlet for your travel writing if you have an established track record, if you have been published regularly in large newspapers, if you can find the right syndicate that will cut you a fair deal, and if you can offer the syndicate a unique and salable product. You'll find syndicate editors more receptive if you can produce a regular column on some subject about which you are uniquely qualified to write. This might be traveling with children, travel for the handicapped, travel for senior citizens, cruise ships, or touring by car. For three years we were syndicated to more than 250 newspapers throughout the U.S. and Canada. We did two regular columns, "Vacation Camera" and "Two for the Road," a destination travel feature. Both were illustrated with our pictures. In general, these went to medium-sized papers and a handful of larger papers. The weekly deadlines were heavy on our shoulders, but the income was a welcome addition to our bank account.

Unless you're a "Dear Abby" you won't be able to make a fortune from newspaper syndication. Some syndicates pay a flat fee to a writer for a column; others pay a negotiated percentage based on the number of papers that use the column. In the latter arrangement, it is usually necessary for about 100 papers to carry the column before it becomes profitable for both the syndicate and the writer. We highly recommend using a lawyer when signing a contract with a syndicate. Such points as copyright, photo usage, percentages, extension of the contract, and renegotiation of fees should be ironed out in advance.

If you provide color or black-and-white photographs to a syndicate to illustrate your travel articles, it is vitally important to specify the rights you are transferring to the syndicate. A syndicate does not usually pay well for photography and prefers to give its subscriber papers the right to use the pictures at any time for any purpose. We would strongly advise against giving up all rights to your pictures. Specify that they are to be used only with your articles. Otherwise, you may someday receive a copy of a paper that used your photo with an unrelated article and did not pay you.

You never can tell when a photograph will capture an editor's attention. Ann took this shot in Tanzania, never dreaming it would end up on the cover of *The American Baptist*.

KEEPING SQUARE WITH UNCLE SAM

As a travel writer, it is important to keep a detailed record of your expenses and to be able to prove that all your travel was done for the purpose of your business. This means keeping receipts for postage, hotels, meals, airline tickets, film and film processing, office supplies, business cards, etc. These items can be deducted in the year they were purchased. Capital expenditures for cameras, office furnishings, and equipment must be depreciated on the basis of their life expectancy, possibly ten years for a computer.

If you work out of your home, you should measure the exact living space of your house (check your blueprints) and then measure the exact space used for your office. The percentage that your office occupies will determine what you can deduct from your taxes of the amount paid for your rent or house payments and utilities.

If this sounds complicated, it is. We highly recommend your using a qualified tax accountant to advise you. Our accountant saved us enough money in one year to buy a snappy red sports car.

PROFESSIONAL ORGANIZATIONS

We spoke earlier of networking and the financial advantage of frank dialogue with your writer colleagues. Travel writers should consider the relative merits of joining certain professional organizations. There are many writer's organizations in North America and Europe as well as several groups composed of travel writers, editors, photographers, and broadcasters. In considering membership, be aware of membership requirements, costs, and potential benefits.

Dixie Franklin, a successful freelance travel writer in Michigan, maintains an active membership in six travel and outdoor writers associations. Dixie says, "I carefully select these associations, adding them one by one to fill a particular need." Through her affiliations, Dixie profits from multiple contacts, seminars, and working trips. Dixie

feels that it is important to be active and make a contribution to the associations she has joined, and she has served as president of the Michigan Outdoors Writers Association and the Midwest Travel Writers Association.

You will be a useful and valuable member to such organizations when you are a "producer," and the membership requirements are usually more demanding for those prestigious organizations that can be most useful to you. The travel industry knows, for example, that you have to be a producer to become a member of the Society of American Travel Writers. If there is one free space left on a tour, you would be a valuable person to fill it.

The Society of American Travel Writers

We are both active members of the Society of American Travel Writers (SATW), the largest and best-known organization of the type that includes both travel communicators and members of the travel industry. SATW is a public-service organization dedicated to serving the interest of the traveling public. It is composed of approximately 850 members, currently about 500 actives and 350 associates. Actives are producing travel journalists (writers, editors, photographers and broadcasters), and associates are public-relations representatives in the travel industry.

Membership requirements are stiff and getting into SATW is not easy. First you need two sponsors who are SATW members. Freelance travel writers must be able to show that during the last year they have published at least fifteen original articles in newspapers of 150,000 circulation or more, or eighteen original articles in newspapers with lower circulations but still over 50,000. A writer may also meet the minimum guidelines by writing, within the last year, six articles in magazines with a circulation exceeding 500,000, or twelve articles in magazines with a circulation of 100,000 to 500,000. A writer may also produce a

combination of magazine and newspaper articles in a sufficient quantity to satisfy the membership committee. It is clear that these minimum qualifications cannot be met by someone who's just getting started in travel writing, but this level of production is a worthwhile goal. Information about SATW and all categories of membership can be obtained by contacting the Society of American Travel Writers, 1155 Connecticut Avenue, NW, Suite 500, Washington, D.C. 20036 (phone 202-429-6639).

SATW serves a useful function at its chapter meetings and national conventions by bringing people in related fields of work to-gether in a social and professional setting. It gives us a chance to share marketing techniques, pick up story ideas, and learn about the latest computer software. We have the opportunity to talk with editors and find out what they need and want for their publications. Critics have claimed that SATW meetings, especially in foreign countries, are subsidized by the airlines and national tourist offices. In fact, travel arrangements for SATW meetings cost about the same or slightly more than group discount fares available commercially. Members are free to write about the destination if they wish, favorably or unfavorably. SATW is obviously

Consider an appropriate caption for this picture. We used the following: "The terraced rice paddies of Bali march up the sides of a valley like emerald staircases for Hindu gods." Captions should quickly identify the location. In this case, we borrowed some of the poetic language from the body of our article.

Flash-fill can be an effective tool in taking pictures where shadows would blot out detail. Here, we used the flash to photograph a village woman cooking plantain in a remote village in Ecuador. Note that the background detail of the jungle foliage has been preserved.

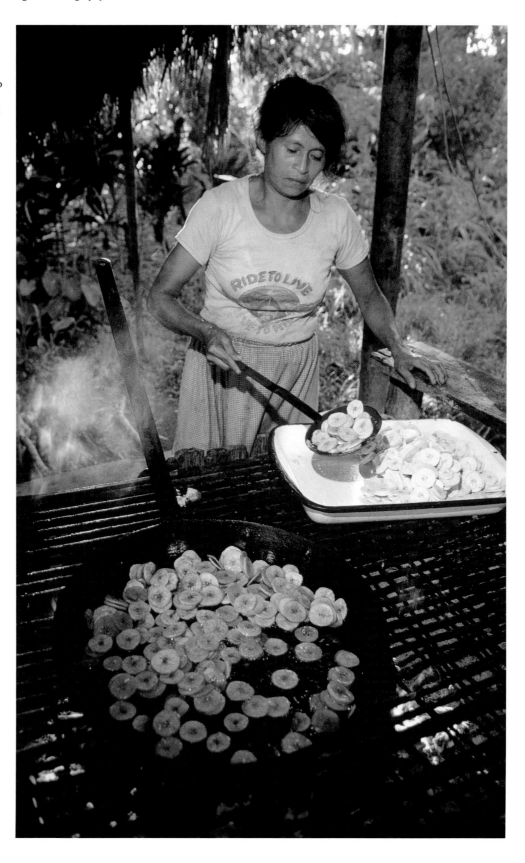

composed of diverse groups, including writers, editors, and travel industry representatives, groups that sometimes have conflicting interests and goals, so there are many chances for healthy discussions of opposing points of view.

The society is made up of a freelance council, an editors council, and an associates council. Council meetings, chapter meetings, and national conventions often include professional development programs and seminars.

We will mention some other writers organizations for your reference. To get addresses for details and membership requirements, write the Council of Writers Organizations, *Michigan Living*, One Auto Club Drive, Dearborn, Michigan 48126.

Travel Journalists Guild

The Travel Journalists Guild (TJG) is an organization with a simple purpose. Its mission is to visit a destination to gather information and photographic material which is used to inform the public. Members are highly qualified and productive professionals. Unlike many other travel-writing groups, it does not hold meetings or conduct seminars during trips. Many members of TJG are also members of SATW.

Midwest Travel Writers Association

The Midwest Travel Writers Association is composed of writers, editors, photographers and broadcasters who report and comment on travel and tourism. This group, like SATW, also includes associate members who are public-relations professionals in the travel and tourism industry. By virtue of its name, MTWA is a regional organization. Many members of MTWA are also members of SATW.

New York Travel Writers Association

This city-based writers group is described by its own members as exclusive and social. It maintains a country club atmosphere, and qualified travel writers often find it difficult to join unless they have the right connections. This group sponsors an annual Christmas party and a spring dinner dance, both prestigious affairs. NYTWA holds a luncheon meeting once a month, except during the summer. The group does not make trips and does not conduct professional seminars. We mention the organization only because many of its members are top professionals and important contacts can be made at social functions.

The Council of Writers Organizations

The Council of Writers Organizations is an umbrella coalition that includes many writers groups. It exists to foster an exchange of information and ideas, offers comprehensive medical and disability insurance, helps obtain discounts on computer hardware and software, and provides tax and legal advice. As a writer, you do not join CWO directly, but become affiliated through a writers group that maintains membership in the organization. Currently these are:

American Society of Indexers
Aviation/Space Writers Association
Computer Press Association
Dance Critics Association
Editorial Freelancers Association
Florida Freelance Writers Association
Independent Writers of Chicago
Independent Writers of Southern California
International Motor Press Association
Midwest Travel Writers
National Association of Science Writers
New York Business Press Editors
Outdoor Writers Association of America
Philadelphia Writers Organization
Science Fiction Writers of America
Society of American Travel Writers
St. Louis Writers Guild
Travel Journalists Guild
United States Ski Writers Association
Washington Independent Writers
Women in Communications
Writers Guild of America, East

As you can see, this is a formidable list of writers groups with a variety of specialties and includes both regional and national organizations. Not all of the groups pertain to travel writing, but (as mentioned earlier) you can obtain an address for any which might be of interest to you by writing to the Council of Writers Organizations.

American Society of Magazine Photographers

The American Society of Magazine Photographers (ASMP) is quite different from all of the writer's groups, but it is very valuable in its own way. ASMP is an organization of more than 4,000 of the leading professional photographers in the United States and abroad. ASMP does not in any way regulate the manner in which its members do business, but it does provide business-related information for its members. We have stressed the importance of travel writers getting involved in photography, but travel photography is a whole new ball game when it comes to marketing and pricing. ASMP publishes the *Stock Photography Handbook*, which has compiled data to indicate average prices paid for the different sizes of photographs used in magazines or publications of specific circulations. When negotiating with a magazine on the use of a picture, such data is indispensable. It provides the photographer with a starting point for negotiation. This handbook gives average U.S. prices for many types of photo usage in both advertising and editorial outlets.

ASMP also publishes a membership directory and *Professional Business Practices in Photography*, an outstanding and definitive publication that covers assignment photography, stock pictures, form agreements, copyright protection, insurance, book publishing, legal matters, and ASMP membership requirements. All three publications can be purchased by nonmembers by contacting *ASMP Bulletin*, 419 Park Avenue South, Suite 1407, New York, New York 10016 (phone 212-889-9144). Information on membership requirements is also available.

ASMP, which is headquartered in New York, does not have an annual convention, but regional chapters hold business meetings and present professional seminars. ASMP also publishes a monthly newsletter with news items and feature articles of interest to professional photographers.

STAYING IN BUSINESS

This chapter is filled with the information you'll need to know and remember to stay in business. Much of it is heavy stuff, the noncreative side of travel writing. These tips and guidelines can steer you through dangerous financial waters and make it possible for you to walk along those sun-washed beaches, to swim in the surf, and to soar with the freedom of an eagle. With talent, energy and organization you can do it and even make a good living. The delight of creativity can only be enhanced by the joy of making money doing what you like to do best!

Sunset at Key West has become a nightly celebration. Visitors and locals gather on the Mallory Square Pier to watch the sun dip into the Gulf of Mexico. This sailing schooner often crosses in front of the setting sun, creating a dramatic silhouette. Sunsets are usually enhanced by placing a visual element in the foreground.

Creative Marketing

Success and even survival for a freelance travel journalist depends on a combination of skills, versatility, and the ability to adapt to changing markets. The basic principles of marketing are simple. Whether you're selling soybeans or travel articles, it is a matter of reaching the buyer at the right time with something that he or she needs. One can learn the principles of marketing in a college course, but the specifics of marketing travel stories and pictures can be more elusive. *Writer's Market*, *Photographer's Market* and *Travel Writer's Market* are three excellent reference books that can be worth their weight in gold.

Professional organizations often offer seminars in marketing and sometimes send out newsletters to help their members. For example, the Freelance Council of the Society of American Travel Writers publishes periodic reports for members on "Constructive Marketing." These reports have been spearheaded by Eunice Juckett Meeker, a remarkable and talented woman who has been in the forefront of freelance travel writing for many years. Eunice draws on the expertise of the finest writers and industry PR experts in putting together the reports on constructive marketing, and the results are enormously helpful. We will mention some of the "Constructive Marketing" suggestions in this chapter.

ADVERTORIALS

One of America's top freelancers, Hal Gieseking, addressed the burgeoning market of advertorials, special newspaper or magazine supplements that provide travel-related information. Advertorials are supported by advertising related to the subject covered in the supplement. Hal points out that advertorials, especially in respected publications, are becoming more acceptable to those travel writers who normally write only straight editorial travel. Hal says, "Serious magazines are taking a second look at advertorials and turning them into in-depth reports on a specific subject."

We have done two major advertorials on travel photography, one for *Travel & Leisure* and the other for *Life* magazine. In both cases we wrote the text and provided the pictures for a flat fee. The magazines sold the advertising to major film and camera manufacturers.

Travel & Leisure magazine also publishes regional supplements covering areas such as the Caribbean and countries such as Australia. The magazine seeks hotel, resort, and airline advertising to pay the contract writer, to cover the costs involved with producing the supplement, and, it hopes, to make a profit.

As a travel writer, how would you obtain an assignment to do an advertorial? These most often come through the advertising or promotion departments of a magazine. Care is usually taken to keep an advertorial supplement completely separated from the editorial staff. If you have an area of expertise or a good idea, call the advertising or promotion manager of the publication and make your proposal.

The patterns and designs found in nature can make effective travel pictures. A ridge of sand atop Sand Mountain in Nevada has the stark simplicity of a Georgia O'Keeffe painting.

SPECIALIZATION

Not all travel writing is about destinations. Many writers have a particular area of expertise. For years we have written about travel photography with monthly columns in *Popular Photography* ("Traveler's Camera") and *Signature* ("On Camera"). We also wrote a weekly newspaper column for Copley News Service called "Vacation Camera." In addition to all these we did a coffee-table-style book, *The Traveling Photographer*. This does not even mention the dozens of individual magazine and newspaper articles we wrote and illustrated on this subject. Altogether we have made well over $400,000 writing about this subject alone.

Erwin and Peggy Bauer of Wyoming are veteran travel writers-photographers who specialize in wildlife. This talented couple have written seven books and they are working on more. Like ourselves, the Bauers combine their ability as writers with their expertise in photography to present a publisher with a finished package. Some of their illustrated books include *Bears in Their World*, *Wildlife Adventures with a Camera*, *Horned and Antlered Game*, and *Photographing the West*. In addition to their books, they maintain an extensive stock file of wildlife photography. For the Bauers it has paid to specialize.

There are many unique subjects on which to write. Maybe you're very good at on-the-road car repair; you could develop a monthly column for an automobile club magazine. A former airline executive will have specialized knowledge of the airline industry and could write a consumer column for travelers who fly to their destinations. Consider your specific knowledge and expertise and come up with a subject on which you are well qualified to write.

SELLING YOUR WORK OVERSEAS

Selling travel stories and photography overseas can be profitable. Once an article has been used in North America, it can be sold again and again in different countries. It is easier to make sales in English-speaking countries, but a really good article can be translated into the language used by your intended publication. Unless you are a language translator or have access to such expertise, it is far wiser to let the publication make the translation.

Some picture agencies will market your work in a combined package of photography and text. Query individual agencies about this possibility. In other cases you can sell your articles directly to publications abroad. Writer Michael H. Sedge produces a quarterly newsletter that offers advice on foreign markets. He lists publications that accept freelance articles, details author's rights, and tells you how and where to cash foreign currency checks. His quarterly newsletter is available for twenty-five dollars a year from Michael H. Sedge, 2460 Lexington Drive, Owosso, Michigan 48867.

We suggest submitting high-quality duplicates of your pictures for illustrating your articles. Never send original color slides abroad. The possibility of loss or damage is too great.

ADVERTISING YOURSELF

As photographers, we have advertised in the *Washington Source Book*, a directory of artists and photographers sent to 10,000 art directors in the Middle Atlantic states. Other source books such as *ASMP*, *American Showcase*, and *Black Book* have national distribution. In addition to the source-book distribution, we are provided 1,000 copies of our advertisement, which can be used for direct-mail promotion to show new clients examples of our work. It is important to know the precise message you want to get across. Keep your words brief and to the point. Unless you are a graphic artist, it is better to let a trained professional choose the typeface and do the layout for your page.

Cost for advertising in source books is high. After layouts, one page in the 1990

ON ASSIGNMENT WITH:

*The Purcell Team**

The Purcell Team
5913 Skyline Heights Court
Alexandria, Virginia 22311 U.S.A.
(703) 845-1103

Carl and Ann Purcell have the unique ability to produce images create a sense of place. Their visual interpretation of a travel dest gives the viewer the vicarious experience of being there. Althou work is most often associated with the pages of major travel mag they frequently do assignments for advertising and PR in th industry.

Elliott Joseph on safari with the Purcell team.

Hot Air Balloon Fiesta, A

Taj Mahal, Agra, India

The Purcell Team (Carl and Ann)
5913 Skyline Heights Court
Alexandria, Virginia 22311 U.S.A. (703) 845-1103

Moyglare Manor, Ireland

Hydra, Greece

Carl & Ann Purcell, Governor's Camp, Kenya

ON ASSIGNMENT WITH:

*The Purcell Team**

The investment you make in self-promotional materials will pay off down the line.

The timing of a picture can make a big difference in the result. In taking this picture of Ayers Rock in the Australian outback at sunset, we saw the color of the massive rock change over a brief period of time. It started with a light clay red, shifted to a deep blood red, then to purple, and finally to a blue-black silhouette. We shot all the colors. This was one of our favorites.

Washington Source Book costs about $6,000 and national books are even more expensive. (Simply having your name listed in these books is much cheaper.) It often takes time for stock sales and assignments to pay back your investment, but if your photography is good and it is well presented, such advertising can pay off.

Writers do not have the same options as photographers in promoting their work. As a group, writers feel that it's somehow undignified, almost unprofessional, to advertise. This does not mean that you cannot promote yourself by direct mail. Most successful writers and photographers market their work nationally and often internationally. You will deal with many clients you never get to meet. It is still possible to make a good first impression through your promotional materials, business cards, stationery, and envelopes. These printed materials should be attractive and well designed, and they should make a statement about your professional ability. Some travel journalists list professional affiliations on their letterhead and/or business card. It might be effective to publish a quarterly newsletter that would be sent to magazine and newspaper editors, listing your planned travel itineraries, major published articles, awards, and even a list of story ideas. Such a newsletter could be produced on your computer with a desktop publishing program.

TEACH WHAT YOU KNOW BEST

Consider classes on photography and travel writing. Other possible sources of freelance income are from consulting or conducting seminars and workshops on travel writing

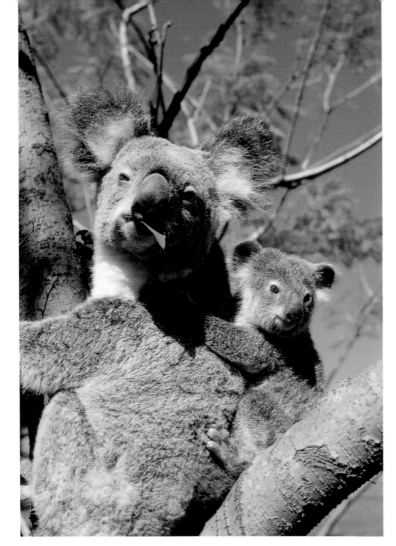

Qantas airlines has made the koala bear the symbol of Australia. This sluggish marsupial dines on tender eucalyptus leaves and can be found in the wild. You'll get your best close-up shots, however, in the many animal sanctuaries throughout Australia.

and travel photography. Open University in Washington, D.C., offers courses in travel writing, and the Smithsonian Institute offers courses in photography. If your city doesn't already have such courses, you may want to consider putting something together. If your course is offered through some existing structure such as Open University, the payment will not be great, but there is prestige connected with teaching. Some entrepreneurs put together their own courses and reap more profit. Our rule of thumb for teaching a five-day class for one hour each day, or a five-hour workshop for one day, is $100 per student. This means that you should get $2,000 for twenty students. That may sound quite good, but it is important to remember that you must invest considerable time and planning in putting together such a class. This may involve, among other things,

the preparation of an audio-visual presentation and at least three hours preparation for each hour of lecture. If your class is successful, you may be able to present it several times in your city or even take it on the road to other parts of the country.

We were called upon by the United States Agency for International Development (USAID) in the State Department to teach a workshop on photography to foreign-service officers. The purpose was to teach these officers the basics of taking good pictures of USAID projects with an automatic, single-lens reflex camera. The workshop included a shooting assignment and a critique of the resulting pictures.

There are many things to consider in teaching a class that is not part of some larger adult education program. Where will your class be held? How will you promote

Notre Dame Cathedral is a symbol of Paris as well as an outstanding example of Gothic architecture. Such a picture can serve very well as a lead illustration on a travel story about "The City of Light."

the class? Where should you advertise? Sometimes you may have to rent a room with a screen, or you may be able to hold your workshop in cooperation with a local camera club or writers' group. Clever advertising can be done through camera shops, bulletin boards, newspaper ads, school newsletters, etc.

Illustrated Lectures and Speaking Engagements

Another forum for your expertise can also be from the lectern. Some travel experts present illustrated lectures based on their trips to exotic destinations. These lectures can be illustrated by slides or 16mm film, sometimes with appropriate background music. The more successful people in this field are booked months in advance by a booking agent. Jeanne Porterfield and Lisa Chickering of New York are two women who work together as a team to produce the visuals for their lecture series. Jonathan Hagar of Missouri and Sherilyn Mentes of California are also prominent film lecturers.

Carolyn Patterson, a senior editor at *National Geographic* before her retirement, gives an illustrated lecture based on her colorful career with that distinguished magazine. Her lively narrative features an extended walk with a donkey in tow through the mountains of southern France, life in a Haitian village, and Winston Churchill's funeral in London. Carolyn receives $3,500 for her presentation to national groups.

Opportunities to give professional travel slide shows might be found through your local college or university, at a nearby high school, or for a church group. Your focus might be to amuse, such as an engagement to be the after-banquet entertainment, or you might give a destination slide show for travel agents.

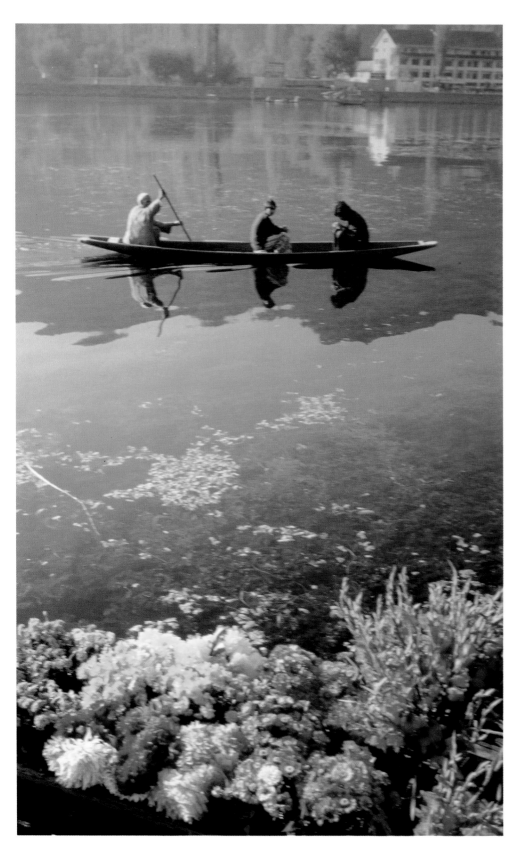

Every traveler has his ideal dream destination. One of ours is the Vale of Kashmir in northern India where the visitor can rent a houseboat on the mirrored surface of Lake Dahl. The luxurious houseboats come with cooks and servants; the floors are covered with oriental carpets. Fresh flowers are delivered every morning and your mode of transportation is a brightly painted shikara.

If wishes were horses and houseboats were dreams, we would all ride and live among the lotus blossoms on the placid surface of Lake Dahl.

A leopard is a prize trophy for a photographer. These predatory cats are very elusive. We found this one relaxing in the shady bower of an acacia tree on the Masai Mara. The leopard presented a difficult exposure problem due to the bright sky in the background, a factor that will underexpose the subject with a normal exposure reading. In this case, the exposure was set automatically by the spot meter on our Minolta 7000i.

CAMERA TOURS AND SAFARIS

While we have taught classes and given lectures, our real forte is conducting camera tours and safaris. We enjoy sharing an exciting travel experience along with our expertise in taking pictures. We have conducted these tours to destinations such as the Galapagos Islands, the Amazon, and New Mexico for the Albuquerque Hot Air Balloon Fiesta. Due to an increased number of writing and photography assignments, we have narrowed these safaris down to East Africa, an area we love and have traveled to more than a dozen times. Our extensive experience in Kenya and Tanzania has allowed us to put together an itinerary that includes only the most exciting photographic sites and allows every participant to get dramatic close-up shots of big game.

For the future, we plan a writing workshop to India, with the final stop to be in the Vale of Kashmir, where participants will live aboard the elegant houseboats in Lake Dahl. Here, they will organize their notes and transcribe them onto portable word processors and print a draft of their travel story. We will offer suggestions for improving the stories and develop a marketing plan for placement with magazines or newspapers.

The logistics of putting together a photo or writing tour can be overwhelming. We suggest that the beginner work with an established travel agency for cutting tickets, obtaining visas, and making ground arrangements at the destination. After several years, you may be able to take over these functions and make a greater profit from your effort. The major problem is advertising and promotion. Some magazines such as *Outdoor & Travel Photography* carry one section of small ads about tours and safaris. It is sometimes possible to get free promo-

tion about an interesting trip by sending out a press release and a black-and-white photograph to newspaper travel editors. The burden of selling places on the tour rests with the writer-photographer who is the tour leader.

This sounds like fun and a great way to make a living, but the would-be tour leader should be aware that conducting a tour can be hard work and a serious responsibility. It can also be frustrating to occasionally deal with difficult people who are hard to satisfy. We have been fortunate in that our tours cater to people who are seeking adventure instead of luxury, although we contend that they will find both in East Africa. Over several years, we have found that our best advertising is word of mouth, and we are pleased to have a high rate of repeat business, even to the same destination.

PUBLIC-RELATIONS CONSULTING

There is also an opportunity for travel writers to serve as consultants to tourist boards and public-relations firms that handle travel accounts. After all, a successful travel writer-photographer has a field of knowledge that can be quite valuable. A PR firm specializes in promoting its own accounts, while a travel writer places stories on any destination he or she visits and finds worth writing about. In practice, travel writers are more objective, including both the positive and negative aspects of a destination. The successful freelancer knows how to get his or her material used and can often teach PR people how to market their message in a form acceptable to editors. Barry and Hilda Anderson, travel writers in Seattle, Washington, act as consultants to companies, PR agencies, and city and state tourism organizations.

"Writing for the traveling public gives us a perspective on what editors want. In the context of PR, it allows us to take an unbiased view of a product or a travel destination," says Barry Anderson.

Hilda adds, "We offer an honest opinion, and if they have problems, try to come up with viable solutions."

Some freelance writers are hired by public-relations firms to write articles about cruises or travel destinations, but in such cases it is always important to make clear in your contract or letter of agreement that such an article will be placed by the PR company and, although you will be paid by the PR firm, the article will be offered free to editors.

Our own special expertise is in the area of photographic distribution, or the practice of providing good public-relations photos to editors who cannot afford to buy from photographers. Unfortunately, many PR firms have very little experience in working with professional photographers or little technical knowledge about reproducing color and/or black-and-white pictures in quantity. Surprisingly, many PR firms don't even know whether to send editors color prints or color slides. The most common complaint from editors about PR firms concerns the quality of their photography. In many instances the photography itself is poorly done and the prints or color duplicates are unacceptable. We often get calls from editors who are willing to pay for our pictures of a resort or destination after they have found the pictures from the PR firm to be lacking.

In consulting with public-relations firms on this subject, we stress that the original photography must be outstanding, both from an artistic and a technical standpoint. We also explain that advertising photography is not usually suitable for editorial use. Often we are retained by a client to take the original pictures. (We shoot for both advertising and editorial clients.) For editorial placement we may use models, but we take care not to create images that appear designed to sell the resort, the hotel, or the destination. Our goal is to create a sense of place. Certainly we want our images to convey romance and luxury, but it is important for them also to be believable as travel pictures. Static advertising shots cannot convey

Bogota, Colombia, is not a particularly breathtaking city but it becomes more romantic at dark. The comparison of the Seguro skyscraper and an ancient Colombian church worked best just after twilight, when all the lights had come on but while there was still an ambient blue light in the sky.

the excitement of real people interacting and real activity taking place, even though we may have chosen a specific spot for its visual beauty, uncluttered background, or graphic color combinations.

Once the pictures have been shot and processed, we advise our client on filing and protecting the originals. Too many negatives and chromes (color slides) are lost or damaged. It seems easy and convenient to send original slides to a magazine or newspaper, but often original slides are not returned. Some PR firms are surprised to learn that photographers charge a client $1,500 for a lost or damaged original.

We guide a PR client to the best labs for making color duplicates (see "The Submission Process," Chapter Four) or converting color slides to black-and-white (see "Choosing the Best Film," Chapter Three). Most are delighted to learn that outstanding quality can be achieved; but they also learn that only a few labs have the knowledge or take the care to get the best possible results.

We help a PR client set up a master file of original color slides which are theoretically never sent out to a publication. Multiple quality dupes are made of the best images in the files, and these carefully captioned dupes are mailed to magazines and newspapers on request. High-quality duplicates, especially in the 70mm format, are truly equal to the original. If a very important magazine insists on having an original from a PR firm, it should be sent by registered mail or Federal Express with a clear understanding that

it must be returned.

In our role as consultants, we also advise on such mundane matters as using protective plastic sleeves for color slides, printed submission forms, cardboard protectors, and methods of delivery.

In order to get a job as a public-relations consultant, you will have to have had enough of your work published to be believable when you say that you know what the editors want. Start making notes now about editors' pet peeves and your more successful approaches. Whether you become a consultant or not, your notes will eventually earn you money.

CONTRACTING FLAT FEE BOOKS

Can you write and publish your own books and make money at it? Diana and Bill Gleasner of North Carolina have found book publishing to be a profitable effort. This couple seeks out book sponsors for tourist attractions, cities, and land developments. They point out that the key to financial success is finding a client who wants to have a book written and is willing to pay you to do it. Examples of such clients might be a visitors and convention bureau, an amusement park, or a private property destination. For example, the Gleasners have published books on Calloway Gardens, south of Atlanta; Lake Norman in North Carolina; and a family resort in the Poconos. Payment comes in the form of a substantial advance (at least 25 percent of the final fee) with three or four additional payments made during the course of the project. Final payment is made upon delivery of the book.

The Gleasners stick with the creative side of publishing, an area they know well. Books usually start with a well-researched outline and a precise, clean contract with all the details spelled out. They make sure there is a clear understanding with their client on

A lone fisherman watches the sun set over the Potomac River in Washington, D.C. The Francis Scott Key Bridge is in the distance.

the concept and purpose of the book.

"We are concerned and involved with every phase, from the idea to the final product. Publishing our books is roughly twice as much work as writing and photographing a book for a regular publisher." Obviously the Gleasners are willing to do the extra work for the sake of maintaining creative control over the entire project.

The only thing that the Gleasners will not do is get involved in distribution. They use a professional graphic designer for design, layout, typesetting and mechanicals. They have their printing done in the Orient for the best available combination of cost and quality. The books are submitted to the printer in camera-ready form. The printer handles color separations, printing, binding, and shipping. A custom broker is used for getting the books back into the U.S.

The Gleasners have derived profit and satisfaction from their books. Self-publishing has worked for them. Maybe it can work for you. Realistic pricing of the book production will be the most complicated part of this undertaking, and you could lose your shirt by jumping into a contract unprepared. A good source book to read on this subject would be *The Complete Guide to Self-Publishing*, by Tom and Marilyn Ross (Writer's Digest Books).

KEEPING PACE WITH TECHNOLOGY

The modern travel journalist would consider it ludicrous to write with a quill pen or take pictures with an 8″ × 10″ view camera on a tripod. Even so, some of us are hesitant to embrace new technology that can make our work both easier and better. We tend to be traditionalists. When we find something that works, we stick with it.

Lee Foster of California is a writer-photographer who has stepped boldly into the 20th century. Like many of us, Lee gropes with technical changes, but he has the unique ability to turn them to his advantage. At last count, Lee had put 210 articles and two of his guidebooks into a special travel service offered by Compuserve. Any subscriber can log onto this computer service and read Lee's articles on California and other travel destinations. Lee is paid a percentage of the on-line charges.

Many people in our business are learning that newspapers and magazines prefer to work with writers who can transmit their articles via modem over the telephone lines to a central computer.

Cameras are undergoing drastic changes that can help you take better, more professional-looking pictures. Automatic exposure came first, followed by autofocus. Many old-fashioned press photographers resisted these changes at first, but the wise ones have now taken advantage of these features. Films are being improved, thanks to an open and competitive market. Canon has introduced a still camera that takes electronic pictures on a disk. Computers can manipulate and enhance an image through a digital process. We predict that the still cameras of the future will utilize electronic images for both television and the printed page. The chemical emulsion film will be relegated to museums.

Our advice is to take advantage of every new technological development that can help you in your work. The criterion is: If it works, use it!

Obviously there is more than one way to skin a cat in the travel-writing and travel-photography business. We have tried to open some windows into areas that are worth looking into. There are many opportunities out there for the writer who has the imagination to recognize them.

Sometimes you'll see a graphic detail that delights your eye and you should grab the chance to document it with your camera. In this case, we were on a boat ride through Venezuela's Canaima Lagoon. We couldn't resist capturing the vivid picture of our young Canaiman Indian guide's black hair and colorful feather against the sky.

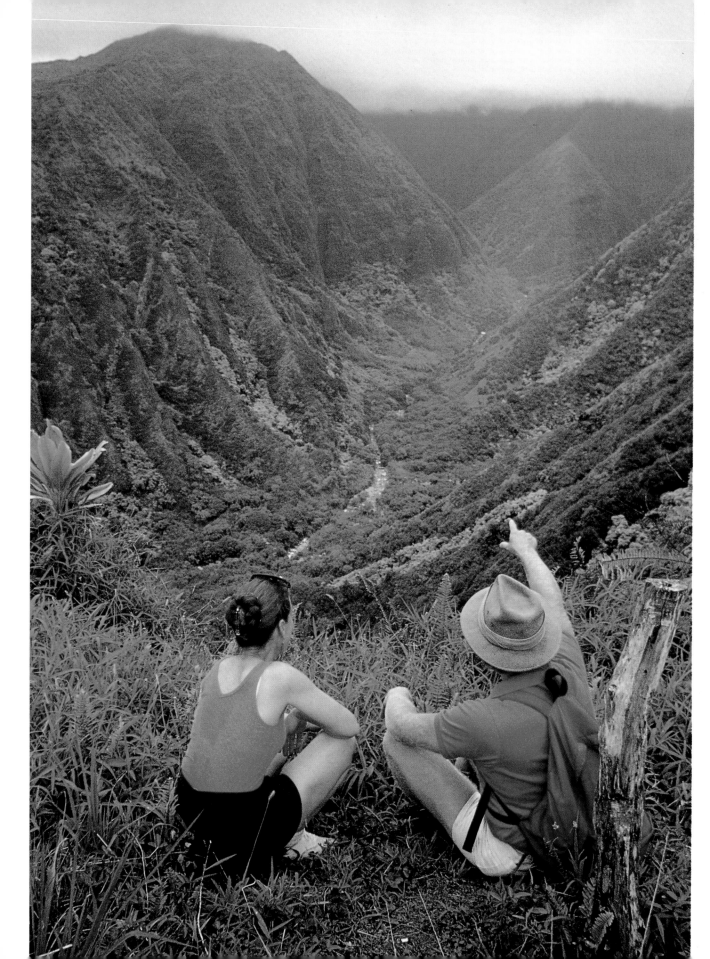

The Birth of an Article

ow does a travel article come into being? What happens from the moment of conception to the time it appears on the printed page? The evolution of each article is different, depending on the writers, editors, and art directors involved. We selected one of our articles for *Travel Holiday* as an example. In this case we queried the managing editor, suggesting an article on water sports in the Florida Keys. She said it was a good idea, but that the magazine needed something on Hawaii. Could we do the same type of article on Maui? Changing the destination was easy, but we discovered that Maui offered unique adventures both in the water and on the land. This chapter presents the resulting article and our comments about its development.

First, of course, we had to have our opening, and we wanted to catch the reader's eye. There were several exciting moments during our Hawaiian trip, and our opening had to be at the peak moment of one of those experiences. We chose those minutes just before we started the plunge down the side of a volcano. Note that the first paragraph also had to give the reader some hint of what was to come in the rest of the article.

When possible, your travel pictures should impart a sense of adventure and allow the viewer to share your experience. Ann Purcell and naturalist Ken Schmitt sit on the edge of a hidden valley on the island of Maui. The photograph was used full page with an article about Maui in *Travel Holiday*. Note that Ann and Ken are wearing brightly colored shirts to contrast with the green foliage.

"SURF AND TURF: ADVENTURES ON MAUI"
by Carl & Ann Purcell
for *Travel Holiday*

At 5:30 A.M. we stood shivering on the rim of the dormant volcano of Haleakala, watching the sunrise in the clear, chilled air high above the clouds at 10,023 feet. Fourteen of us were about to embark on a daring downhill bicycle ride of thirty-eight miles, starting at the rim of the crater and speeding down the slopes and hairpin curves of the winding highway. We wanted to experience the unique adventures that Maui had to offer, both on the island and in the water. This was our first.

The rules for the Maui downhill bicycle ride stipulate that participants must already know how to ride a bike, a skill that most Americans possess to some degree. This popular new sport, however, is regulated by strict safety procedures. Group size is limited and riders must be at least five feet tall. Helmets are required. Our attractive leader-guide, Valerie Engel, carried a walkie-talkie to communicate with the van as it followed our group on the downhill journey. When cars wanted to pass, the van driver contacted Valerie via radio and she signaled the riders to pull over to the curb.

Maui Downhill provided protective, full-face helmets and gloves, and they had warned all riders to dress warmly. Waterproof rain suits are also issued to participants, but fortunately no rain materialized. Our bicycles, basic Schwinn frames equipped with heavy-duty front and rear hand brakes, were issued to us from a trailer which had been pulled to the top by our van. We tried our wings, so to speak, in the Haleakala Crater parking lot and quickly rediscovered the rusty skills acquired delivering newspapers as teenagers. At a signal from Valerie we donned our shiny helmets and formed a single-file line at the curb in the parking lot. With a shout, we were off like the U.S. cavalry and suddenly we were flying like birds, the wind whistling past our face guards. It gave us a sense of exhilaration, but for all the freedom we were still an integrated part of a group which precisely followed the hand signals of our leader.

The clouds parted and the valley below appeared as a green patchwork quilt, verdant fields of sugarcane and pineapples, tied together by lavender tufts of jacaranda trees and laced by windbreaks of eucalyptus. Cows gazed with mild curiosity as the long line of bicycles sped past. Our actual ground speed was governed by Valerie and ranged from a cautious crawl up to 40 mph. There were a few bunny hills, slight inclines where we found it necessary to peddle, but most of our exercise on this ride came from "pushing our luck."

About halfway down there was a stop at the Silversword Inn for a hearty brunch of scrambled eggs, muffins, bacon, and country sausage lubricated by copious quantities of chilled orange juice and hot coffee. After a brief rest, we resumed our ride past waving fields of sugarcane and groves of macadamia nut trees. We glided into the coastal community of Paia with a genuine feeling of accomplishment. Our spirits and our bodies had soared with the legendary gods of Maui.

Before getting into our next Hawaiian adventure, we had to have a transition paragraph that would also indicate the location of our underwater dive. Using actual names of people personalizes an experience and makes the account feel more real, even for the armchair traveler who may never really get to meet these people. Vivid descriptions are very important—you want your reader to be immersed in this underwater realm with you.

Having tried this downhill adventure on the Maui turf, we decided to dip into the deep, clear water of the Pacific on a scuba dive in the ancient volcanic crater of Molokini, off the western coast of Maui. The persistent waves of the Pacific have eroded the rim, creating a protective U-shaped lagoon which has given birth to elaborate coral formations and spawned schools of colorful tropical fish. It is a natual sanctuary for the myriad forms of marine life indigenous to the Hawaiian Islands. The lagoon is the most popular snorkeling and scuba diving site in the Hawaiian Islands. We donned wet suits and strapped on tanks and weight belts. On entering the clear water, we had the sensation of floating in air. Our divemaster, Paul Beattie, spiraled down to the reef, trailing a pearl necklace of white bubbles from his air regulator. With a gentle motion of our flippers, we followed like sleepwalkers in this blue dream-world of enforced silence.

Paul paused at a coral head and pulled out a plastic bag filled with bread from

The horseback-riding shot was almost a double-page spread, with only one column of text on the far right. It was important to show the volcanic coast to help establish the setting as Maui.

his weight belt. The lemon butterflies swimming near him sprang to attention as he extracted pieces of bread and let them drift free in the water. The brightly colored fish flocked around him in a feeding frenzy, flashing like a treasure trove of golden doubloons.

After providing the fish with a free brunch, Paul led us to the lair of a giant but gentle moray eel nicknamed Garbanzo. Carefully following instructions from Paul, we were able to stroke Garbanzo on his soft, undulating back. Other denizens of the deep often seen at Molokini are small sharks and octopi, all quite harmless to divers and snorkelers.

Although everybody likes to read about exciting, slightly dangerous adventures, not every tourist to Maui will want to try them. Some people prefer what we call "soft adventure," and you, the travel writer, should explore as many possibilities as time allows, to let the potential visitor know what is available.

Another morning found us on the coastal ranch of Frank Levinson, a genial horseman who conducts adventures on horseback in one of the most spectacular settings in the world. Frank looks like a cross between Tom Selleck and Crocodile Dundee, with a combined enthusiasm for horses and the physical beauty of Maui. His stable of ten horses is well trained and responsive, even to novice riders. The first part of the ride with Frank and his colleague, Bea Robinson, was along the steep cliffs overlooking the Pacific Ocean. Brief rain squalls were forming just off the coast, and the freshening wind whipped the manes of our spirited horses. When the rain actually hit, it lasted less than five minutes, but the horses instinctively turned their backs to the short squall and stood, patiently waiting for it to pass. The warm sun mixed the pungent odor of horses, saddle leather, and damp Levis as we rode across the fields to the coastal road.

The Long Beach on Maui is one of the most beautiful beaches in the world. It forms a perfect crescent of sand and turquoise water. For our story it was important to include a picture showing that, among other things, Maui is endowed with fine beaches.

After crossing the road, we entered a heavily wooded slope under a canopy of eucalyptus trees with a ground cover of lush ferns. This mini rain forest was another world, a hot house of tropical plants and exotic blossoms. Frank and Bea dismounted and established a base camp with a canvas tarp to protect us from unexpected showers during lunch. They then led the way along a fern-covered path and down a steep incline to a hidden, pristine waterfall splashing into a green pool of fresh water. This was the Maui of our dreams, the cliché of a tropical paradise. In this isolated glade, we were the only people in the world, drinking in the beauty and enjoying the solitude. We swam in the natural basin, letting the falling water cascade over our heads and later sitting in warm pools of sunshine. Frank explained that this was private property, but that he leased the right to bring riders to the waterfall.

You'll notice that our article has so far introduced excitement, glamour, beauty and animals. What would you seek on Maui if you were a purist, an athlete, or a scholar? We found one experience that might appeal to such a person and we wrote about it.

We had experienced Maui on bicycle, under water, and on horseback. The simplest way to see the island, however, is on foot, and the best way to do this is with naturalist Ken Schmitt, who introduces small groups of visitors to the flora, fauna, legends, and geological history of Maui. (Maximum size of a group is six and hikes range from easy to rugged.) We met Ken early one morning in the parking lot at Buzz's Wharf near the neck of the island, at Maalaea Bay. His well-muscled legs attested to the fact that he had climbed the steep volcanic trails many times; his already blonde hair was bleached almost white by the tropical sun. Ken is an encyclopedia of knowledge on the subject of Maui, imparting this knowledge in a gentle way as he walks. We drove with Ken to

Camp Mahulia, parked the car, and followed a trail through a mountain pasture. The first thing Ken pointed out was the pressure-sensitive mimosa pudica plant. At the slightest touch it would fold its tiny leaves with the mobility and sensitivity of a newborn baby curling his hand. Later we walked along a lush jungle trail in a mixed mesic forest, carpeted by ferns and accentuated by tiny tree orchids.

As we walked, Ken picked berries, leaves, and the tips of sword ferns, passing them to us to taste. "This is actually the world's longest fruit and salad bar," explained Ken. "A person could survive here without any trouble."

Later we stopped for a real picnic lunch at a park near the Iao Needle, a natural rock formation near the center of the smaller part of the island. Ken, a devout vegetarian, had brought spinach nut burgers and avocado-and-cheese sandwiches. He cut open a fresh Maui mango, undoubtedly the most succulent fruit we had ever tasted.

If there is an adventure that we want to report but we haven't tried it ourselves, we feel honor-bound to let our readers know that this is only hearsay.

The one Maui adventure we regrettably didn't have time to try during our visit was a morning helicopter ride. These dragonflies of fantasy can fly you to remote waterfalls, along white sand beaches; they can float over Haleakala Crater and then descend to the Seven Sacred Pools of heavenly Hana. The brochures say, "Fly through rainbows" and, under the right weather conditions, that's literally possible.

Now we get to some practical facts for people who have decided to go. Editors, as a rule, will not publish anything that sounds like advertising copy. It is important, if you are mentioning your hosts, to make them an integral part of your story. It is helpful to give descriptions of what the traveler might expect to find and pointers for making the trip more pleasant. Be honest. If the food had not been good at the hotels, we would have suggested some alternatives. If we had run into unpleasant situations, we would have warned our readers to expect them. Fortunately, in this case, we could report favorably.

To taste the adventures of Maui fully, it is helpful to have your own transportation. We picked up a Toyota Camry at Tropical Rental Car, a short distance from the Maui airport. This company offers an attractive trip-saver rate of $25.95 per day, which includes unlimited mileage, additional driver charges, and full insurance coverage. Advance reservations are suggested. The Tropical Van will pick you up and deliver you to their office.

Walking through the lobby, gardens, and around the pools of the Westin Maui at Kaanapali, we had the strong impression we had stumbled into Coleridge's opium dream of the Kubla Khan pleasure dome. This hotel is a stage setting, from the incredible collection of oriental sculpture to the cascading waterfalls which splash into multilevel pools. It is understandable why this hotel attracts honeymoon couples from all over the world, but the beauty and drama of the stage setting can be appreciated by both young and old. Frequently people come to Maui for a tropical wedding and stay on for their honeymoon. Such

arrangements, including a minister of your denomination, can be made through the hotel.

At the southern end of the island and later in the week, we stayed at the Maui Prince at Makena, an equally luxurious but less ornate hotel. The simple, clean lines of the Maui Prince represent contemporary hotel architecture at its best. This hotel is located near what must be the finest public beach in the world, simply called Big Beach. It is well worth the three-minute drive to Big Beach to watch the sunset with a chilled bottle of California blush. The Maui Prince also has a world-class 18-hole golf course and several fine restaurants.

Whether your editor has specified it or not, you should always provide the material for an information box. Sometimes this will not be used; but especially in magazine articles, information boxes are often the acceptable closing of your article. The questions you need to answer are: How do you get there? Where can you stay? How much is it going to cost? If your readers want to do what you did, who should they contact and what is the fee? Notice that there is a "-30-" at the bottom of the piece. In the newspaper and magazine publishing world, this means "The End."

GETTING THERE AND FINDING THE FUN!

You can fly to Maui directly from Chicago on American Airlines aboard a wide-bodied DC-10, with only a brief stop in Honolulu. This is far more convenient than changing aircraft in this major, sometimes hectic Pacific hub. The climate and temperature on Maui has little variation, so you can go during any month.

The Westin Maui is located at Kannapali Beach, a very posh and expensive part of the island. Rates range from $185 to $350 per night. The Maui Prince is located in a quieter, less-developed area near Makena. Its rates range from $170 to $270. Hotel dining in Maui, while excellent, can be expensive, but if you have the mobility of a rental car you can dine around. Denny's Restaurant has numerous locations around Maui and offers a wide menu at reasonable prices.

It was possible to book any of the adventurous activities described at most major hotels on the island. Brochures are available in the lobbies. There is often a choice of companies offering particular tours or activities, sometimes with slight variations in cost. We personally tried the ones we have described in this article and have included them in the following list.

Adventures on Horseback: Five hours in and out of the saddle exploring the coast and rain forest of Maui. Lunch included. Cost is $125 plus tax per person. Book at hotel or contact Frank Levinson at (808) 242-7445.

Maui Downhill: Coast by bicycle from the rim of Haleakala thirty-eight miles to the sea. Pickup at hotel, rolls and coffee, full brunch and safety gear included. Cost is $93 (including tax) per person. For reservations, book at hotel or call (808) 871-2155.

Hike Maui: Walk the island of Maui with naturalist Ken Schmitt. Personal itineraries arranged to meet hiking abilities and interests. Planned hikes range from $60 to $100 per person. Book at hotel or call (808) 879-5270.

Ocean Activities Center: Scuba dive in the crater lagoon of Molokini. Choose a beginner's dive (including instruction) if you have no previous experience or a more advanced dive if you're already certified. Snorkeling is also available.

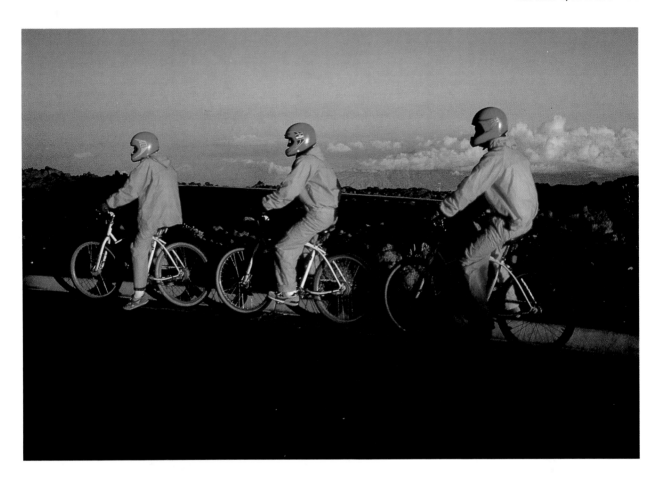

Double tank dives for certified divers are $85, a dive for noncertified participants if $75. The deluxe snorkel trip with an open bar, gourmet lunch, and use of an underwater camera is $80 for adults and $60 for children. Book at hotel or call (808) 879-4485.

-30-

The title was changed from "Surf and Turf: Adventures on Maui" to simply "Adventures on Maui." We liked our original title, but the editor may have wanted it shorter or may have been reminded of food, like lobster and steak. It is often desirable to include the name of the destination in the title. In the original version we wove the information included under "Getting There and Finding the Fun" (the information box) into the text at the appropriate places. *Travel Holiday* preferred putting it all together in a sidebar at the end. Aside from minor changes, the text remained very much as we wrote it.

We put forth considerable effort to take pictures that illustrated our personal experiences on Maui and we appreciated the fact that the picture editor used only our photography. Magazines usually send out requests to other photographers and picture agencies throughout the country to obtain pictures to illustrate travel articles. This was a vote of confidence in our photo coverage and we appreciated it. In fact, payment for the pictures exceeded our fee for writing the article. (This aptly illustrates the value of being able to deliver a complete package of words and pictures.) We were very pleased with the layout and the balance between pictures and text.

One of the most exciting adventures on Maui is the thirty-eight-mile downhill bicycle ride that begins at the rim of Haleakala Crater. The picture editor selected this shot as the closing for our article.

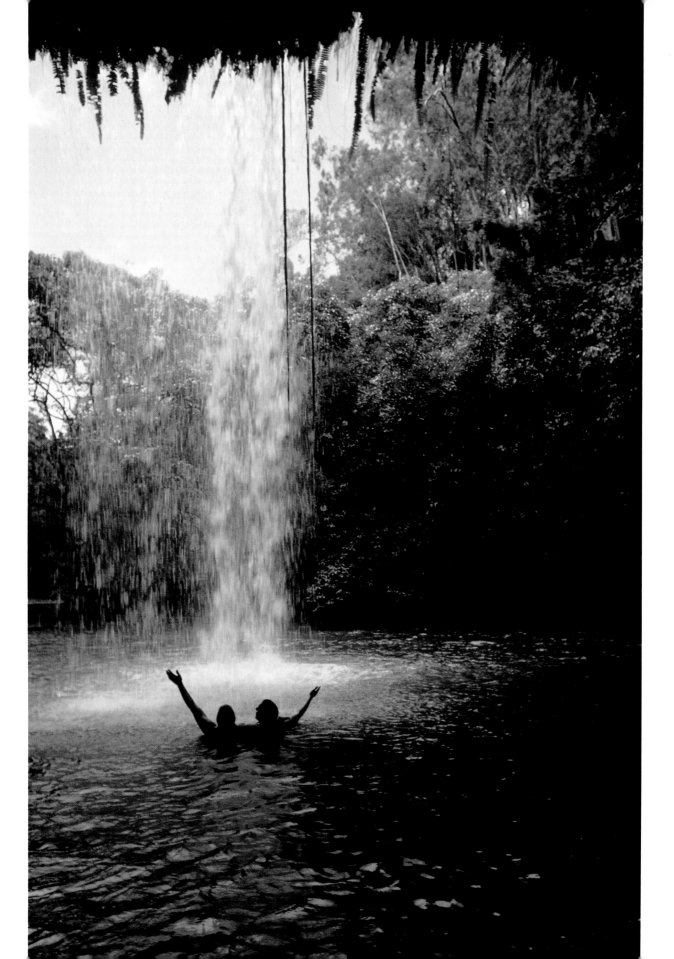

Conclusion

We have introduced you to our world and shared the professional trade secrets of our craft. We know that writers with talent, sensitivity and energy can succeed in this competitive field. It is not a road to riches, but it is a career that has its own very special rewards. To walk along a deserted beach as the Pacific surf washes around your ankles is a unique experience. To watch the setting sun turn the tropical sky into a Winslow Homer watercolor is something a person files away in his or her memory, to be pulled out and cherished on a cold winter evening. To walk through a field of wild flowers in an Alpine meadow in the spring, ringed by the majesty of snow-capped peaks, is a moment a traveler will never forget. Such opportunities create a substantial balance in the bank account of life.

For many of us, travel is the substance of our dreams. If we didn't earn our living as travel writers and photographers, we would probably be in another profession involving travel. Our goal has been to show you a way to blend reality with your dreams. We know you can also achieve our kind of life-style if you are willing to work hard, suffer a little, develop a grand sense of humor, and exercise an inexhaustible sense of curiosity, because we have done it and love it. Someday, when you are photographing patterns in the sand on Australia's Lizard Island, watching a royal cremation in Bali, or using chopsticks to pick up snow peas in China, our paths might cross. Look for us and say hello. If we're floating over you in a hot-air balloon or swimming under you in a coral grotto, wave to us. If you are in Alexandria, Virginia, pick up the phone. We are always delighted to hear from colleagues who also get joy and profit from travel writing!

Picture editors and photographers often disagree with each other about the pictures chosen for a layout. Overall, we were happy with the choices of pictures used in our article, "Adventures on Maui," but we were sorry this one was eliminated. We're pleased to be able to share it with you here!

Index

Permissions